E. J. Hughes

PAINTS BRITISH COLUMBIA

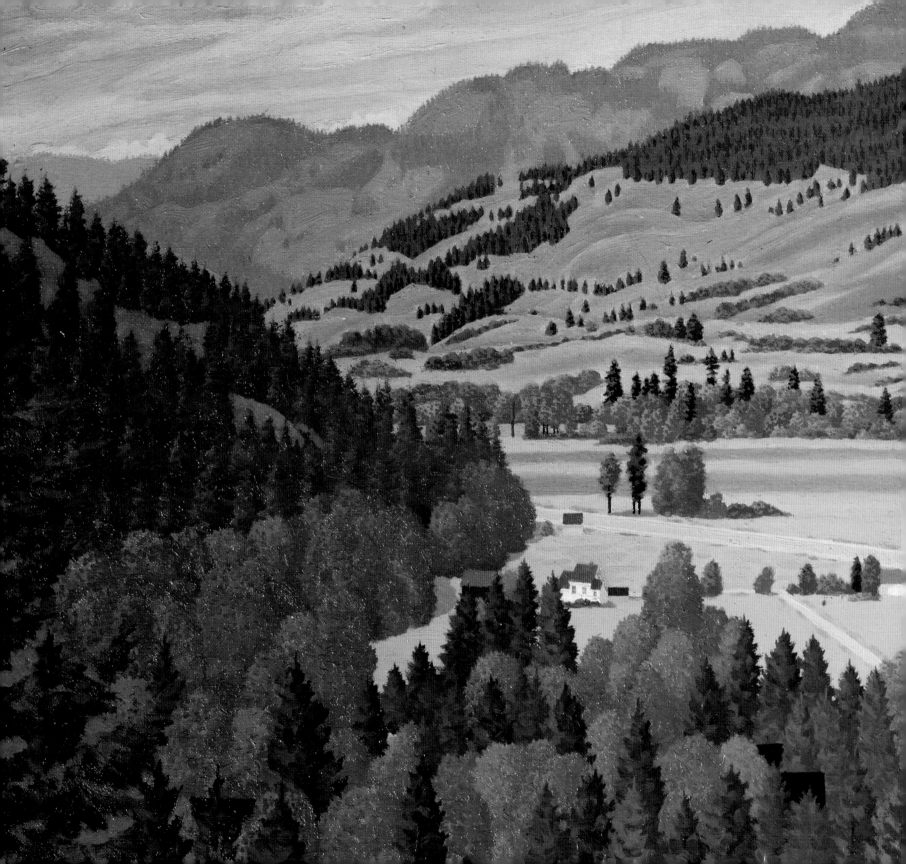

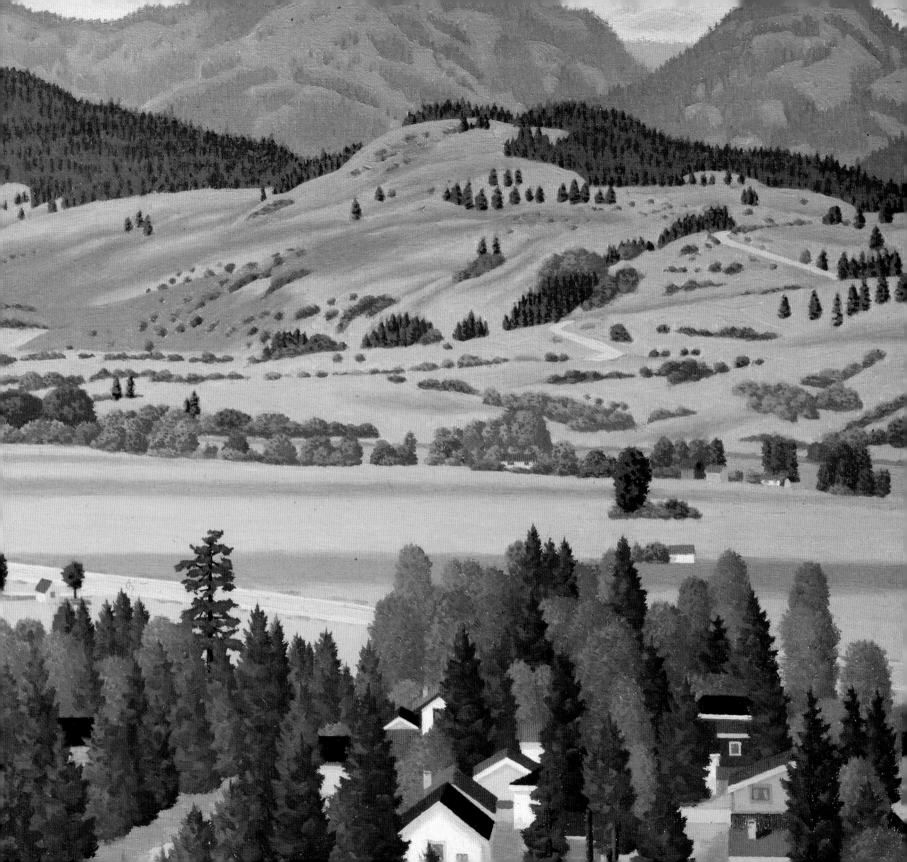

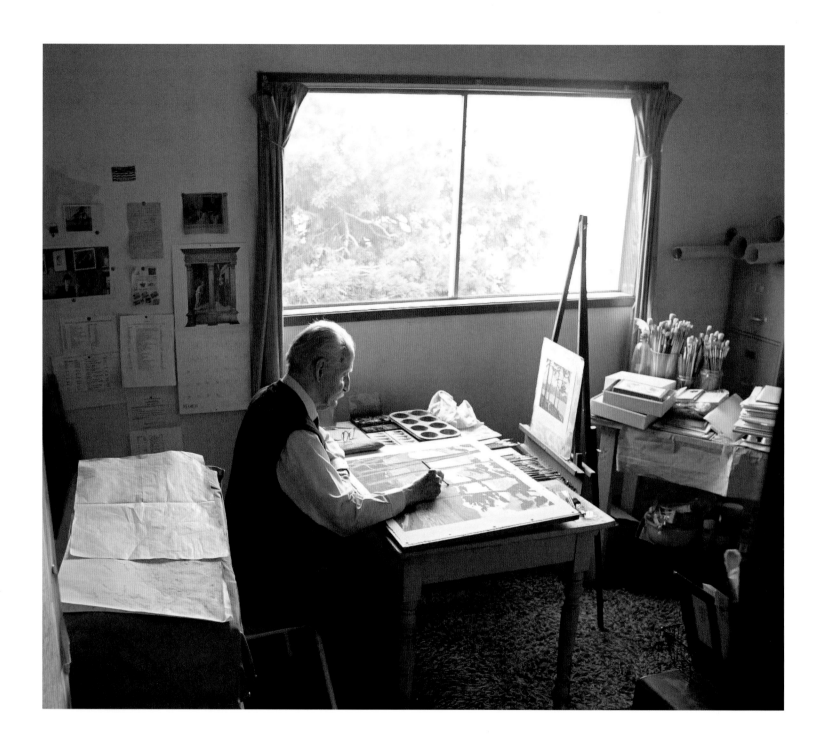

E. J. HUGHES
PAINTS BRITISH COLUMBIA

Robert Amos

WITH THE PARTICIPATION OF
THE ESTATE OF E. J. HUGHES

TOUCHWOOD

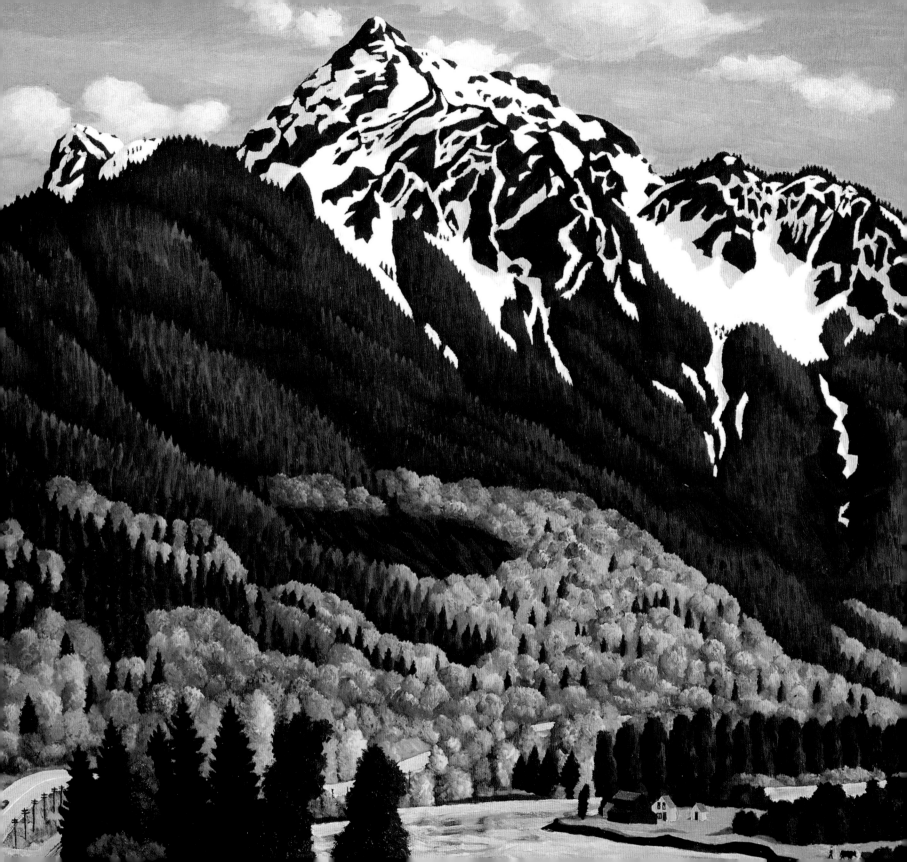

Contents

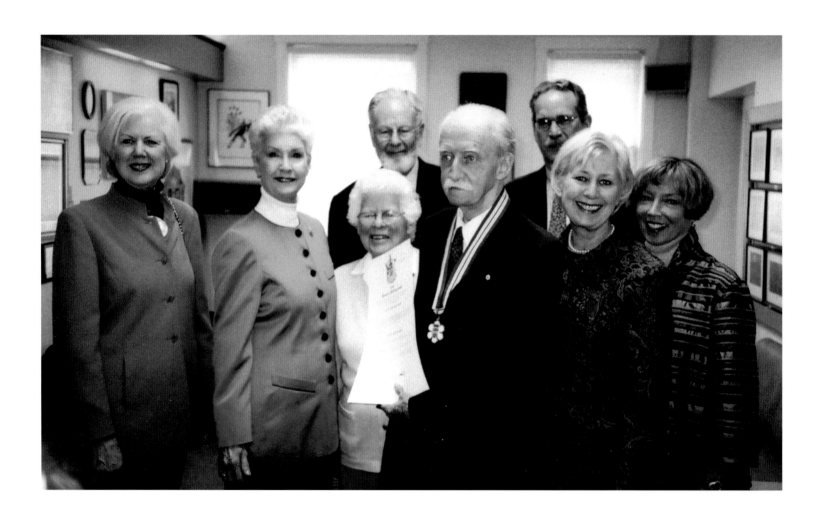

E. J. Hughes was presented with the Order of British Columbia at a ceremony at Duncan City Hall in September 2005. In this picture (from left to right) are his niece June Simpson, Her Excellency Iona Campagnolo, collectors and supporters Sheila and Denham Kelsey of Thetis Island, the artist E. J. Hughes, cousin Richard Hamilton (who nominated Hughes for the honour), niece Virginia Dalton and Richard's wife Gail Hamilton. Photo by Pat Salmon.

From the Estate of E. J. Hughes

To accompany our foreword for the book *E. J. Hughes Paints British Columbia*, we have chosen a photograph of a proud moment in the life of our family. In September 2005, Hughes was presented with the Order of British Columbia by Lieutenant Governor Iona Campagnolo in a special ceremony at the Duncan City Hall. This was by no means the artist's only award—he was given three honorary doctorates and was a member of the Royal Canadian Academy of the Arts and the Order of Canada. But this time he was surrounded by his family.

Hughes was part of a devoted family, which continues today. He was always supported in his art by his father, Edward S. Hughes, and his mother Katherine (Kay). He was the eldest of four children, all of whom had rich creative lives. His sisters Irma (Hamilton) and Zoë (Foster) were themselves artistically gifted. Ed was always happy to give them encouragement, and they kept in touch all their lives. All lived into their nineties.

Their younger brother Gary chose music as his career. After wartime service in the army band, he lived in England, where he worked as a composer and arranger at the BBC until his untimely death at the age of 57.

The responsibility for the Estate of E. J. Hughes has been taken on by his family, and we feel a deep respect for his life and work. It is important to acknowledge the tremendous support provided to Hughes in the last thirty years of his life by his Shawnigan Lake neighbour, Mrs. Pat Salmon. In addition to looking out for many practical details of our uncle's life, she assembled an extraordinary archive about him. In 2010, Salmon chose Robert Amos to take over her work as Hughes's biographer. We know that she was deeply satisfied to attend in 2018 the launch of the first book produced from her materials, *E. J. Hughes Paints Vancouver Island*. It is with sadness that we note her death in June 2019 as the present volume was going to press.

Hughes knew Robert Amos as a writer and as an artist. His special combination of interests is perfectly suited to making the work of our uncle better known to the public. Once again, the Estate would like to thank Robert Amos for his unwavering dedication which now results in this second volume of the life and work of E. J. Hughes.

While few can own one of his originals, E. J. Hughes always wanted everyone to share the beauty he saw all around him. This book is intended to help that happen, and we are pleased to participate in the publishing of *E. J. Hughes Paints British Columbia*.

The Estate of E. J. Hughes
JUNE SIMPSON, VIRGINIA DALTON,
DR. ANDREW FOSTER, SARAH DURNO,
ANDREA HILL, AND JOHN H. DALTON

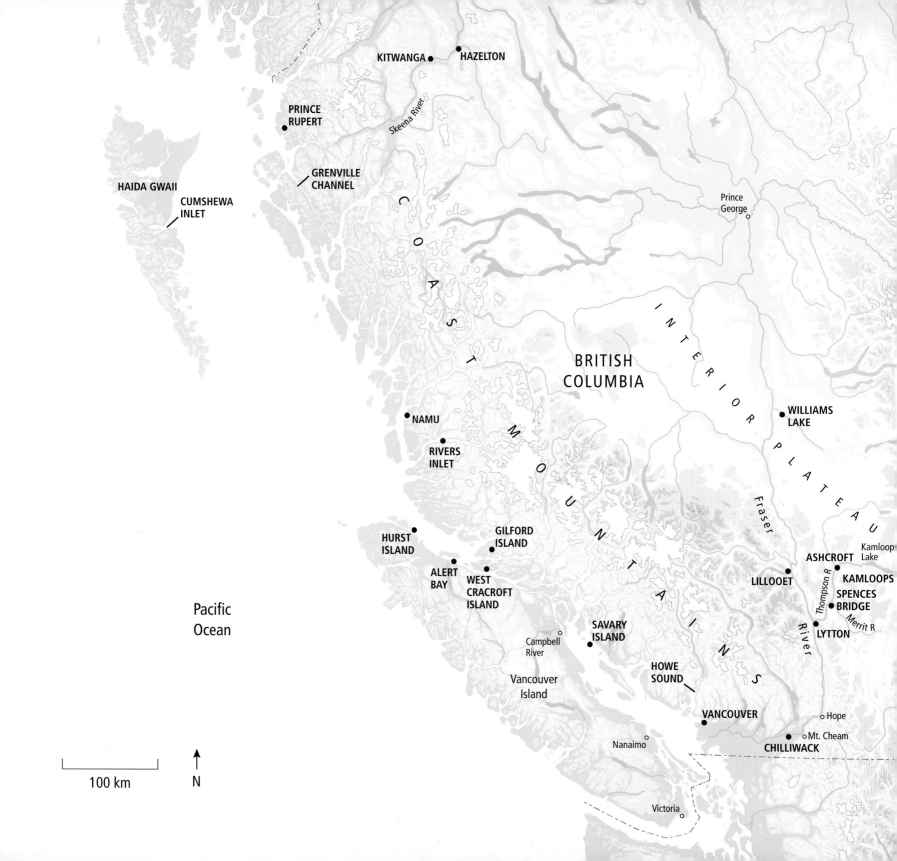

KITWANGA • HAZELTON

PRINCE
RUPERT

Skeena River

GRENVILLE
CHANNEL

HAIDA GWAII

CUMSHEWA
INLET

C O A S T

Prince
George

BRITISH
COLUMBIA

I N T E R I O R P L A T E A U

NAMU

RIVERS
INLET

WILLIAMS
LAKE

M
O
U
N
T
A
I
N
S

HURST
ISLAND

GILFORD
ISLAND

Fraser

Kamloops
Lake

ALERT
BAY

WEST
CRACROFT
ISLAND

ASHCROFT

LILLOOET

Thompson R

KAMLOOPS

SPENCES
BRIDGE

Pacific
Ocean

SAVARY
ISLAND

Merrit R

Campbell
River

River

LYTTON

Vancouver
Island

HOWE
SOUND

VANCOUVER

Hope

Nanaimo

Mt. Cheam

CHILLIWACK

100 km

N

Victoria

ALBERTA

ROCKY MOUNTAINS

FIELD
Lake Louise
BANFF
CANMORE
Calgary
REVELSTOKE
CHASE
KALMALKA LAKE
Okanagan Lake
Kelowna
KASLO
RIONDEL
KOOTENAY LAKE
Nelson
Cranbrook
WASA LAKE
PENTICTON
CANADA
USA

Introduction

"As we look, we are like jaded summer vacationers from the city, rejuvenated by the simple vital drama of the Coast Islands as it unfolds before our cottage door. There is, too, the intensity of experience which we associate with the world of the child . . . there is for the spectator this sense of a cherished moment, vividly experienced and held clear in memory . . . "

—DORIS SHADBOLT, *Canadian Art*, SEPTEMBER 1953

I have loved the paintings of E. J. Hughes from the first time I saw them. In my previous book, *E. J. Hughes Paints Vancouver Island*, I described my introduction to the artist and his work in detail. As I learned about him, I became fascinated by this man who stayed home, lived quietly, worked diligently, and chose his immediate surroundings as the subject for his life's work. Hughes has been thought of as a recluse, a hermit, a naïf—but in person he was none of those things. He was a man of upright bearing, gracious consideration, and unfailing politeness. Visiting him seemed to me like meeting someone for whom time had stopped in 1933.

My point of contact with Hughes was always Pat Salmon. In a letter to the Dominion Gallery on October 31, 1988, Hughes described Mrs. Salmon as "my long-distance chauffeur, as well as secretary and biographer." She variously described her role in his life as his "go-between" and a person engaged in "crowd control."

As his biographer, she gathered materials for an unparalleled archive, which has become the single source for all information about the artist. He gave her his letters, clipping files, and photo albums. She began taking notes and photographs, conducting interviews, and filling her diaries with observations and anecdotes. Because Hughes had just one dealer, Max Stern, and conducted all his business by mail, the collection of letters to and from Stern are a central source of information about his career.

Beyond assisting him with all practical matters, Salmon wrote essays about Hughes. Her first, in 1984, was published in *Raincoast Chronicles #10*. Then came the catalogue essay for the Nanaimo Art Gallery's show *From Sketches to Finished Works by E. J. Hughes* in 1993. Salmon contributed the most useful essay in the catalogue that accompanied Kamloops Art Gallery's exhibition *E. J. Hughes: The Vast and Beautiful Interior* in 1994. She expected that she would be chosen to write the book for Vancouver Art Gallery's retrospective in 2003, but the job went to the gallery's curator, Ian Thom.

In the end, because of the trials of publishing, her failing health, and an archive that just kept growing, Salmon realized that she would never be able to achieve her goal. So, one day in 2010, she called me and asked if I would take over. I was pleased to accept. The stewardship of the legacy of this wonderful artist is the greatest gift an art historian in British Columbia could be given.

Pat Salmon holding Hughes's watercolour of *Kamloops* (1994). Photo by E. J. Hughes.

The life and work of E. J. Hughes is a story larger than one book can tell. My first task was to compile the catalogue raisonné, a list of every artwork produced by Hughes, a project now approaching 2,000 entries. Then came the long project of assembling, reading, and transcribing everything written by and about Hughes. This resulted in a document of approximately six hundred thousand words—twenty times the length of this book. With these resources in place, I opened discussions with the E. J. Hughes Estate, which owns the copyright to his work. The estate approved of my efforts, and, after seven years of work, we were ready to take the first volume about Hughes to press.

Because of Hughes's practice of studying subjects in the field during a series of sketching tours and subsequently creating the paintings from the resulting drawings in his studio years later, I decided that a geographical rather than a chronological approach was the way to approach the subject. The first book begins with a long biographical essay, specifically relating to Hughes's life on the Island. It then follows him on an imaginary journey from Sidney and Victoria to Courtenay.

The current volume describes Hughes's early life in Vancouver, then describes his trips up the coast and across the "vast and beautiful interior" of British Columbia. I hope to follow this with a volume about his work as an artist with the Canadian War Art Program, documenting the years 1939 to 1946. These books are meant to complement one another, and do not simply repeat the same story.

It has always been my impression that the career of an artist is the work of more than one person. Hughes had the unquestioning support of a number of women throughout his life. The first among them was his mother, Kay, who always believed in the artistic talent of her firstborn child. Second was his wife, Fern, the only girl he ever fell for and his constant companion until her death in 1974 at age fifty-eight. Third was Pat Salmon, herself a wife and mother of seven. Recognizing Hughes's needs in 1977, she became indispensable to him until his death in 2007. While this book was being produced, Pat Salmon passed away in June of 2019.

At that time the E. J. Hughes Estate became the responsibility of the artist's surviving family members and thus passed the next generation. In particular, Hughes's niece June Simpson has given me every encouragement and graciously represented the estate in the creation of my books. The Hughes Estate is also involved in the publication of the prints and calendars published by Excellent Frameworks Gallery in Duncan under its new owner, Suzan Kostiuk.

Just about any book on Canadian art history is a labour of love, and this is no exception. My efforts toward creating these books have been supported by Pat Touchie of TouchWood Editions. And all the time I have poured into the books and archive over the past ten years has been enabled by the engaged interest of my wife, artist and author Sarah Amos.

Early Days in Vancouver (1923–35)

Edward John Hughes was born on February 17, 1913, in North Vancouver, at his mother's family home. Katherine, known as Kay, and her son soon returned to Nanaimo where her husband, Edward Sr., worked as a time keeper at the coal mines and pursued his talents as a professional musician. In Nanaimo, at three-year intervals, the Hughes family had three more children: Irma (1916), Zoë (1919), and Gary (1922). For E. J. Hughes's first ten years, Nanaimo—Vancouver Island's hub city—was his home. The Hughes children had a warm and encouraging childhood.

In 1923 the Hughes family left Nanaimo to live in Seattle, Washington, where, with the encouragement of his wife, Hughes Sr. secured work as a professional musician. The family lived in a comfortable home on Queen Anne Hill, and life went on much as it had in Nanaimo. Young Ed made friends with a neighbour boy and helped him with his paper route. In return, Hughes got free tickets to the movies for the Saturday morning show and soon became a fan of his American friend's favourite movie stars: Fay Wray, Lillian Gish, and especially "America's Sweetheart," Canadian Mary Pickford.

Within a year the family returned to Canada, settling this time in North Vancouver, the home of Kay's parents. Hughes Senior, often regarded as the best trombonist in the province, now had a full-time job in the pit orchestra at the Orpheum Theatre and worked at the Capitol Theatre as well. During the summer, he played symphonies and concerts with the Cal Winters Orchestra at the Malkin Bowl in Stanley Park.

Ed (age three) and Irma (one year).

Kay Hughes saw her eldest son's potential and enrolled him in drawing lessons in North Vancouver. His teacher, Miss Verrall, invited him to attend her summer art class, which took place in her garden, and introduced Hughes to oil paints. He had been doing his best for some years with the faint colours of pencil crayons and the inferior, uneven colours of wax crayons, and

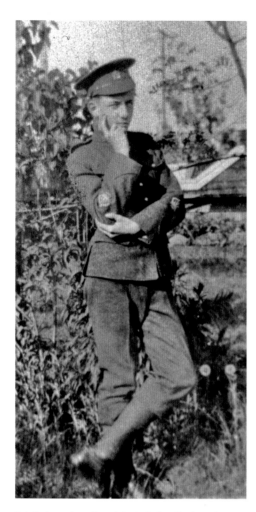

E. J. Hughes in the uniform of the Seaforth Highlanders cadets, ca. 1928.

he was immediately excited by the possibilities of this richly coloured medium.

While living in North Vancouver with his parents, rather than signing up for sports teams or church groups, Hughes joined the 6th Field Company of the Royal Canadian Engineers Cadets. At the company's drill huts in Mahon Park, he rose to the rank of cadet lieutenant. Then, as their fortunes improved, the Hughes family was able to move from North Vancouver to a larger home in Kerrisdale, where young Ed joined the Seaforth Highlanders, Vancouver's non-permanent militia regiment. An enthusiastic cadet, he was proud to wear the Mackenzie tartan and to march in parades. He excelled in target practice, shooting at targets twenty-five yards away with a .22 calibre rifle.

Throughout his life, Hughes treasured the two silver trophy cups that he won in marksmanship contests. In recognition of this skill, he recalled that, at age sixteen, he was offered a job as a machine gunner for some Canadian rum runners. This was during the Prohibition era, and Hughes was excited by the prospect, but his mother instantly forbade it. And, typically, he accepted her judgment without question.

School work proved difficult for young Ed, especially the compulsory Latin course. Because of the time spent in Seattle, he was a year behind his classmates. But he surprised himself with an intuitive grasp of geometry, and the family noticed that his hands were made strong by his relentless drawing.

Hughes liked to spend his evening hours drawing. He and his brother, Gary, nine years his junior, would take over the kitchen table after dinner, and with the radio placed on the floor to maximize their workspace, the two would listen to jazz and spend happy hours lost in their art. Most of the small paintings from this period are based on military themes. A cache of Hughes's early drawings and watercolours that was in the possession of the family of E. J. Hughes's mother,

Katherine McLean, later came to light. The earliest of these is dated 1926, and it follows the illustration style of magazines of the day.

In a letter to Max Stern on October 10, 1974, the artist described the watercolours: "I have received from my Mum about 12 older sketches . . . done when I was 14 to 17 years old. The subjects are mostly of soldiers of the Napoleonic era and the First World War, as I was very interested in uniforms." That would place them between 1926 and 1930.

When Hughes came to the end of secondary school in 1929, he failed to matriculate. Unable to pass his English exam, he could not enter university. At that time, one of his uncles pointed out that he could enrol in the newly opened Vancouver School of Decorative and Applied Arts (VSDAA), which did not require matriculation.

One of Hughes's early watercolours shows The 72nd Seaforth Highlanders at Kandahar. The Highlanders were a British line artillery regiment under the command of General Roberts. They were victorious in the last major conflict of the Anglo-Afghan War on September 1, 1880, defeating the Afghans under Ayub Khan. In Hughes's fine watercolour from 1929, a Highlander is wearing puttees, tartan socks, and a Mackenzie kilt with sporran and khaki tunic. His white "colonial pattern" pith helmet has a cloth band around it and a chinstrap of leather. With rifle and bayonet, he and three cohorts bring fire from positions behind the rocks of the Afghan hills.

The Seaforth Highlanders fought with valour in the Second Boer War and later in World War I, at Ypres, the Somme, Arras and Passchendaele. With such a splendid reputation, the Highlanders naturally attracted the attention of the young cadet.

Hughes didn't know anything about "fine art," and his childhood interest was in illustration only. His favourite artist at the time was Stanley L. Wood, whose work he saw in the popular British compendium *The Boy's Own Annual*.

72nd Seaforths at Battle of
Kandahar (1929). Watercolour.

In the fall of 1929, on the eve of the Great Depression, young Ed was accepted into the new VSDAA. With money for his fees provided by his uncles, the sixteen-year-old went to live in North Vancouver, first with his grandparents and then with his uncles. He lived there until at least 1935 as a student, commuting daily from his North Vancouver home on the ferry across Burrard Inlet to the art school, which was just a few blocks south of Vancouver's downtown waterfront.

E. J.'s father was still working as a theatre musician, which was a hard way to make a living in those days. Not only was the Depression settling in, but with the advent of the talkies, theatre orchestras were no longer needed. During the summers of 1930 and 1931, Hughes joined his family at the Tulameen mines near Princeton, a town in the BC Interior and close to the border with the United States. His father found a job running the tipple above the Tulameen mine, a device that loaded the coal into railroad cars, and Hughes joined him there, sorting ore. This somewhat dangerous and heavy work was unusual for Hughes, but he was happy to be reunited with his family and soon became tanned and strong.

The Hughes family brought something of a sunny renaissance to Depression-era Princeton. Mr. Hughes joined the local orchestra and was the organist at the Anglican church. Daughters Irma and Zoë helped their mother run a dance school for children during the day, and Kay led ballroom dancing classes for the adults in the evenings and was accompanied by her husband on the piano. At the end of the summer, the family put on a glorious dance recital, followed by a ball. Hughes avoided the limelight—a preference he'd exhibit his entire life—by running the ticket booth.

The family also ran the local theatre. Mr. Hughes wanted to train Ed to become a projectionist, but the youngster begged off, feeling that electrical studies would be too difficult for him. More to his taste, Hughes painted a poster of a movie star to decorate the theatre lobby.

During his second summer in Princeton, Hughes managed some outdoor sketching in the surrounding woods. For the first time, he made notes of the colours on his drawing. Because he had yet to develop his later shorthand method, he wrote out his intentions in full: "a little lighter than distant hills . . . some stones are pinkish."

243 6th Street West, in North Vancouver, where Hughes lived with his uncles. Photographed in 1992 by Pat Salmon.

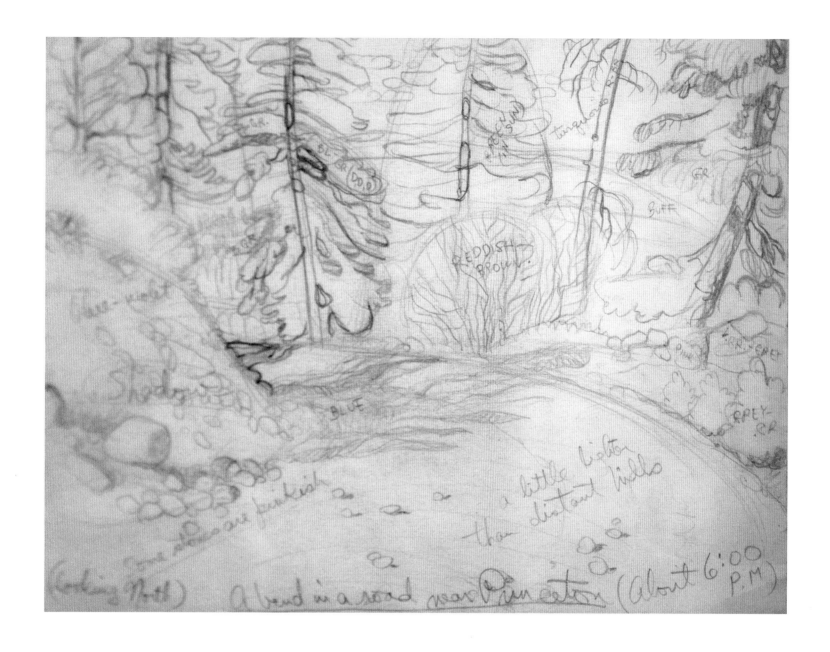

A Bend in a Road Near Princeton (about 6:00 P.M.) (1931). Pencil.

Vancouver School of Decorative and Applied Arts (1929–35)

The Vancouver School of Decorative and Applied Arts (VSDAA) opened in 1925 in a few rooms on the third floor of its parent organization, the Vancouver School Board. This was at 590 Hamilton Street, just across the road from Victory Square. The red-brick building with a quaint tower had been built in the 1890s as the first high school in Vancouver.

When Hughes began attending the art school in 1929, there were ninety-seven day students, with an additional 324 students crowded into the two large studios in the evening. Maria Tippett wrote of these students: "though 'keen as mustard and brimming with talent,' most of them had not seen a museum or gallery."[1] The Vancouver Art Gallery did not open for another two years. According to Hughes, the great majority of the students were women, mainly "daughters of successful Vancouver businessmen." The attrition rate among them was considerable: of the seventy day students who began in 1925, only eleven graduated four years later; however, the Depression may be somewhat responsible for this.

A newspaper article of the time reported "the light is poor—an almost fatal defect in an art school. There is no common room; there is no staff room; there is no library or print room; there is no lecture room; there is no lunchroom for the students . . . and the sanitary equipment is entirely inadequate to the needs."[2] In addition to the space in the school board's building, VSDAA also used a huge space in an old school building that was connected to it by a covered passageway. In this annex they had a general studio, two sculpture rooms, and a pottery room. This situation continued after Hughes's years at the VSDAA until 1936.

The fees for the first term were fifty dollars, and there were two terms per year. While Hughes was a student, he was supported by his grandfather McLean and his two unmarried uncles, and he lived with them in North Vancouver. Every morning, he walked down to the waterfront and

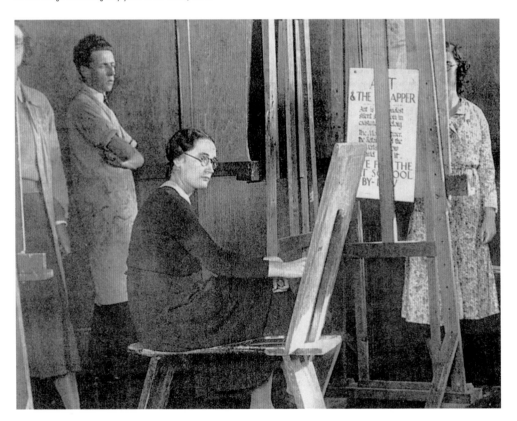

E. J. Hughes (left) at the Vancouver School of Decorative and Applied Arts, 1935, from a publication of the Emily Carr College of Art and Design celebrating fifty years of the school, 1975.

took the ferry across to Vancouver, paying the student fare of a penny. After crossing Burrard Inlet, the ferry landed between Gastown and Stanley Park, at a wharf near the CNR terminal. From there, it was just a short walk up the hill to the school. In winter the ferry ride was a cold one, and Hughes said that sometimes his teeth ached from the icy wind.

Coincidentally, this was the same ferry that took his painting teacher, Fred Varley, and a student of his, Vera Weatherbie, to their trysting place up at Lynn Canyon on the North Shore.

CHARLES H. SCOTT AND STAFF

The principal and acknowledged leader of the VSDAA, Charles H. Scott, was born in Scotland in 1886 and received his diploma from the Glasgow School of Art in 1909. He immigrated to Canada in 1912, soon becoming art supervisor for the public schools of Vancouver. Scott was called to became head of the new VSDAA in 1926 and ably filled that position for the next twenty-six years. He was an expert draughtsman with pen and ink and loved to paint West Coast landscapes in watercolours, drawing inspiration from summer trips to Hornby and Savary islands. Scott had a proper British sense of responsibility, and with his distinguished wartime record with the Canadian Expeditionary Forces, Scott was exactly the sort of man that Hughes could look up to.

In addition to Charles H. Scott, Hughes was instructed by Grace Melvin, Scott's sister-in-law. Like him, she was also a graduate of the Glasgow School of Art, where she had studied with Charles Rennie Macintosh. She taught design—the more "applied" of the arts—and her specialty was calligraphy and the illuminated manuscript. Hughes responded well to the instruction of Melvin and Scott, and for the next six years this art school was his home.

Hughes entered VSDAA determined to succeed, and after his problems in high school,

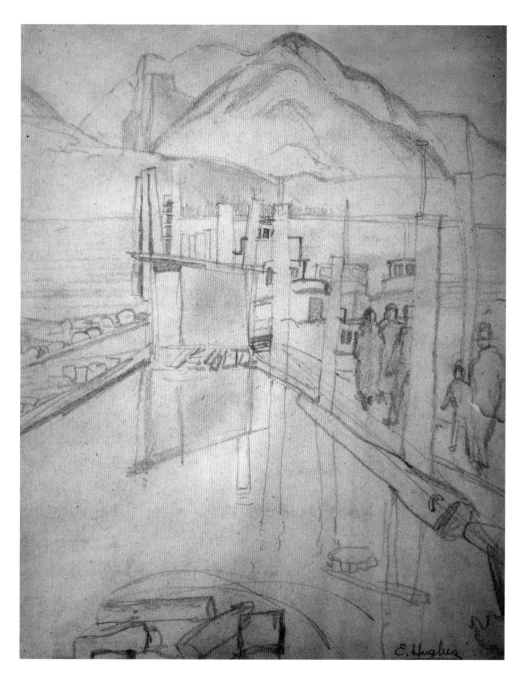

Wharf on Burrard Inlet, ca. 1933. Pencil.

Hughes on the front steps at home, ca. 1938.

this new art-school curriculum suited him well. The diploma course at VSDAA was a four-year program. The first two years covered general studies: drawing, composition, design, commercial art, and modelling. Then, for the final two years, the students specialized.

In his third year, Hughes joined the sculpture class taught by the dynamic Charles Marega, a talented artist who had recently carved the stylized lions that grace the Lions Gate Bridge.

It is always said that Fred Varley—of the Group of Seven—was one of Hughes's teachers, and strictly speaking, that is true. But Varley's style, both for teaching and painting, had little to offer the young student. Though Hughes was never one to utter a disparaging word, Pat Salmon wrote in her diary a few of the things Hughes had told her about the man: "Varley was the best painter of his period in Canada, especially his portrait of Vera. Hughes said Varley tried again and again to paint such a good work, one that had portions unpainted, loosely painted and highly resolved all in one picture. He also praised his landscape work, but shook his head sadly over the waste of talent, sacrificed to alcohol. He said that Varley treated Maud, his first wife, very badly. These were things Hughes found entirely unacceptable."[3]

On a brighter note, Hughes reported with gratitude that "Charles H. Scott taught us what we wanted to know. Scott taught us how to square up drawings for enlarging them, and he was a fine watercolourist. He seemed to have the knack for putting the lines right where he wanted them."[4] Unity Bainbridge, a VSDAA student from 1932 to 1936, reported that "in those days we were severely disciplined to be thorough and honest. Grace Melvin and Charles Scott were solid and dependable mentors."[5]

While fine art was the focus for everyone at the school, it was hard to ignore that there were people lined up at Vancouver's main welfare office, just across the street from the school.

Throughout the dirty thirties, the nearby Victory Square was the site of frequent demonstrations by the unemployed.

Yet Vancouver's harbour was the stuff of romance. For the students it was just a moment's walk to the wharfs, where one might board a ship bound for Nanaimo or Victoria—or even Yokohama or Shanghai. Seagulls swooped low over the sun-sparkled water, while the snowy peaks of the North Shore Mountains looked down in majesty.

In about 1936, hard times hit the Hughes family, and they had to sell their house in Kerrisdale. For a while the men lived in a rooming house, and the women had rooms nearby. At that time, Hughes made drawings of the family spending the evening relaxing together. The ink drawing of Edward S. Hughes shows him lying on a couch after a musical performance, still wearing his dress shoes.

Hughes was a student at VSDAA from 1929 until his graduation in 1933. Recognizing that the current labour market offered no prospects for the young artist, Charles H. Scott invited him to work at the school, but Hughes was unsuited to the teaching. Yet he was truly the finest artist in Vancouver at the time and stayed on as a postgraduate student. Among other facilities, Hughes was allowed to use the school's press during evening hours, and he created a series of drypoint engravings, hoping to attract a buying public with inexpensive prints.

Drypoint is the most basic method of engraving. A drawing is engraved directly on a copper plate with a sharp pointed tool. Hughes used the point of a pair of compasses from his old school geometry set. This engraved metal plate is then covered with oil-based printer's ink and wiped more or less clean. With a sheet of soft paper laid on top of it, the inked plate is then run through a hand-cranked rotary press. Hughes engraved eleven plates in 1935, and less than a dozen proofs were printed of each image.

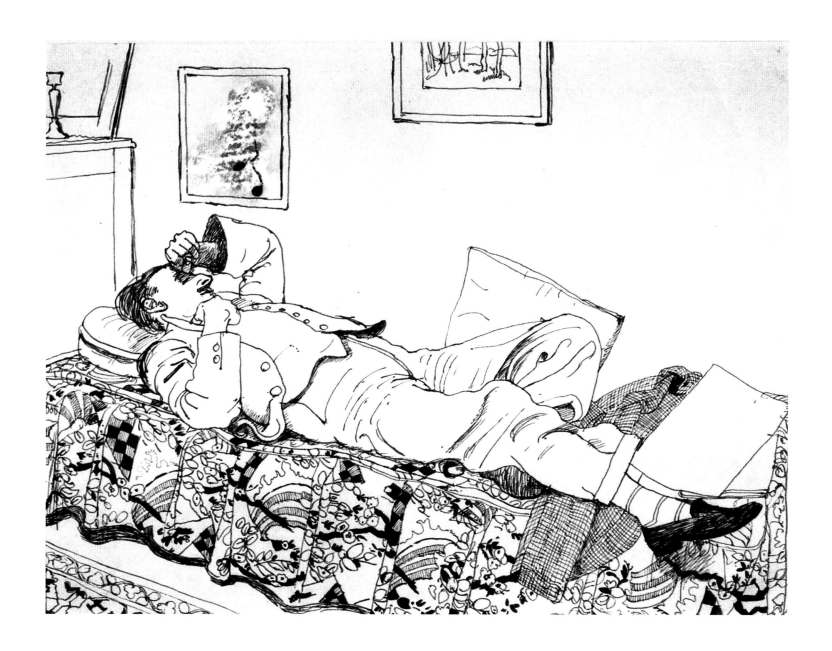

Dad Having a Lie-Down (ca. 1936). Ink.

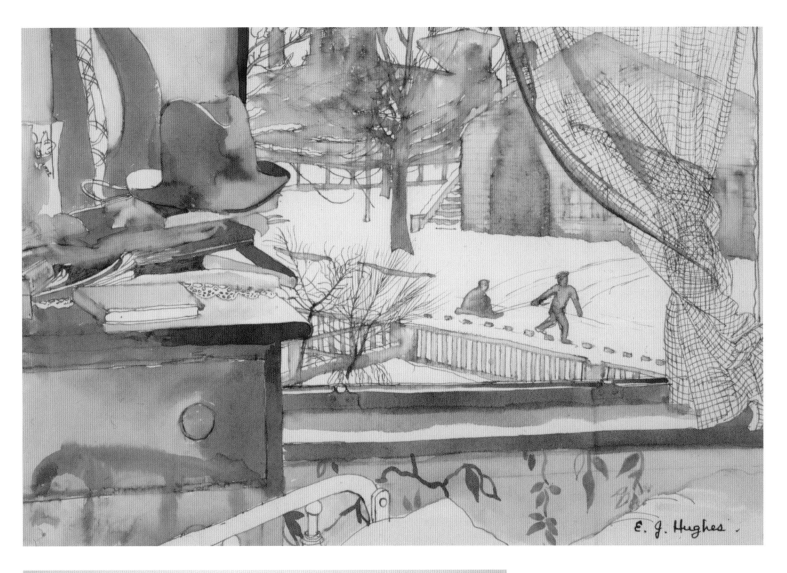

Above: *View from a Rooming House Window* (ca. 1936). Ink wash, 8½" × 11¾" (21.5 × 30.0 cm).

Left: Statement written by Hughes on the back of *View from a Rooming House Window*.

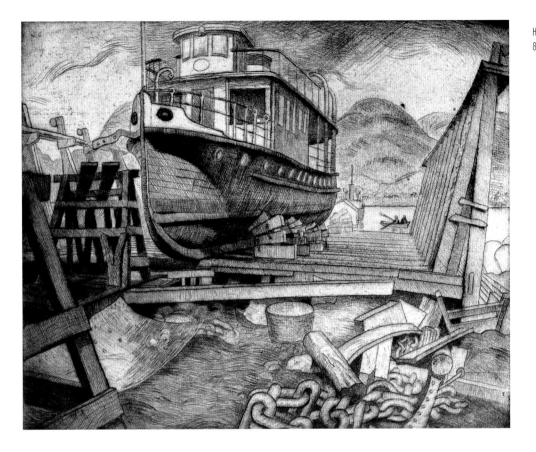

Harbour Princess *in Drydock* (1935). Drypoint engraving, 8¼″ × 8¼″ (21.3 × 21.3 cm).

The most attractive of these small prints is the Harbour Princess *in Drydock* (1935). This jaunty little tour boat was used to carry tourists around Vancouver harbour. In his engraving, many wooden chocks are jammed diagonally under the hull of the boat to keep it upright, and the foreground is given over to the bold links of a chain and other dock paraphernalia. Beyond the *Harbour Princess*, Hughes drew a vignette of a small fishing boat with two men aboard. The familiar forms of the North Shore Mountains rise in the background.

Fellow students Paul Goranson and Orville Fisher joined Hughes in making drypoint engravings. They held exhibitions of their prints at the Vancouver Art Gallery in 1935 and 1936. At prices ranging from $2 to $2.50, Hughes sold four prints of this image in 1935 and two more in 1936.[6] Clearly, there wasn't much of a future in small black and white prints.

Savary Island (1935)

Each summer, from 1933 until 1939, about fifty students from the Vancouver School of Decorative and Applied Arts left the city for a summer school session on Savary Island. To get there, they travelled up the Strait of Georgia about a hundred and forty kilometres on one of those coastal steamships that Hughes loved to paint. When they arrived at their destination, the staff and students were put up for ten days at the Royal Savary Hotel, located at Indian Point.

One of the students, Maud Sherman, recalled her time on the island: "Savary is only five miles long and half a mile broad, but its variety seems almost inexhaustible to one who sketches. It is crescent-shaped and has a beach of white sand right around, except for one rocky point where it drops off into the channel. On the inside of the crescent the trees come down to the water in a series of bays, on one of which is a row of pretty summer cottages."[7]

Another of the students, Noel Robinson, wrote a memoir of summer school on Savary: "Led by the principal of the school, Charles Scott, this large party of youth of both sexes, chaperoned by Mrs. Edward Mahon, invaded the island on the eve of the Savary season. Favoured, on the whole, by glorious weather, the venture, from both practical and social standpoints, proved a success beyond the brightest hopes of its sponsors. This sojourn has combined a most attractive admixture of work and play, as scheduled working hours were fairly firmly adhered to morning and afternoon."[8]

Evenings were given over to masquerade parties and musicales.

Working from a drawing made on Savary in the summer of 1935, Hughes printed a drypoint titled *On the Beach at Savary Island*. This shows a young student, Celey Horan, with a sketchbook in her hand, sitting on the sand. She appears blissful, lost in thought. Ian Thom wrote: "the tracks in the sand to her right . . . lead to a barely indicated figure in the distance. Her slightly windblown hair suggests a gentle summer breeze." Close examination reveals that "figure" to be an artist's easel. Thom went on to describe the print as "an

Postcard of Royal Savary Hotel, Indian Point, Savary Island, ca. 1935.

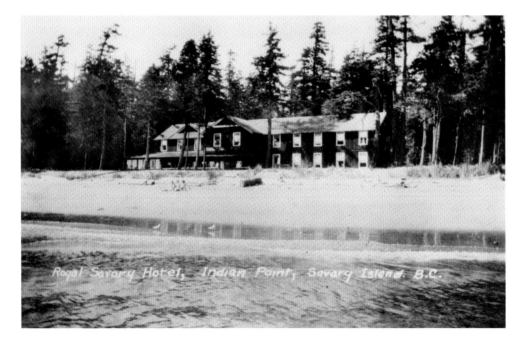

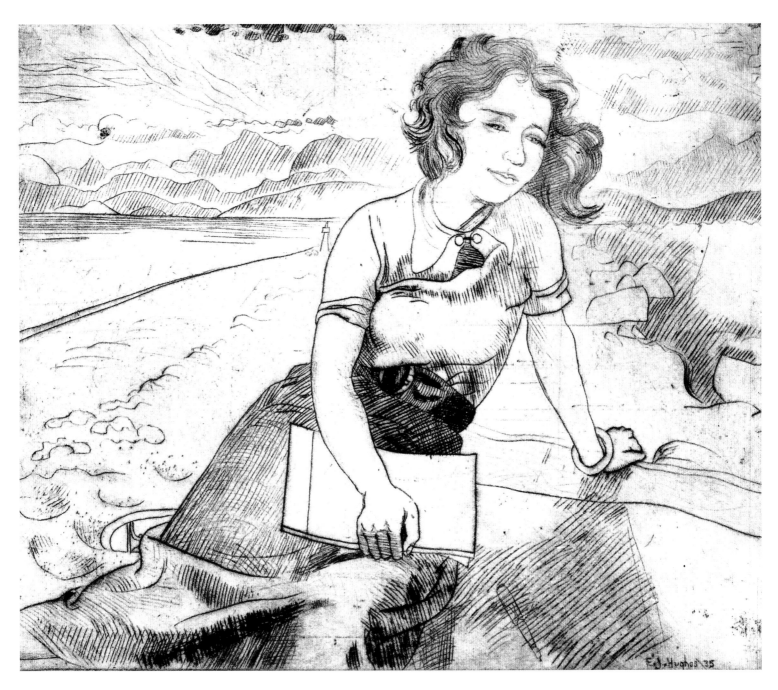

On the Beach at Savary Island (1935).
Drypoint engraving, 6" × 8" (17.5 × 20.6 cm).

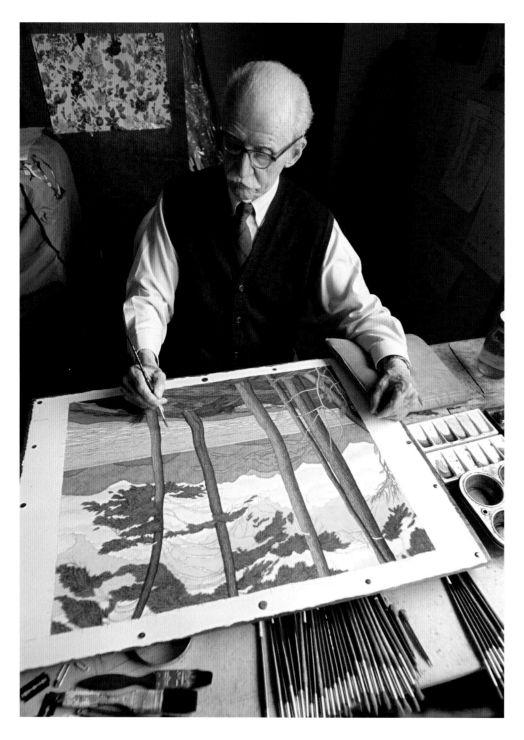

image of subdued but real visual pleasure, of leisure but not abandon."[9]

During his time on Savary Island, Hughes was joined by fellow students to draw the elderly artist and connoisseur Harold Mortimer-Lamb. Mortimer-Lamb later left his papers to the Art Gallery of Greater Victoria, and among them were his photographs of the grove of trees just beside the Royal Savary Inn, and a drypoint print that Hughes made of the same grove of trees. In 1953, Hughes painted this image as *Trees, Savary Island* (1953) in oil on canvas. In 1964 it was given to the Montreal Museum of Fine Arts by Doctor and Mrs. Max Stern of the Dominion Gallery. Toward the end of his life, in 2004, Hughes returned to the subject to create a watercolour that brought back those happy days.

E. J. Hughes painting *Trees, Savary Island*, 2004.
Photo by Darren Stone.

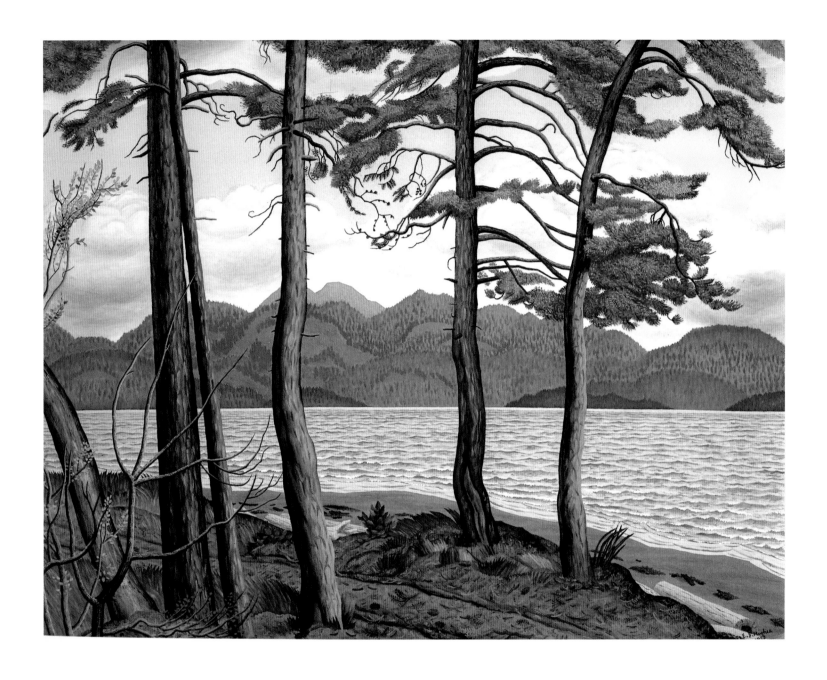

Trees, Savary Island (1953).
Oil 24" × 30" (61.0 × 76.2 cm). National Gallery of Canada.

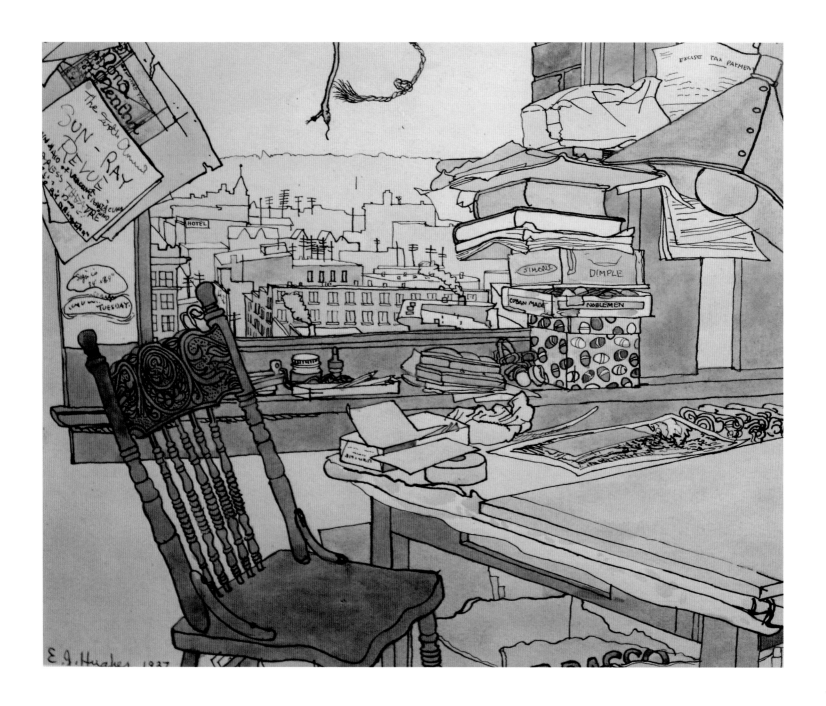

Studio of the Western Brotherhood, Bekins Building,
Vancouver (1937). Ink and colour.

The Western Brotherhood (1935–39)

Realizing that he was temperamentally unsuited for teaching, Hughes put his energy into his new career as a commercial artist. He was joined by talented fellow students Orville Fisher and Paul Goranson. The eager young graduates set themselves up in business in an office on the sixth floor of the Bekins Building, located not far from the Vancouver School of Decorative and Applied Arts (VSDAA). The iconic Bekins Building, after 1937 the headquarters of the *Vancouver Sun*, is now known as the Sun Tower and is still a landmark in downtown Vancouver. At the top, the building's podium features nine caryatids, stone maidens sculpted by Charles Marega, who had recently been Hughes's teacher at VSDAA.

In their office, the Western Brotherhood awaited commissions for pencil portraits, poster designs, and calendar illustrations, hoping to raise the monthly rental of fifteen dollars. Perhaps while they waited for work, Hughes drew this scene. The casual study, titled *Studio of the Western Brotherhood, Bekins Building, Vancouver* (1937), provides a look at the working environment of these young artists. Piled precariously on the windowsill are some books, his watercolours, an ink bottle, and some cigar boxes of art materials. To the side hang roughs for a poster.

Pat Salmon noted that the office is "bright and busy where a mood of general optimism prevails, although among the details is a rat-nibbled cardboard box." Outside the window (beyond a frayed sash cord), the rooftops of Vancouver bask in the sunshine.

Of course, the Western Brotherhood didn't just wait for work to magically appear. Fisher volunteered the services of the Brotherhood to paint what turned out to be a five-mural scheme over the course of two summers. The murals were for Fisher's church, First United Church, at Hastings Street and Gore Avenue in the east end of Vancouver. First United was primarily a mission church, with many recent immigrants in its congregation. As some of them were unable to read or speak English, the Reverend Andrew Roddan, in collaboration with the artists, decided that murals would speak to them in a universal language. The artists spent two summers painting these murals, which remained in the church for many years. They were later put into storage and eventually destroyed.

Above: Logo of the Western Brotherhood, detail from a study for the Golden Gate International Exposition murals, 1938. Ink.

Below: Study for *The Alabaster Box*, used for a mural for First United Church, 1936. Pencil and tempera on card.

Stanley Park Prints (1935–38)

The Western Brotherhood spent more than a year creating drypoint engravings. Then Hughes and his associates, Paul Goranson and Orville Fisher, decided the prints might sell better if they were coloured, and set out to create a suite of colour prints printed from blocks of linoleum that they carved. This was to be a portfolio of images of Vancouver's Stanley Park. Each artist agreed to make five prints—though when completed in 1939, each set contained only two images from each artist.[10]

The sequence in which Hughes created his linocut images is undetermined, but *Bridges on Beaver Creek* (1938) may have been the first. In his 2004 book, Ian Thom made a brave attempt to describe this uniquely intricate print: "the circular pattern of the trees and the reflections of the branches in the water contrast with the rectilinear lines of the stone bridge, and the fact that neither bridge is parallel to the picture plane introduces a further level of complexity."[11]

For another print, Hughes made a detailed pencil study of the totems in Stanley Park in 1937. He drew the image again and developed it with watercolour and white paint. Though no linoleum blocks were ever carved of this design, the unusual close-up of two totems was substantially complete.

The taller of the two totems is the Nhe-is-bik "Salmon Pole," which belonged to Chief Wakas of the Owikeno people and tells the story of the coming of the salmon to Rivers Inlet. The sixty-foot-tall (18.3 m) pole was carved in 1892 by Willie Seaweed and raised in front of Chief Wakas's house at Alert Bay. It is topped by a thunderbird that, in the Hughes rendering, is missing its wings. (The original pole was removed from the park in 1988 and now is in the Royal British Columbia Museum in Victoria. The pole currently standing in Stanley Park is a replica carved by Doug Cranmer in 1987.)

The smaller of the two poles is a house post made for Chief Tsa-wee-nok of Kingcome Inlet and was carved by Charlie James of Alert Bay. It is one of two house posts that were erected in the park by the City of Vancouver in 1927. (A new version of this pole was carved by Tony Hunt to replace it in 1988.)

At the time when Hughes drew these poles, they were positioned in Stanley Park near Lumberman's Arch, but in 1962 they were moved to their current position near Brockton Point.

Rarely did Hughes let one of his drawings go unused, and this study became the basis of his watercolour painting almost fifty years later, in 1985.

It may be that Hughes abandoned the print because of mounting technical difficulties. As he went on, Hughes's appetite for making linoleum block prints waned. Later he explained: "We had hoped that these coloured works would sell more readily than the drypoints, but it was a failure. The linoleum warped almost immediately and we got very few prints from each motif."[12]

Not only were the blocks unsatisfactory but Hughes was inking the blocks with a rubber roller and oil-based printer's ink. This method was not compatible with the absorbent Japanese paper he

Facing page: *Bridges on Beaver Creek* (1938). Linocut print, 9" × 9 5/8" (24.8 × 24.7 cm).

Old Empress of Japan Figurehead at Stanley Park (1939).
Linocut print, 9" × 12" (22.9 × 30.5 cm).

was printing on. At the time, one of the few artists whom Hughes admired, Walter J. Phillips, was producing fine block prints of Canadian subjects with water-based pigments in the true Japanese tradition. But the combination of materials Hughes was working with would never yield the results he hoped to achieve.

The masterpiece of the linocut set is *Old Empress of Japan Figurehead at Stanley Park* (1939). Hughes produced a simple image, favouring large areas of tonal gradation so that the sky glows and the hills seem veiled in mystery. With its simple shapes and graduated tones, this is the most "Japanese" in style of any of his block prints, a traditionally Japanese medium.

Coincidentally, the subject of the print is the carved and painted figurehead of the CPR ship, the *Empress of Japan*. The colourful wooden dragon sweeps forward above three stylish park benches, which are arranged in clever counterpoint. A grove of trees frames the figurehead beside the path with mastery and an economy of means, making its point rhythmically against the spacious backdrop.

The suite of prints leads us around the seawall from Beaver Creek, and the next subject Hughes depicted was the Prospect Point Lighthouse and its boathouse. Only two prints of this image are known. This is a fresh little print, rich with information. The red and white lighthouse has a picturesque

balcony and may be approached by a wooden walkway through the trees. As fishing boats pass through the narrow waterway, now the location of the Lions Gate Bridge, their wakes surge up on the beach in the foreground. A little red boathouse next to the main building has a launching ramp that, in the print, is catching a big swell.

In his book about E. J. Hughes, published to coincide with the Vancouver Art Gallery's retrospective exhibition in 2004, Ian Thom paid particular attention to the eleven drypoint engravings Hughes made in 1935. "Although his print oeuvre is small," Thom wrote, "he is one of the most significant printmakers to have worked in British Columbia."[13]

Near Second Beach (1938) offers only the hint of a breakwater to show that it is in the city. Otherwise its interest is entirely organic. The major component of the design is the tideline. Hughes spreads before us the West Coast seashore he knew so well: pitted stone of volcanic origin, waves curling in succession toward the shore. A filigree of fir trees dances against a golden sky, and beyond, distant hills fade into a milky horizon. In the foreground, the crests of the incoming waves are overprinted with the same white pigment used for the mist. Fully aware of the reality of the seashore, the artist deployed its colours and shapes with bold invention.

Totem Poles at Stanley Park (1985).
Watercolour, 24" × 18" (61 × 45.7 cm).

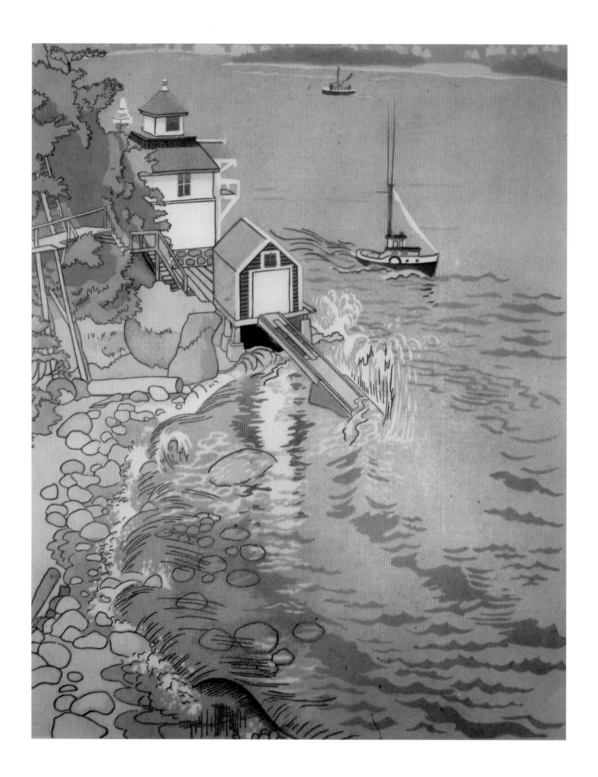

Lighthouse, Prospect Point.
Linocut print. Photo by Sarah Amos.

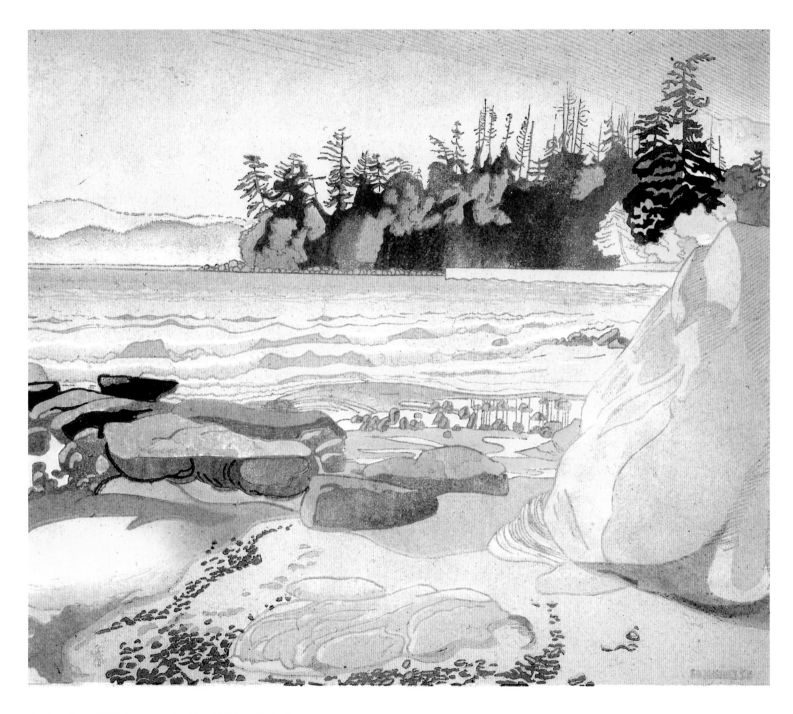

Near Second Beach (1938). Linocut print, 9 1/2" × 12" (25.3 × 30.5 cm).

The Courtship and Marriage of Ed and Fern (1937–40)

Trees, Stanley Park (ca. 1937). Pencil.

"I was sketching a group of beautiful deciduous trees in Stanley Park when a beautiful girl who was out walking her little dog came up and very considerately asked if I would mind if she looked at my work," Hughes told Pat Salmon. Perhaps at the time he was at work on this pencil drawing. It's a study of the deep woods, with sunlight filtering through. Despite its tattered condition, Hughes saved the drawing to the end of his life.

"I was impressed with her polite seriousness," Hughes continued. "For once I had met somebody who was easy to talk to. I asked to walk her home, and while we were walking, I asked if she liked parties. She replied that she 'liked *some* parties,' and that came as a big relief. There were many nice girls at art school, but I always felt that they liked parties too much.

"I asked her name, which was Fern Smith, and I told her mine was Edward Hughes. We walked to her grandmother's house at 1217 Robson Street, and that's how I met my wife."[14]

We know from their letters that Hughes met Fern at Second Beach on October 15, 1937, and this place became sacred to them in a special way. They were married a year and a half later.

Rosabel Fern Irvin Smith was born on April 17, 1916, in Brandon, Manitoba, and her family soon moved to Regina, Saskatchewan. At the end of her high school years, her parents sent her to Vancouver to be a companion for her grandmother, who was living alone in the West End.

In Hughes's earliest drawing of Fern, she is sitting on the beach in Stanley Park, just a pleasant walk from her grandmother's house. In this modest little pencil study, Fern is wearing a light sun hat, blouse, long skirt, and a jacket. She leans against a beach log with her walking shoes tucked beneath her: demure, a bit withdrawn, but very much present. Hughes drew her with the assurance that came from years of training at the Vancouver School of Decorative and Applied Arts, and from the beginning the two shared a perfect rapport. Fern was the only one for him, and until her death in 1974, they were seldom out of each other's company.

The courtship and marriage of E. J. Hughes and Fern Smith took place during the onset of the Second World War. Hughes enlisted in the army on September 1, 1939, and while they were planning to marry he was involved in three months of basic training in the Canadian Army at the base in Esquimalt near Victoria. A posting to Vancouver followed, and on December 29, Gunner Hughes of the 5th Heavy Battery was granted permission to marry Miss Fern I. Smith. Their wedding took place on February 10, 1940, at the Central Presbyterian Church at 1100 Thurlow Street. According to their marriage certificate, Edward, a bachelor and soldier, twenty-six years old, married Fern, aged twenty-three, occupied as "home help." The witnesses were Zoë Hughes and Ed. S. D. Hughes, Hughes's sister and father. At this time, Hughes was registered as living with his family at 2606 West Third Avenue in Vancouver.

Almost immediately after their marriage, Fern got pregnant. Sadly, she lost the child at birth, and then was hospitalized with peritonitis. Just about that time, Hughes was posted to Ottawa. It was

the couple's first separation. During the long years that the war went on, it seems that every time the young couple got together, they were suddenly torn apart by Hughes's distant postings as a Canadian war artist. After a year in Vancouver, he served in Ottawa and Petawawa, then all over the south of England, and finally at Kiska, the outermost of the Aleutian Islands.

During their intermittent and brief visits during the war years, Fern became pregnant twice more. In Ottawa, she lost a premature daughter, Elizabeth, after two weeks. Their third, a boy named McLean, died of meningitis at the age of six months. Fern spent the last few months of Hughes's war service waiting for him at her family's home in Regina. The couple's reunion was held up because Hughes had taken the role of administrator for the arts program, and he was, therefore, the last artist to be demobilized. He had enlisted in the army on September 1, 1939, and was only permitted to leave Ottawa on October 1, 1946.

After he was discharged, Hughes met with Fern, and they visited little Mac's grave, and almost immediately afterwards they moved west. They headed for a large old house at 410 Quebec Street in Victoria, which his parents had bought in 1943. It was near the Inner Harbour, and there was a room in the attic for a studio. The artist set right to work. The first canvas he painted in those trying times was a jagged and angular interpretation of *Near Third Beach, Stanley Park* (1946–59).

In style, this is a very different painting from the naturalistic sketch that inspired it, with its dark and menacing mood and harsh angular drawing. The darkness that pervades it is typical of his immediate postwar paintings, and the stylized nature of the trees may be credited to the influence of the so-called primitive paintings of Henri Rousseau, which Hughes had recently seen at the Museum of Modern Art in New York.

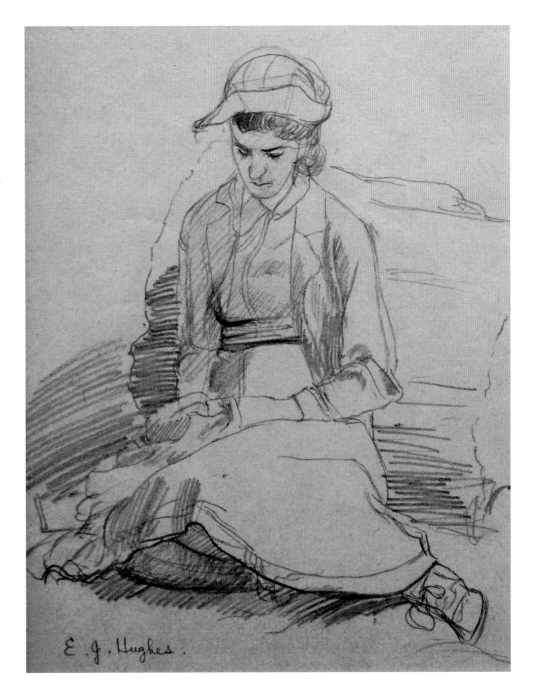

The Artist's Wife on Second Beach (1938). Pencil, 11 3/8" × 9" (28.9 × 22.8 cm). Photo by Robert Amos.

Near Third Beach, Stanley Park (1946), pencil.

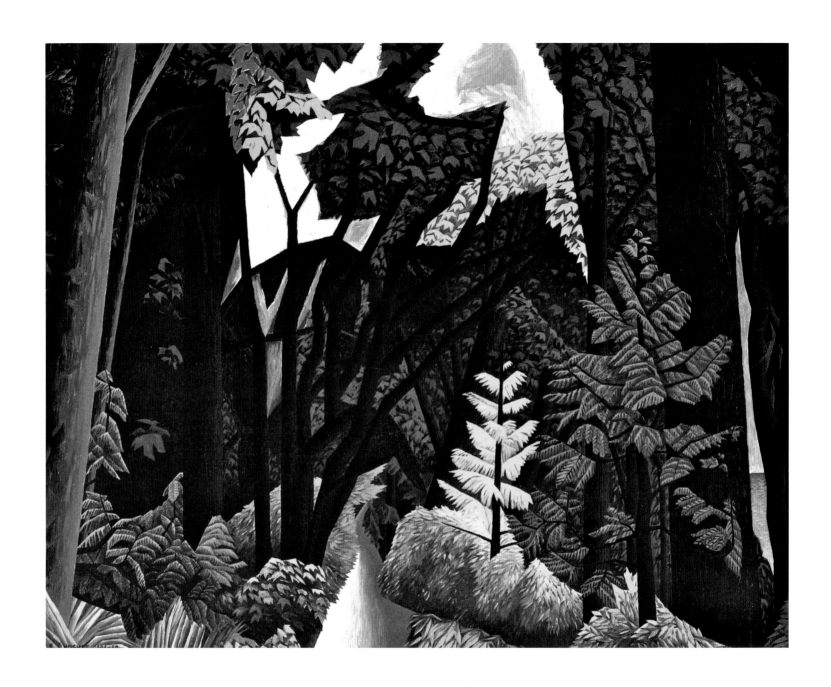

Near Third Beach, Stanley Park (1946–59).
Oil, 40" × 50" (112.2 × 127.4 cm).

Study of a Stove , Rivers Inlet (1937). Pencil.

Rivers Inlet (1936, 1937)

In 1946 Hughes started work on the dark and difficult painting *Near Third Beach* (1946–1959) and then set it aside. He did not take it up again to complete until 1959. For his next subject in his new West Coast studio, he returned to something he had drawn before the war. This was to be a painting of *Fishboats, Rivers Inlet* (1946).

In June of both 1937 and 1938, Hughes had spent the summer gillnetting in British Columbia's commercial fishery. His commercial art partner Paul Goranson worked for the fishing season with his family at the Brunswick Cannery on Rivers Inlet, beyond the north tip of Vancouver Island. Times were tough, and all around them in Vancouver, swarms of unemployed men were taking political action and occupying the Vancouver Art Gallery and the post office in desperation. It wasn't difficult for Goranson to persuade Hughes to join him gillnetting as a way to make some money.

At the beginning of each of the two summers, Hughes and Goranson made their way north to Rivers Inlet on a Union Steamship and then prepared to rent boats and nets. There were ten canneries on Rivers Inlet at the time, and from each cannery's base of operations, individual fishing boats took up their places around the inlet. Each day the canneries fired a signal gun, and the boats then started paying out gillnets over their sterns. Cedar floats held up the fifty-foot-deep (15 m) nets, which hung like walls below the water's surface. The salmon were caught as they swam through the gillnets, and then the nets were pulled aboard the little one-man fishboats.

Years later, on November 26, 2004, the painting *Fishboats, Rivers Inlet* (1946) became Hughes's first "million-dollar painting" when it sold at Heffel's Fine Art Auction in Toronto for $912,000 plus 12% tax. It was, at the time, a record price achieved by a living Canadian artist at auction.

In a CBC Radio interview at the time of the sale, Hughes was asked if he had "lived that scene." "Yes," he replied. "Two summers I was gillnet fishing." Not that he enjoyed the experience. Looking back, he recalled, "I was really just out of it . . . it wasn't my character at all. I was seasick and things like that. The first time I just about broke even, my expenses and that. And in the second year I had a few hundred dollars profit."[15] But, all things considered, he considered himself lucky. Some men ended the season with a loss after paying the boat-rental charges.[16]

In 2018 the painting was again sold by Heffel's Fine Art Auctions, this time for more than two million dollars.

In 1938, when he arrived at Rivers Inlet for the summer, Hughes found that his fishing permit was not in order, and he had to wait a week until things were sorted out. Time hung heavy on his hands, and while he waited, he drew a sensitive portrait of Paul Goranson titled *In a Cabin at Rivers Inlet* (1938). Goranson is pictured at the camp table smoking, with a half loaf of bread and a stack of coffee mugs at this elbow.

Another rendering from the time centres on a wood stove with a scrolling ornament decorating its sides. Hughes gave his full attention to the beauty of the stove, and just as much care to

In a Cabin at Rivers Inlet [portrait of Paul Goranson] (1938). Pencil.

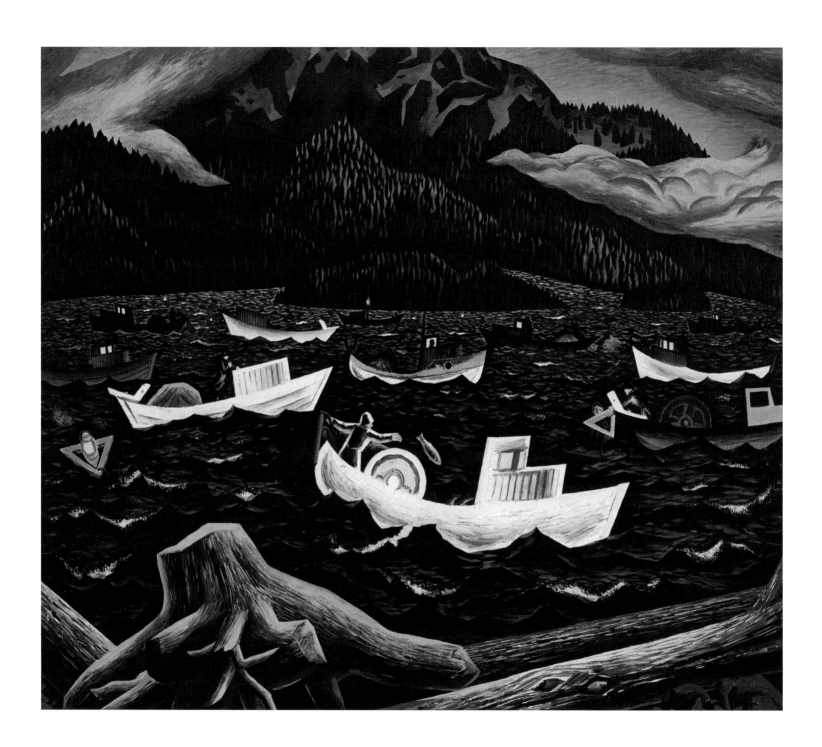

Facing page: *Fishboats, Rivers Inlet* (1946).
Oil, 42" × 50" (106.7 × 127 cm).

Above: *Study for Fishboats, Rivers Inlet* (1946). Pencil.

drawing the spent matches littering the hearth. The wood pile beside the cast iron stove, a frying pan hanging on the wall, the coffee pot, and even the wood grain on each rough-hewn plank—each is detailed with unwavering attention.

Outside the cabin window at the fishing camp, Hughes discovered a world of bold forms. Nearby was a waterwheel, a steep-roofed shed, and a gnarled tree stump cast up on the shore. Behind this were cabins built by Japanese fishermen, though when Hughes was there, they were not in use. In those peaceful pre-war times, he devoted himself to capturing the scene with a careful realism. The prominent stump from this drawing eventually turned up in the foreground of his famous night scene, *Fishboats, Rivers Inlet* (1946).

In 1947 Hughes took up his sketch of the "abandoned village" and waterwheel and painted the subject as the third of his dark postwar paintings. The artist's record of quiet days on the coast was transformed into a vehicle for his thoughts about war.

It's hard to determine just what time of day Hughes thought his *Abandoned Village* (1947) painting was meant to represent. A moonlight glare lights up the buildings from the front, while the sky is a deep blue beyond the clouds. Disintegrating buildings collapse beneath the storm-tossed forest, while the "wheel of fate" churns through the tormented roots of a writhing stump. From a centre point on the lower margin, a rope tied like a noose hangs down to the dark waters beneath.

After his military service, Hughes never again painted any pictures based on the drawings of his war years. Yet, though the recently concluded hostilities are not explicitly referred to in *Abandoned Village* (1947), this powerful statement owes much to Hughes's wartime experience.

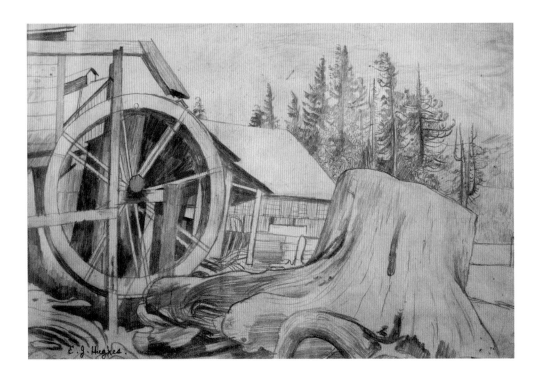

Right: *Abandoned Village Stump* (1937). Pencil.

Facing page: *Abandoned Village* (1947). Oil, 30"× 38" (76.2 × 96.7 cm). University of British Columbia.

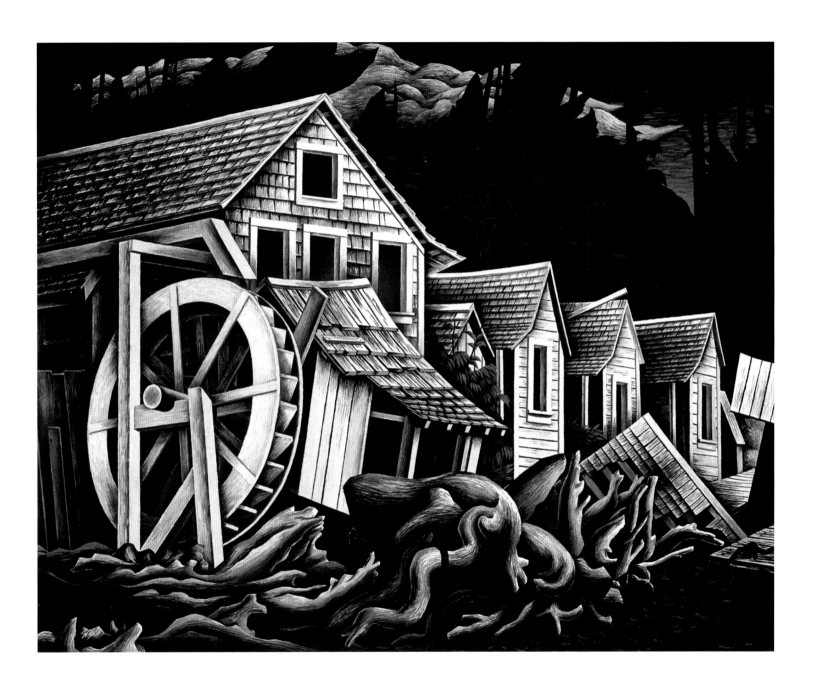

St. Paul's Church, North Vancouver (1933–47)

The fourth of Hughes's dark postwar paintings, *Indian Church, North Vancouver* (1947), involved more extensive preparation than any other Hughes image.

For some time, while he was a student at the Vancouver School of Decorative and Applied Arts (1929–35), Hughes lived with his mother's older brothers, the "McLean uncles," at 243 6th Street West in North Vancouver. Nearby is St. Paul's Church, a western mission of a Catholic religious order, the Oblates of Mary Immaculate. This tall wooden building, with its distinctive twin spires, was built near the shore of Burrard Inlet in North Vancouver in 1909–10.

Previously, the Coast Salish peoples and Portuguese settlers had lived at what came to be Stanley Park. When the Hastings Mill on Burrard Inlet came into operation, the new colonial government decided to expropriate those residents and transform their homes into a civic park. Uprooted from desirable sites, they were moved across the harbour to a place called Ustlawn.

Father Leon Fouquet built a small church at Ustlawn in 1866, and a larger one called St. Paul's on the same spot several years later. In 1869 the colonial authorities set aside Ustlawn for the Squamish people and called it Mission Indian Reserve Number One.[17]

Almost next door to St. Paul's Church was the home of Emily Carr's friend, the basket maker Sophie Frank. Carr visited her there a number of times, even during the years when Hughes lived nearby. Susan Crean wrote about the relationship of Sophie Frank and Emily in her book *The Laughing One*: "[Carr] had formed a friendship with a Squamish woman named Sophie Frank, whom she met in 1906 when she moved to Vancouver. They visited back and forth, Emily taking the motor launch across Burrard Inlet to visit Sophie on the North Vancouver reserve where the two of them would drink tea and tell stories. From the time they met, Emily felt a special attachment to Sophie, and they remained friends until Sophie's death in 1939."[18]

Hughes's first pencil note of the shoreline and St. Paul's Church is tentatively dated 1933. Children play near the tidewater, and the twin spires of the church are reflected in the pools below. Back from the water, Hughes drew a couple of canoe sheds and, beyond the church, a row of wooden houses. A single telephone pole adds a modern touch and anchors the composition on the right of the church.

Hughes was clearly fascinated by St. Paul's Church in North Vancouver, creating a number of drawings and paintings of the building from different angles. The extensive annotations on an early watercolour of the church, *Indian Church, North Vancouver, BC* (1939), indicate that Hughes had plans for the image, and through a number of drawings and prints he continued to develop it. Each time he returned to this subject, he refined and dramatized the scene. At one point it had a railroad track, but then he drew a meandering shoreline and a dugout canoe at the water's edge. Among the people on the boardwalk, a man heads home with his oars over his shoulder. This beautiful watercolour has been squared off for

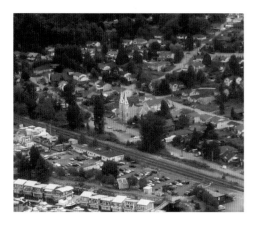

Top: St. Paul's Church, Mission Reserve, North Vancouver. Photo by Sarah Amos.

Bottom: St. Paul's Church, North Vancouver, 2018. Photo by Robert Amos.

enlargement for eventual production as a linocut, and though two prints of the black-printed key block are known, no colour print of this design was ever produced.

Hughes again took up the image of St. Paul's Church in 1947, after his return from the war. This was the fourth of his postwar paintings, and he was determined to make it an outstanding picture. In preparation, he created a small tonal study in watercolour that, though tiny, he believed could be seen across the room. He had seen his work exhibited in various exhibitions with official Canadian War Artists, often with poor lighting in dim drill halls. Now, to make his paintings ring out, he decided that he needed to simplify his subject matter and put it across with a strong compositional kick. With that in mind, he did this little study to bring a different expression to what had been a gentle picture of St. Paul's Church in North Vancouver.

Without the prospect of likely customers or exhibitions ahead of him, Hughes took out one of the large canvases he had brought home from the War Art Program and set to work. The painting of St. Paul's is one of the largest Hughes ever made, at forty by forty-eight inches (101.6 × 122.0 cm). In the new image, the fronts of the church and the houses shine with an intense light from the south, set against a brooding sky of tumultuous and profound darkness. The North Shore Mountains now seem to rise to awesome heights.

"There is an element of menace in the image," Ian Thom wrote in his book on Hughes, "heightened by the minute scale of the people. The houses are monstrously large, and the church, in contrast to everything around it, is nobly erect."[19]

Hughes himself didn't think of the scene as menacing at all, but full of dignity. Pat Salmon quoted him as saying, "I saw dignity in the sight of the old church rising above the humble houses nearby. I cut out a lot of the ornament and detail of the steeples. I almost made them unreal in attempting to simplify it."[20] In the foreground, children are going about their activities, there are people sitting on the boardwalk, and smoke rises from a distant chimney. Despite its darkness, this painting shows a world at peace.

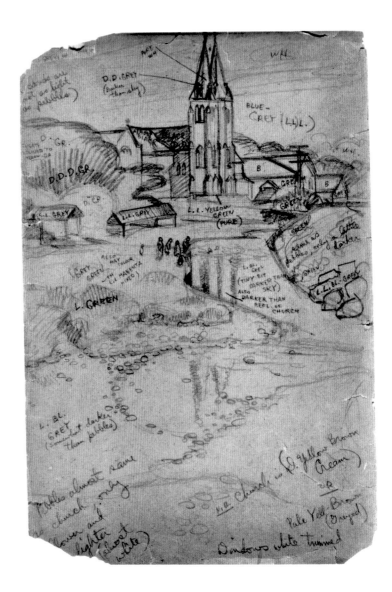

St. Paul's Church, North Vancouver (ca. 1933). Pencil.

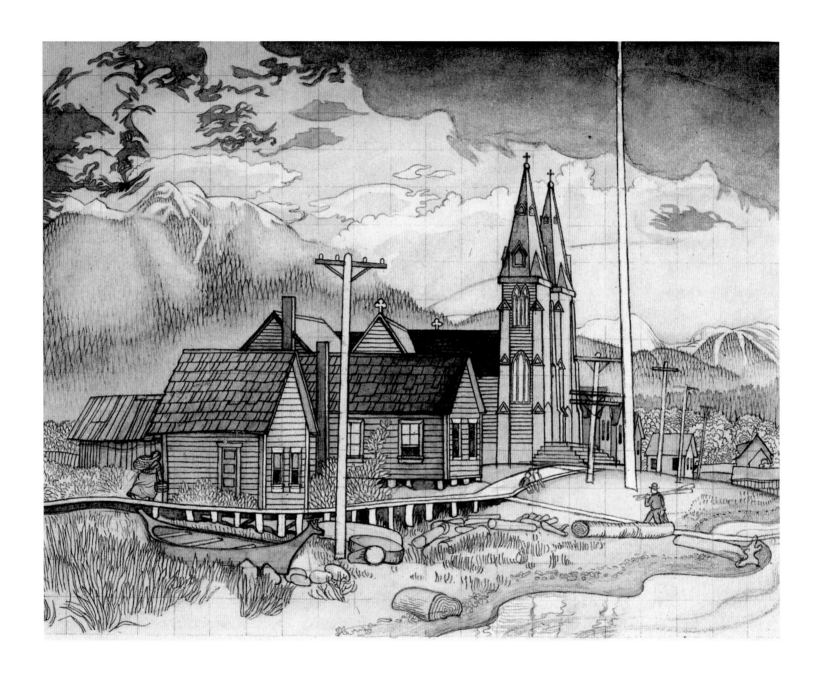

Indian Church, North Vancouver, BC (1939).
Pencil and watercolour, 8¾″ × 11" (22.3 × 28.1 cm).

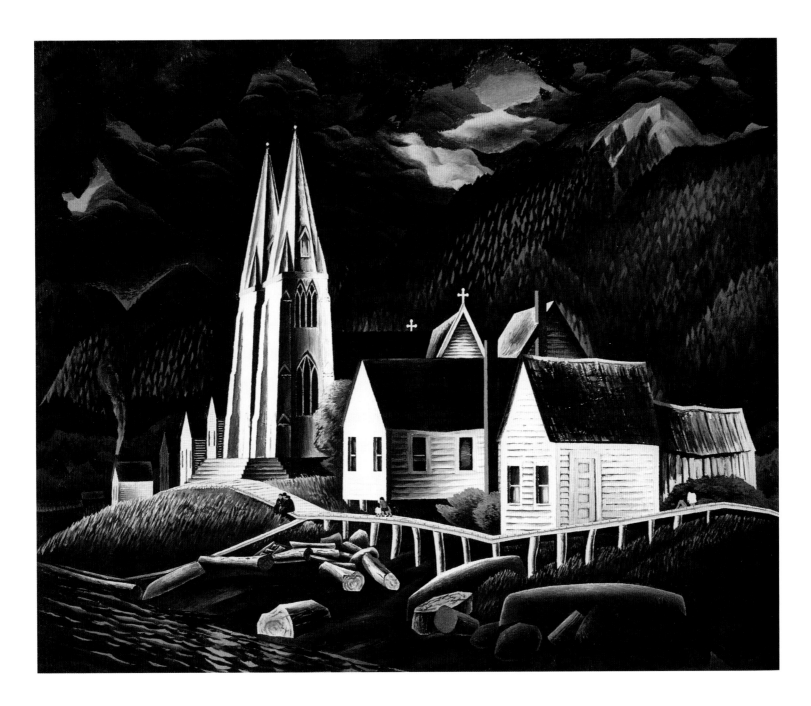

Indian Church, North Vancouver (1947).
Oil, 40" × 48" (101.6 × 122.0 cm).

Military Service (1939–46)

At the time when Hughes first met Fern, in 1937, he was struggling to make a living through his art. With the Western Brotherhood, he kept himself busy painting murals during two summers at the First United Church in Vancouver, and then for three months at the Malaspina Hotel in Nanaimo. In the last half of 1938, the Western Brotherhood were working in a warehouse in Vancouver to create murals that had been commissioned for the British Columbia Pavilion at the Golden Gate International Exposition, to be held in San Francisco in 1939. These murals were highly accomplished productions, created for specific and unusual spaces. The young artists first drew fully rendered studies of the murals on a smaller scale. These designs included many characters working at specialized activities. Though the actual murals have not survived, the drawings are, in themselves, works of art. Even so, after all their trouble, the artists didn't come away with much more than their room and board.

In a memoir describing his military service, Hughes wrote: "In August 1939 I was not quite making a living at art, and was on Relief so had my application in to several small permanent force (full time) military units, all of which had waiting lists." But about that time, things changed. Perhaps Ed Hughes hadn't noticed it, but war was imminent. "Immediately I received favourable answers from all three units," he noted.[21]

He enlisted on September 1, 1939—the very day Germany invaded Poland. It was that invasion that convinced France and Britain that the territorial ambitions of Adolf Hitler could not be appeased. Britain and France declared war on September 3, and a week later, on September 10, Canada also went to war with Germany.[22]

Hughes—now known as P/7518 Gnr. Hughes, E. J.—had three months of basic training in Esquimalt near Victoria. Then, on December 6, 1939, he was posted to the Coastal Battery in Vancouver. Perhaps naively, he thought he could be in the army, and at the same time get married and raise a family. As he explained it, "almost from the beginning, I was pestering my commanding officers for permission to marry Fern."[23] Permission was received, and they were married on February 10, 1940, at Central Presbyterian Church in Vancouver.

The Canadian War Art program, which Lord Beaverbrook had initiated in the First World War, was something Hughes was aware of, and almost from the beginning, he had written to headquarters to ask for status as a war artist. Hughes was so obviously suited to the task that they named him the first of three "official war artists." In the winter of 1940, he reported for duty to the Experimental Farm buildings in Ottawa, where the Canadian Historical Branch had its headquarters. In 1942 the army formalized the Canadian War Art program, and Hughes was promoted to captain.

Hughes was the first official Canadian war artist. He was also the longest serving, as he was the last one demobilized, serving until October 1946. During his years in the military, he worked with extraordinary focus at his self-directed task, and in so doing, created the largest body of work of any Canadian war artist.

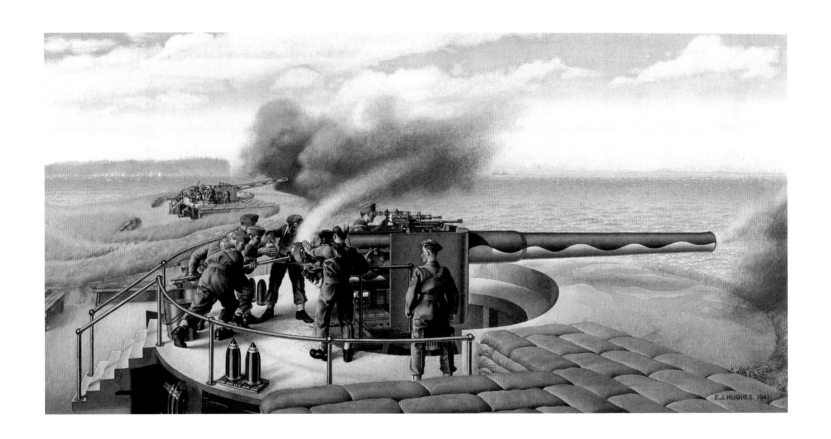

Coastal Defense Gun and Crew, Stanley Park Battery (1941).
Oil, 20" × 40" (50.8 × 101.6 cm). Canadian War Museum.

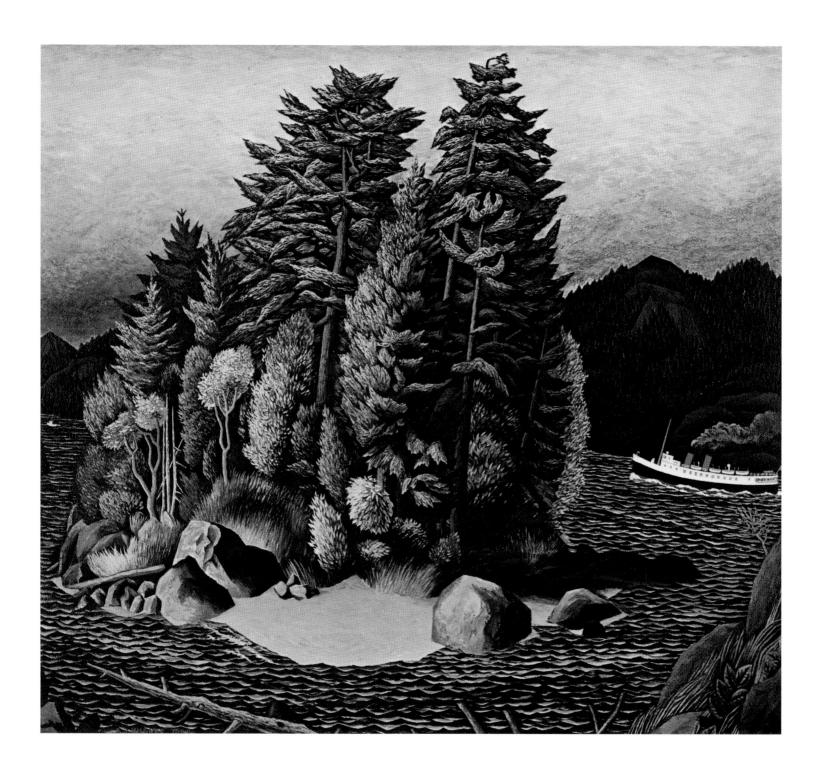

Princess Adelaide and the Emily Carr Scholarship (1947)

As they began their life together in Victoria after the war, Hughes and Fern shared a big old house with his parents. There was a studio set aside for him in the attic, and it was there that Hughes painted four dark elegies: *Near Third Beach, Stanley Park* (1946), *Fish Boats, Rivers Inlet* (1946), *Indian Church, North Vancouver* (1947), and *Abandoned Village, Rivers Inlet* (1947). The first paintings made after his war service are a reaction to the uncertainty and oppression of the times he had just lived through. They did not revisit war subjects but were a way for the artist to consider some places that were remote from the war. Even so, a powerful darkness threatens to overwhelm the peaceful subject matter.

Living again on Vancouver Island with his wife and family around him, Hughes could begin to leave those dark days behind. He was ready to open himself to sunlight and fresh air and scenes of the West Coast already imprinted in his mind.

He was trained to make a living as an artist, but he had never sold a painting. How was he going to do that? His student days in Vancouver were a lifetime away. Hughes had no patrons to return to. There was no market on the West Coast for contemporary Canadian art.

Fortunately, Lawren Harris had his eye on Hughes. One of the most important figures in Canadian art, Harris was a man of wealth and influence. He had been the driving force behind Canada's famous Group of Seven. Much changed when he met Emily Carr in 1927.

Carr had come east to participate in the landmark Exhibition of Canadian West Coast Art Native and Modern. This show opened at the National Gallery of Canada in Ottawa, and the world had its first look at her paintings—forty-four of them. The show was later seen in Toronto and Montreal. Harris began a correspondence with the Victoria artist, and their friendship provided for Carr a lifeline to the larger world.

Harris left Toronto in 1933 to live in New Hampshire and New Mexico. With the coming of the war, he became a permanent resident of Vancouver in 1940. Now on the West Coast, he continued as an advocate for Emily Carr. In 1944, he introduced Carr to his dealer, Max Stern, the owner of Montreal's Dominion Gallery. Later that year, they produced the only successful gallery show Carr ever had. Astonishingly, they sold forty-six of her fifty-nine paintings. This took place in Montreal, during wartime.

During the early 1940s, Harris and Ira Dilworth helped Emily Carr plan her estate. They set up the Emily Carr Trust, a collection of her art (now at the Vancouver Art Gallery) that eventually included about 245 of her best paintings. The remainder were sold, mostly through Max Stern and the Dominion Gallery. The money raised was used to create the Emily Carr Scholarship Fund, providing money for art students residing in British Columbia to further their art education.[24] Harris and Ira Dilworth administered the fund.

Carr died in 1945. In 1946 the estate awarded the first Emily Carr Scholarship to Joseph Plaskett, a twenty-eight-year-old painter from New Westminster who had been recommended

Facing page: *Entrance to Howe Sound* (1949). Oil, 32" × 36" (81.3 × 91.4 cm).

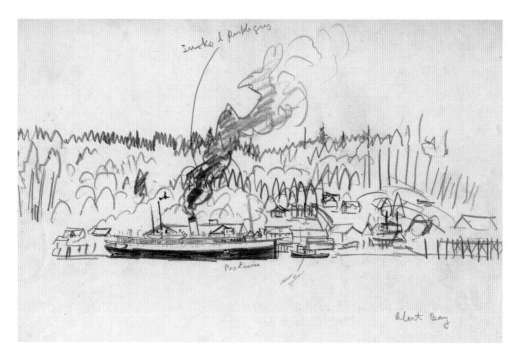

Princess Louise Docked at Alert Bay (1947). Pencil.

by A. Y. Jackson. At that time Harris gave his thoughts: "I would suggest the Emily Carr Trust give him a grant to take care of his living for one year with the understanding that he devotes all of the year to painting."[25]

When Hughes was at last released from the army in October 1946, he was the natural choice for the next scholarship. Harris was certainly aware of Hughes's reputation, as the premier art student in Vancouver through the 1930s. Through exemplary war service, Hughes had diligently cultivated his artistic promise. Here was an ideal candidate for some financial and artistic support.

Harris contacted Hughes in Victoria and let him know he had been awarded the Emily Carr Scholarship. A financial boost could provide the artist with time to gather some new subject matter at a crucial point in his career. As a landscape painter, he would use it to explore a truly remarkable landscape—the British Columbia

coast. This subject matter would serve him for the rest of his life.

In total, the award came to twelve hundred dollars. At the time, it seemed to Hughes an enormous sum. He decided to begin immediately with a trip up the coast. Simply getting out in the ocean breezes would be a tonic for the weary soldier. After that, he could better decide how to spend the majority of the money in the following summer of 1948.

Like Carr, Hughes did go up the coast. He was nourished by what he saw on that trip, and the artworks Hughes created during the summers of 1947 and 1948, sponsored by the Emily Carr Scholarship, laid the foundation for his career. After 1951, the Dominion Gallery became the sole agent for Hughes, as it had been for Carr since 1944.

Hughes also had money allowed him from a Veteran's Settlement Grant. Taking out a mortgage, Hughes and Fern were able to buy a house at 239 Menzies Street on February 6, 1947, in the James Bay neighbourhood, where Emily Carr had spent her life. And when the money arrived from the scholarship, Ed bought a ticket on the *Princess Adelaide*. This graceful old steamship was a "pocket liner," operated as part of the coastal service by the Canadian Pacific Railway. The ship was bound for Prince Rupert on the Inside Passage.

With his sketchbook and some pencils, Hughes would make a reconnaissance trip and consider how he would paint the coast. He'd be gone for a week. Fern was left home alone, in the rooming house the inexperienced couple had recently purchased. Fortunately, she had the support and friendship of Ed's mother, Kay, who lived just a short walk away.

In the harbour the *Princess Adelaide* was ready to set forth into the silent forests and fjords of the British Columbia coast. As Hughes headed north from Victoria along the Inside Passage, he left in his wake an extraordinary succession of events.

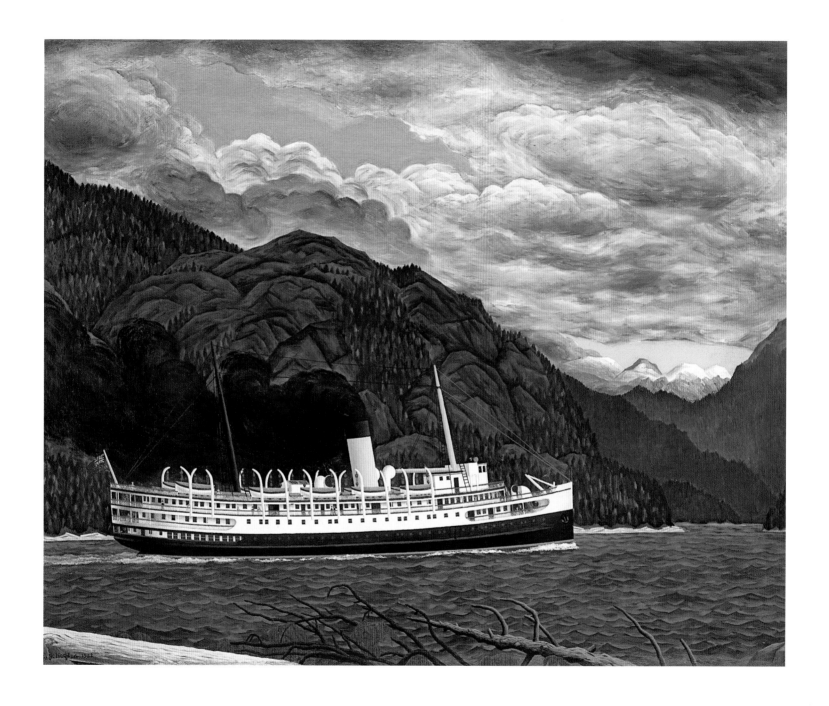

Steamer in Grenville Channel, BC (1952).
Oil, 28" × 36" (71.1 × 91.4 cm).

The deck of *Princess Adelaide* at Alert Bay (1947).. Ink.

The *Princess Adelaide* was the first, and the largest, of the Princess steamships. It was built in Scotland in 1919 for the Vancouver–Victoria overnight route. Hughes was a passenger on the maiden voyage of its new run, for in 1947 the 290-foot-long (88 m) ship was repositioned to provide the weekly service from Vancouver to Prince Rupert. This handsome vessel embodied all the nostalgia that Hughes's beloved paintings of the Princess ships convey.

It sounds like a holiday cruise, but the reality was something else. Attempting to paint a picture from a moving vessel is not as simple as one might expect. It was not an attractive proposition for Hughes. And the cruise to Prince Rupert didn't really allow for any time ashore. "The trip up the Inside Passage—he said it was horrible," Pat Salmon later reported. "While Hughes usually told people that the experience was lovely, in fact he was prone to seasickness. He had been ill all the way across the Atlantic when he was a war artist," she explained. And, as Hughes had told her, "the north coast was usually rainy and dank, and he really had to work hard to bring every possible glimpse of colour to the scene."

All that aside, Hughes set to work. Standing on the deck, he was ready with a pocket notebook. In the years he'd been away at war, gathering subject matter had become second nature to him. At first, he simply wrote down what he saw, and considered how he might someday paint the mountainsides along Johnstone Strait:

"Char. Of Mt. sides Johnstone Straits Various sized pointed trees (some l. green) D grey green coll white spars interspersed—jagged rock cliffs showing among trees and at waterline—mostly square cut—w. wh. And grey r. v., no deciduous except at w/line. water d grey screen. Sparkle of sky blue—sky cool cool pale blue—cool grey wh whisps of cloud faded RV.+Blue grey shirts Dif shades b denim at Port McNeil (Pioneer Timber & C&A Logging)."

Since demobilization in Ottawa in October 1946, he had travelled across the country, reunited with his wife, mourned the loss of his son, moved in with his parents in a new city, bought a house, become a landlord—and also painted four of the most important canvases of his career.

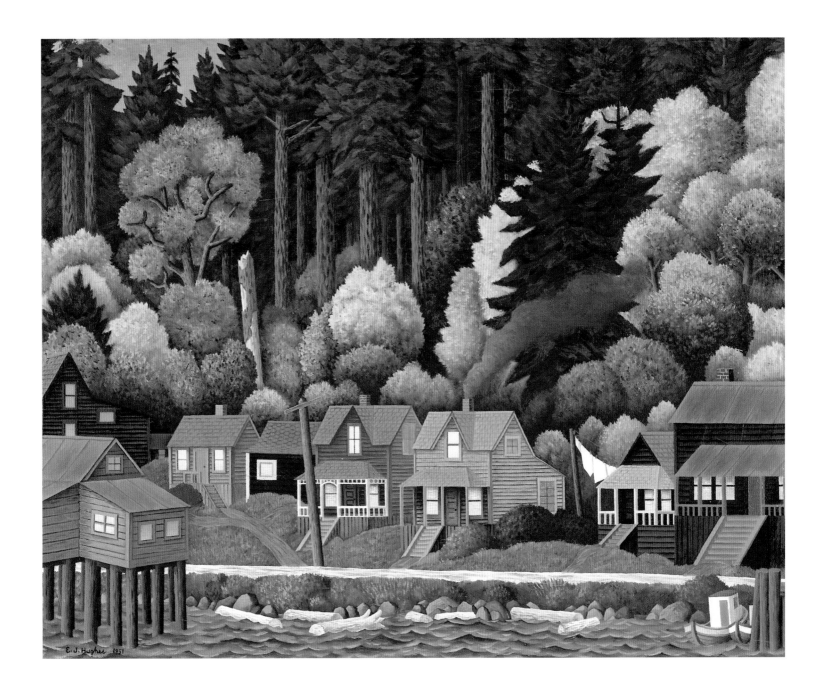

Houses at Alert Bay (1951). Oil, 20" × 25" (50.8 × 63.5 cm)

Photo of a page from Hughes's pocket notebook—"Char. Of Mt. sides," (1947).

Though they are abbreviated, it's quite possible to decipher the artist's written impressions. In fact, these notes provide remarkable access to Hughes's decision-making process at a highly focused moment of his life. The little page is a recipe for a Hughes painting.

The *Princess Adelaide* made its first stop at Alert Bay, the capital city of Kwakwaka'wakw territory. Alert Bay on Cormorant Island was a busy centre, with a cannery and a sawmill. It was a port of call for regular visits from steamships full of tourists. Mostly they stayed just long enough for a promenade along the oceanside road.

In 1908, on her first visit, Emily Carr stayed at Alert Bay for most of two weeks. She painted the canoes and decorated houses along the shore. On her later visits to the northern waters, she ventured far in search of remote traditional villages hidden in the deep inlets of the coastline.

By contrast, there is no evidence that Hughes left the boat. He was ready on the deck as it approached Alert Bay. *Princess Louise* was already at the wharf and ready to depart. He quickly sketched the boat with the smoke rising from its single funnel. Next it was *Princess Adelaide*'s turn at the wharf.

At this point, the artist took out his fountain pen. On a sheet of lined notepaper, he drew his first impression of the scene. From a high point of view, he drew someone sitting within the protective railings on the ship's deck below. That person can be clearly made out, his hand poised above a piece of paper. On the deck with him are folding chairs and a life ring, while a fishing boat is visible in the water below. Beyond, wrapped in the dark forest, the shore is lined with a row of waterside houses.

Four years later, Hughes took out his drawings from that trip and designed the painting *Houses at Alert Bay* (1951). There's a preternatural quiet to the scene, because, in its final form, Hughes left out the people walking along on the seaside. In 1952, this became the first painting

by E. J. Hughes to be acquired by the National Gallery of Canada.

As the *Princess Adelaide* voyaged north, Hughes was well beyond the reach of human settlement. He made a few sketches of simple shapes and distant vistas, without a trace of occupation or industry. Recession in space was his theme. At Cordero Channel, he stood at the rail and wrote down his perceptions of the shoreline. What follows is a transcription of Hughes's note:

Note. Slopes of Channels

South of Prince Rupert similar to those of Johnson Strait

Spars are more numerous. Have app[earance] of having been whitewashed (in some areas)

Deciduous trees are very few; on some hills are not to be seen readily, and if anywhere are at waters edge.

Colours trees (evergreen) in fore usually warm green with velvety warm black shadows. In mid dist[ance] hills they get darker and slightly cooler & greyer green with cool black shadows. Distant hills slightly cooler green h[igh] lights with blue black shadows. Very far distant— highlights get greyer and bluer and shadows paler & bluer until they are the same val[ue] and colour

Note Ev[er]green trees in fore are not all same colour—mostly light warm green with strips of patches or individual dark green trees. Individual trees seem lighter and yellower on upper tips, one at w[aters] edge even colour

The *Princess Adelaide* sailed up the coast to Prince Rupert. As she passed through Grenville Channel, Hughes made detailed sketches of the surrounding hills, which he would later use as the setting of his compelling painting *Steamer in Grenville Channel, BC* (1952). For that project, he was able to draw the ship accurately with

the help of a photograph provided by Canadian Pacific Steamships.

Hughes made no comment about Prince Rupert and returned to Victoria aboard the *Princess Adelaide* on her return voyage. He had been away for a week, and he had learned that being on a moving ship was not helpful to him. For his purposes, he needed to become familiar with his subject, and to consider it at length in some privacy.

Top: *Channel South of Prince Rupert* (1947). Pencil.

Bottom: Compositional sketch for *Steamer in Grenville Channel, BC* (1952). Pencil.

Home of E. J. Hughes on Shawnigan Lake Road (1951–1972).
Photo by Pat Salmon.

Lawren Harris introduces Max Stern to E. J. Hughes

The Emily Carr Scholarship was helpful, but Hughes had yet to establish a clientele for his art. Nothing seemed to present itself. To save money, and also in search of a quieter environment, Hughes and Fern sold their house in May of 1951 and moved twenty-five miles north of Victoria to the rural retreat of Shawnigan Lake. And there, on July 31 of 1951, Max Stern came calling.

Stern had done very well with the estate of Emily Carr and had come from Montreal looking for more talented artists from the west. He met Lawren Harris in Vancouver, and Harris had suggested Hughes. Stern went looking for Hughes in Victoria, but no one knew where to find him. Stern enlisted reporter Gwen Cash from the *Victoria Daily Times* newspaper to help. The two, armed with his mailing address, Post Box Two, Shawnigan Lake, went on a road trip. They made inquiries at the local RCMP detachment and were directed to the artist's home on the east side of the lake near Strathcona School. Of course, they showed up unannounced—Hughes had no telephone—and knocked on the door.

Later, Stern reported on this meeting with Hughes: "The meeting proved to be fascinating: there was a shy painter who was not at all aware of the unusual quality of his work, an artist who was not really convinced of his own talent. So—as I had done seven years earlier in the case of Emily Carr, whose representative and agent I became—I decided on the spot to take Hughes under my wings."[26]

Stern visited Hughes in his upstairs studio, and then made him an offer. He wanted to buy everything. For the price of $500, he purchased fourteen oil paintings, four oil-on-panel sketches, thirty-two pencil studies, and four prints. At that time, Stern also agreed to become Hughes's sole agent. From that point on, Stern and the Dominion Gallery bought everything Hughes produced, in whatever medium. This contract may be unique in Canadian art history. It was certainly the most important single incident in the professional life of E. J. Hughes.

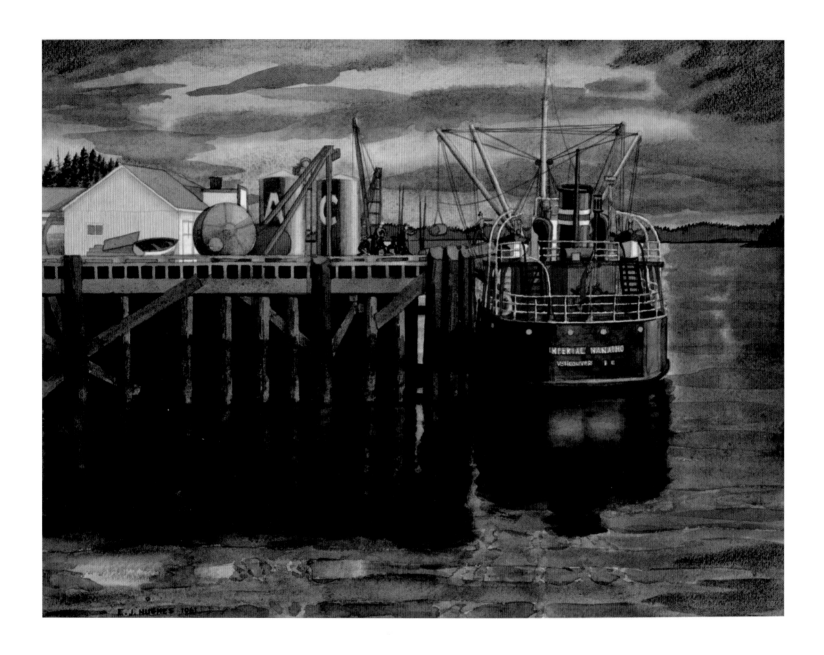

Imperial Oil Dock at Prince Rupert (August 1953) (1961).
Watercolour, 12" × 16" (30.4 × 40.5 cm).

Imperial Nanaimo (1953)

Soon after he took on the responsibility to represent Hughes, Stern forwarded him information regarding a commission. The Standard Oil Company of New Jersey (based in New York) wanted Hughes to create some paintings for the company's magazine, *The Lamp*. They were planning an article about the work of a little oil tanker that supplied fuel oil to logging sites and fish canneries up north on the British Columbia coast.

"You take the trip on the tanker," Stern advised him in his letter of June 25, 1953, "you make the sketches, and then paint the paintings, selling them the reproduction rights to your paintings for an amount of about $400 or $500 each and we will buy the paintings and the sketches from you . . . we will then be satisfied with a commission of 20% of the publication rights and will pay you for each canvas and sketch." On July 1, 1953, Standard Oil agreed to pay Hughes (through Stern) $500 for the use of each of the four pictures and $150 for each pencil drawing used.

The ship was the *Imperial Nanaimo*, based at the Imperial Oil Company (IOCO) refinery at Burnaby near Vancouver. It was loaded with a cargo of gasoline, stove oil, and other petroleum products, ready for delivery to coastal communities. The ship and crew were headed all the way to "the farthest westernmost reaches of the Queen Charlotte Islands," according to the article published in *The Lamp* in September 1954.[27]

Hughes met the boat at Vancouver in August of 1953 and drew it at the wharf. Prominent are the cranes coming from a central mast, used to

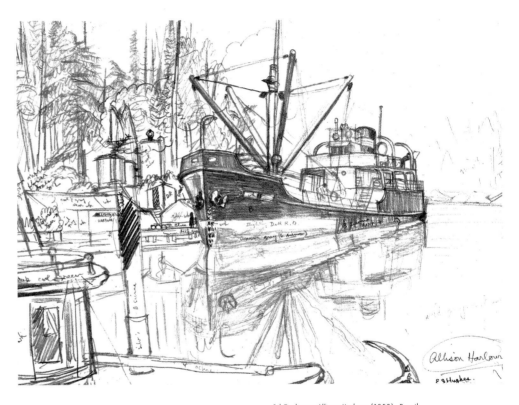

Oil Tanker at Allison Harbour (1953). Pencil.

load the barrels of oil products that are visible on the deck below.

The first port of call was Refuge Cove, on the mainland across from Campbell River. Then, farther north near Port McNeil, they put in at Bones Bay Camp on Cracroft Island. Hughes drew the fuel pumping operation from a vantage point on board the ship. Later, when the painting was completed, Stern was happy to

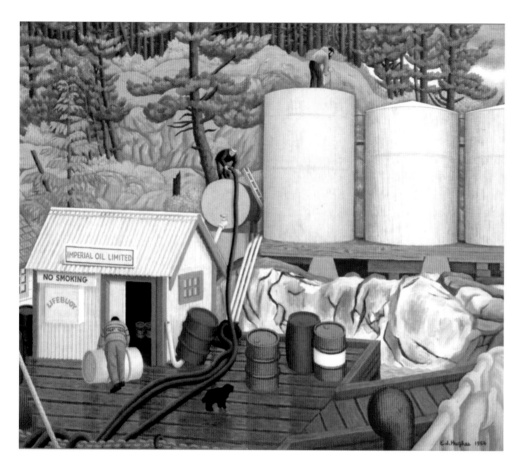

Top: *Storage Tanks at Bones Bay, Cracroft Island* (1954).
Oil, 18" × 22" (45.7 × 55.9 cm).

Bottom: *Looking to Gilford Island* (1953). Ink.
Shawnigan Lake Museum.

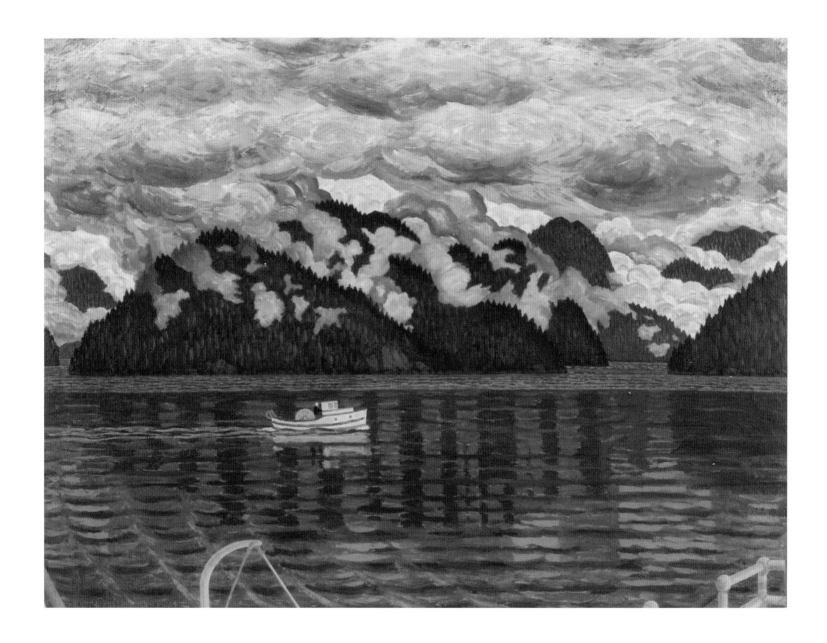

Looking to Gilford Island (1954). Oil, 18" × 24" (45.7 × 61 cm).

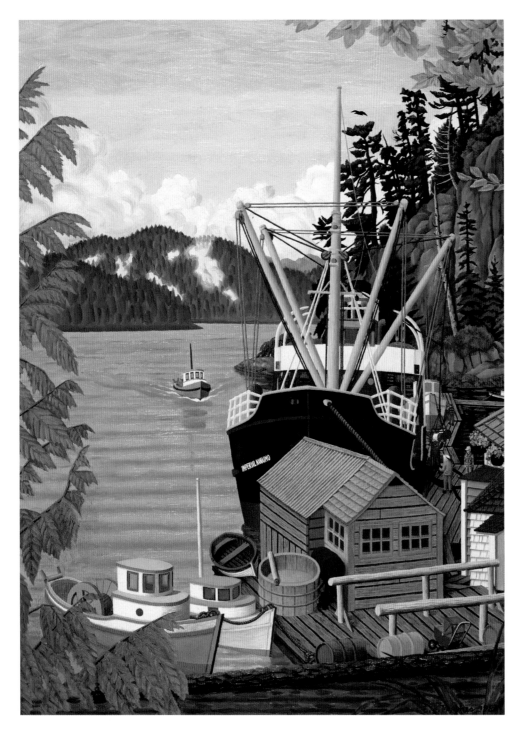

pay him seventy-five dollars for it, and wrote on April 2, 1954, "I admire very much your very good inventions, for instance, this time it was a charming little black dog . . . "

The article in *The Lamp* described the passage on the *Imperial Nanaimo* in dramatic terms: "You are sailing down a lane of water that winds between snow-topped mountains bristling with great firs and hemlocks and cedars. The craggy shore to the west is Vancouver Island, largest of the 10,000 islands that provide a deep, sheltered waterway for the odd medley of coastal traffic."

Sailing north, the ship passed near Gilford Island. A davit and railing on the lower edge of the painting *Looking to Gilford Island* (1954) indicate that Hughes created this image from the deck of the *Imperial Nanaimo*. He painted calm waters and the mist trailing as it burns off the islands nearby. This time, the artist attempted an impressionist effect in his paint handling, with "broken" brushwork on the water surface and strong colour shaping the lowering clouds. When he received the painting on February 1, 1954, Stern remarked that the sky was a bit "spotty." Years later, in March 1990, Hughes told Pat Salmon: "I was trying to be modern like Varley and get a lot of different colours yet keep the general effect of an ordinary sky. But it was overdone."[28]

On the west side of Gilford Island is Echo Bay. It was there that Hughes was able to capture an image for the cover of the magazine, which required a vertical orientation. "This is really a detail of a horizontal sketch," Salmon recorded. "The upper left space was left bare to make space for the title of the magazine. Ten years later, in 1963, Hughes painted the image exactly as he had conceived of it originally."[29] The artist showed odd little buildings clustered on the floats at the water's edge, with life going on between the sea and the forest.

In his unique way, Hughes arranged the shapes and colours of *Echo Bay* (1953) into a composition

Echo Bay (1953). Oil, 24" × 18" (61 × 45.7 cm).

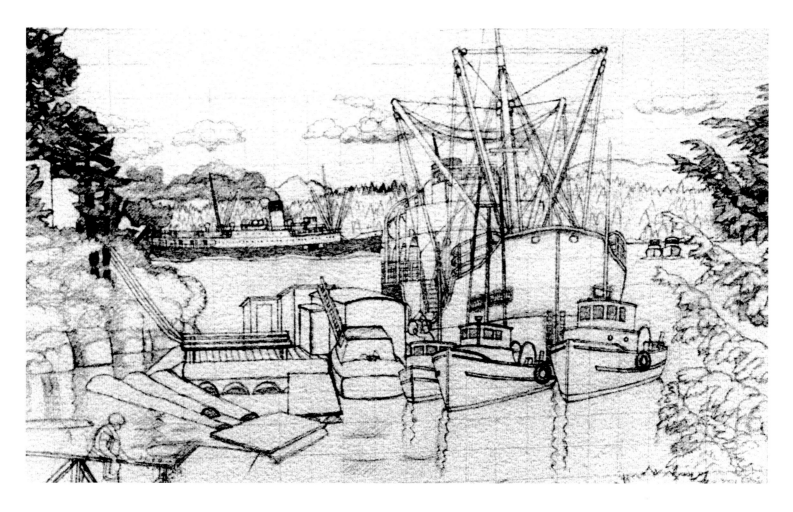

Christie Pass, Hurst Island (1996), underdrawing for watercolour.

of wonderful depth and variety. At the side of the hull of the *Imperial Nanaimo*, a man in a red and black checked shirt walks along the wharf; a deckhand in blue coveralls helps offload red and white barrels; under a hanging flower basket, a person in a Cowichan sweater watches someone guide black hoses into the ship. And on the nearest wharf is a blue baby carriage, unattended.

On April 12, 1962, Hughes sent an oil painting of Christie Pass to the Dominion Gallery. "I was wondering if you think I left enough room for the eye to travel from the foreground, around the group of boats, into the background, as the middle distance centre left is partly blocked by the yellow-funnelled steamer," he asked Stern. "Both the CPR and Imperial Oil were kind enough to supply me with photos of the ships in question, at my request by mail. The authenticity of the ships, I know, is not essential to the Art qualities of a painting, but I, and to a certain extent even the un-maritime observer, will feel better about it, I think."

Stern wasn't worried by these compositional concerns at all. In his reply of April 23, 1962, he said he was delighted with the painting. "I love the woman feeding the ducks and we will have

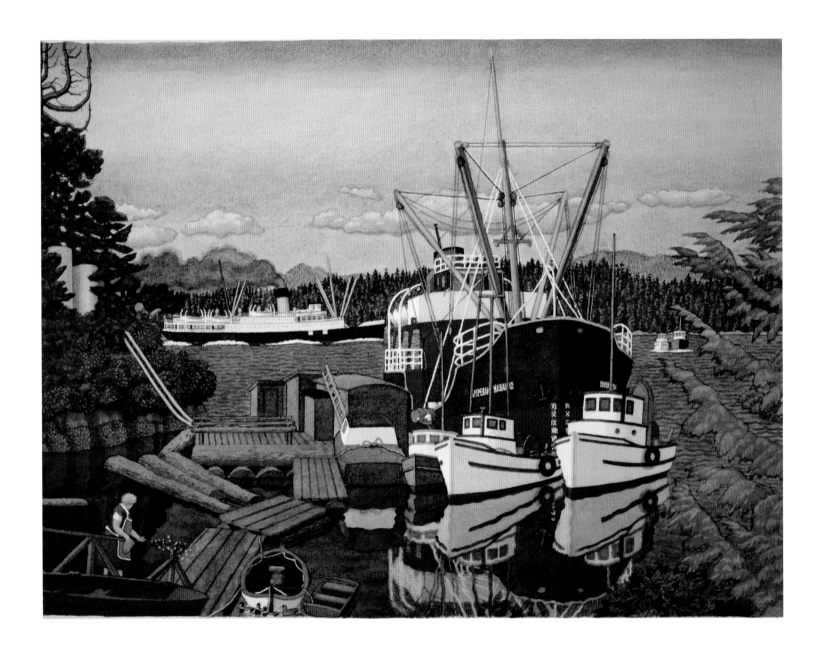

Christie Pass, Hurst Island (1996).
Watercolour, 18" × 24" (45.7 × 61 cm).

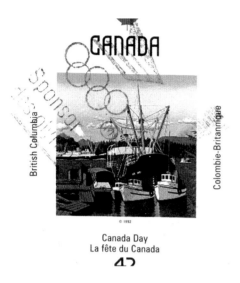

CANADA

British Columbia

Colombie-Britannique

© 1992

Canada Day
La fête du Canada
42

to frame it very sharp so that the ducks remain visible. I admire your constant new ideas and new approach. It is a beautiful painting." Indeed, the ducks, perhaps unique in Hughes's work and very well painted, are almost out of sight on the lower margin. "They are supposed to be mallards," Hughes mentioned in his letter to Stern on May 8, 1962.

Over the years, this painting of Christie Pass has been much appreciated. It was purchased by the National Gallery of Canada and was used by the Canada Post Corporation on June 29, 1992, to commemorate 125 years of Canada's nationhood. Perversely, the stamp is square and set on the diagonal, with a square detail of the Hughes image printed in the centre.

Moving beyond the end of Vancouver Island, the *Imperial Nanaimo* proceeded to Dawson's Landing at the mouth of Rivers Inlet, a place Hughes knew from his fishing days in 1937 and 1938. He used his time at Dawson's Landing to make a careful drawing from the deck of the ship. In front of him an impressive tree stump has washed up on the shore, and a steep flight of stairs leads from the wharf to oil tanks set in the dense forest.

From a position at the stern of the ship, with pen and ink Hughes drew the tiny floating community at Dawson's Landing. It is remarkable that Hughes could translate a simple ink drawing into a large richly detailed oil painting, with

Above left: *Christie Pass, Hurst Island* on a postage stamp, issued by Canada Post on Canada Day, 1992.

Above: E. J. Hughes with his watercolour *Christie Pass, Hurst Island* (1996). Photo by Pat Salmon.

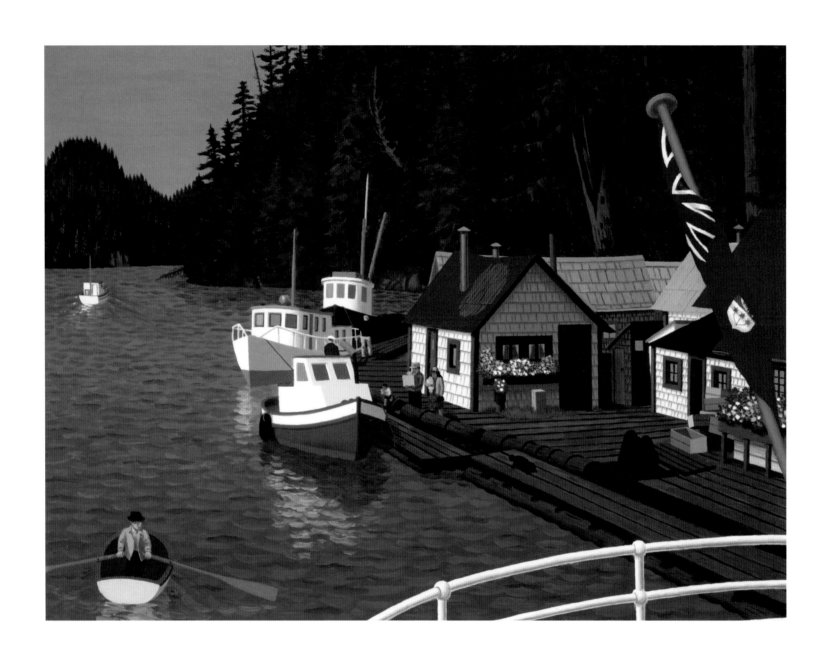

Dawson's Landing, Rivers Inlet (1966).
Oil, 30" × 40" (76.2 × 101.6 cm).

fishing boats from near and far moored at the landing. People of the coast do their shopping at this wilderness outpost. Hughes explained this in a little more detail, as noted by Salmon in February 1984: "When I show a group of people in my paintings, I try wherever possible to show a family. In this case it is an Indian family leaving Dawson's Landing, having purchased their weekly provisions. The figure in the lower left of the canvas is a retired Norwegian fisherman who is rowing to the store to buy his needs."[30]

Cruising further up Fitz Hugh Sound, the *Imperial Nanaimo* pulled into Namu, bringing fuel oil to the large Clover Leaf Seafoods cannery there. Hughes drew the islands of the sound and the sheds of the cannery from a distance, and then from a closer vantage point along the shore. Of special interest in the painting *Namu Cannery, BC* is his treatment of the water. The *Imperial Nanaimo*, tied at the wharf in the centre of the composition, sets up a beautiful pattern of reflections in a bold pointillism. A more primitive wharf closer to the artist is busy with fishing boats. On its near side, eel grass sways beneath a surface interrupted with lazy swells that reflect the cobalt sky. Namu was the first of the five oil paintings Hughes made for Standard Oil in 1953 and 1954, and he revisited the image with acrylic paint in 1991.

The *Imperial Nanaimo* sailed on, making the considerable voyage to Haida Gwaii, then known as the Queen Charlotte Islands. The Kelly Logging Company was at Cumshewa Inlet, halfway up the east coast of the islands, and their offices were built on pilings by the shore. In this painting, *Cumshewa Inlet, Queen Charlotte Islands*, a couple of tank cars are being filled from the *Imperial Nanaimo*, having come to the wharf on Kelly's private railroad. In the forefront is *Cougar III*, a tough little tugboat. Three ravens stalk that boat,

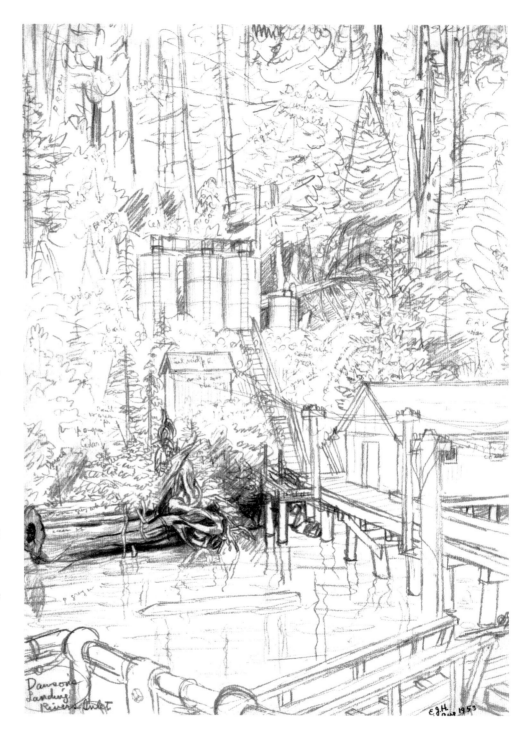

Tanks at Dawson's Landing (1953). Pencil.

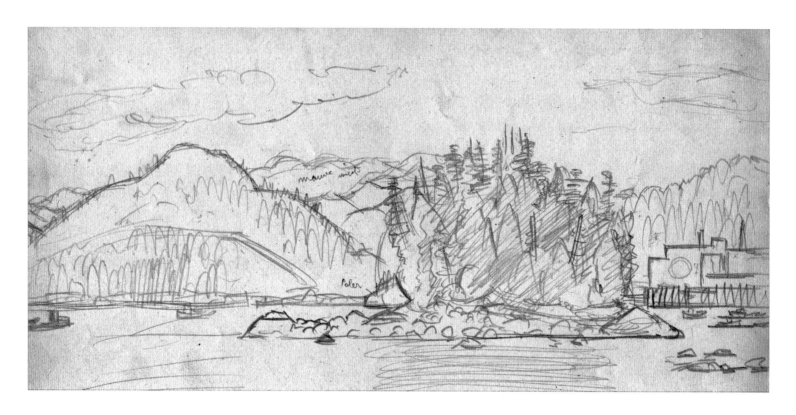

Above: Near Namu (detail) (1953). Pencil.

Right: *Namu Cannery, BC* (1991). Label.

Facing page: *Namu Cannery, BC* (1991). Acrylic, 18" × 24" (45.7 × 61 cm).

"Namu Cannery, B.C." acrylic. E. J. Hughes '91.

(Pictured) In 1953, I travelled up the BC coast on an Imperial Oil tanker, to sketch the stopping places where the tanker delivered oil, gasoline, etc. Quite a long stop was made at Namu so I made the pencil sketch plus another sketch. ~~From the~~ for the above painting. From the sketch used for this ptg. I also produced an oil ptg in 1953

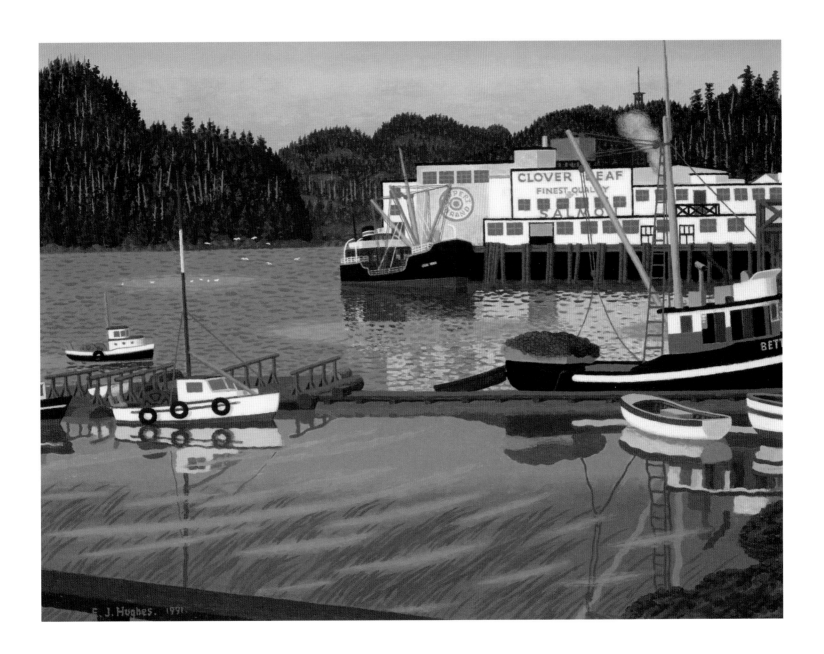

while behind them a white cruiser sits with quiet reflections inside a boathouse.

Further up Cumshewa Inlet is Beattie's Anchorage, where Hughes made a lovely drawing of the precipitous mountains and their forest cover. Once again, Hughes's point of view is from the deck of the *Imperial Nanaimo*. In the foreground, boldly coloured red and green, are the pipes and connections through which fuel oil is pumped from the *Imperial Nanaimo* to Beattie's camp. Log booms stretch across the bay, anchored in the still water. A few logs have escaped from the booms, and pilings line the shore. A little tug boat chugs across the middle distance with a proprietary air.

Above the log booms, Hughes drew an "A frame," a derrick for lifting logs. On the slopes beyond, bare trunks stand out against the green, reminders of the extensive logging that had gone on in the area.

Finally, the artist took the measure of a logging camp on skids that lined the shore.

The trip on the *Imperial Nanaimo* took about three weeks, and Hughes made good use of his time. When, on September 3, 1953, he reported back to Stern, he expressed his satisfaction with the trip: "My trip on the tanker was very enjoyable, and I feel it was profitable too—my sketches were all very rough though as the stops were short, and I had to work rapidly. Have just yesterday despatched thirty-nine pencil sketches to Mr. Sammis of New York and will wait to see which ones are selected to be used for the four paintings . . . "

On September 30 he wrote again to Stern: "Have just received a letter from Mr. Sammis . . . enclosing five of my sketches which have been chosen to be worked up into paintings. I understand from his letter that he now requires five paintings instead of four originally planned on . . . He requires two verticals and three horizontals . . . " Through the fall and winter of 1953, he painted the five canvases needed for *The Lamp*. Beyond this commissioned work, which earned much-needed money for Hughes, the trip provided him with reference material to use for years to come.

Facing page: *Cumshewa Inlet, Queen Charlotte Islands* (1990). Acrylic, 25" × 32" (63.5 × 81.3 cm).

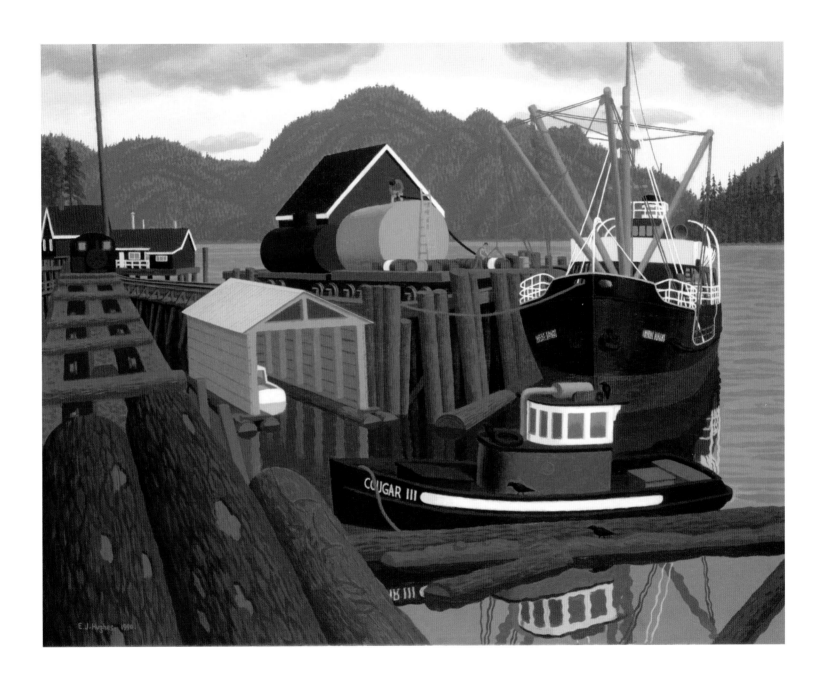

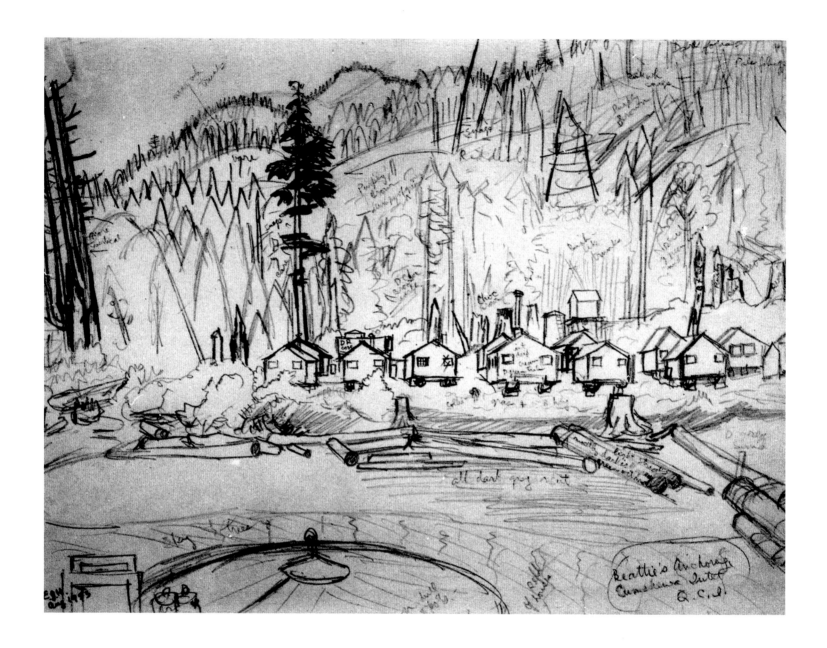

Beattie's Anchorage, Cumshewa Inlet (1953). Pencil.

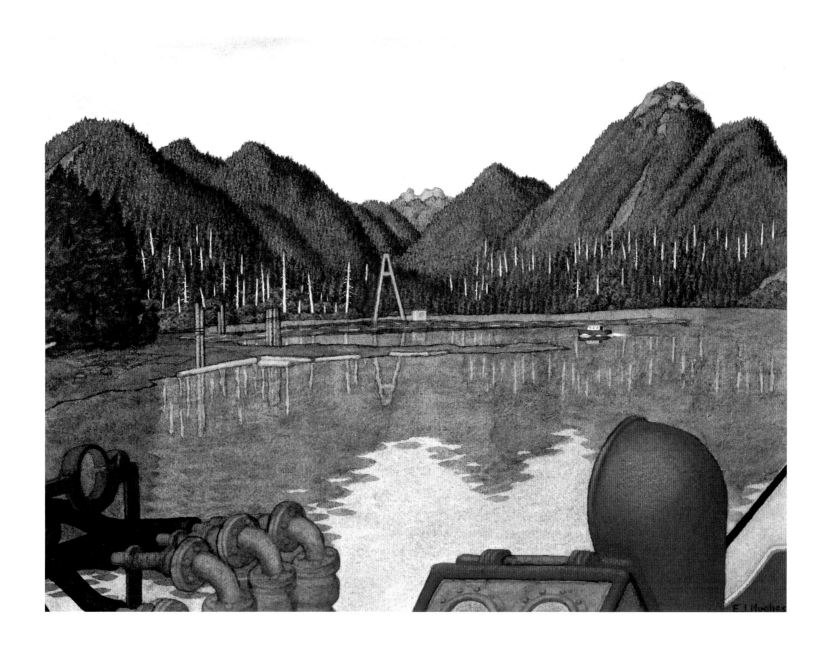

Beattie's Anchorage, Cumshewa Inlet (2000).
Watercolour, 18" × 24" (45.7 × 61.0 cm).

Travel Grants and Doreen Norton (1956)

Max Stern was a constant traveller to Europe, and from the beginning, he encouraged Hughes to travel as well. On September 10, 1952, Stern sent the artist an application from the National Research Council of Canada regarding a grant to travel to Europe, but Hughes was less than enthusiastic: "If by any chance such a fellowship were awarded, I'm afraid from the point of view of my sending regular paintings to you our schedule would be almost at a standstill for a year, as I imagine my studies would consist almost exclusively of taking down written notes and pencil or pen analysis sketches of the old masters." He didn't really want to leave Shawnigan Lake.

On February 7, 1954, Stern wrote to Hughes that, if he applied, there was a good chance that he would receive a National Research Council fellowship to visit Europe. The grant didn't come through, but Stern remained hopeful about a travel grant in the future. "Let us hope that you get the fellowship next year for Europe," Stern wrote on October 14, 1955. "If you should not get it, we should do something for you so that you can travel and see more of the Eastern Canadian countryside." Hughes was noncommittal, replying on October 19, 1955, that "It would be very nice if Mrs. Hughes could go along with me in the event that I was awarded a fellowship."

Without a grant in place, in February of 1956, Stern offered Hughes a loan of four thousand dollars to make a trip to Europe, in part so the artist could meet Stern's wealthy continental clientele. But Hughes had other things on his mind. "We have been installing oil-heating in

the studio and an oil burner in the kitchen stove, which already are saving me some time on my painting," he wrote on March 3, 1956. He felt an obligation to do what Stern suggested, but unlike Stern, Hughes was living in a dilapidated home with no phone and no car and was just emerging from the age of wood heat. As far as contact with the outside world went, once a week, he and Fern walked a couple of kilometres to pick up their mail and groceries in Shawnigan Village.

On May 25, 1956, Hughes wrote to Stern that the fellowship from the National Research Council "has fallen through again this year. No award. It has reached the stage where the disadvantages (for me) of travelling have outweighed the advantages it may have for Art or sales."

And then, in the same letter, Hughes made a surprising announcement: "I may be going next week if I can finish my present painting by then, on a three weeks sketching trip to the interior of BC, around Kamloops, kindly financed by Mrs. Norton of West Vancouver." Compared to the prospect of a long journey to Europe, this trip to the Interior must have seemed relatively easy.

"It should result in some sketches which may make some variety in the landscape of my paintings," the artist explained. He was nearing the end of the sketching material from his 1948 Emily Carr Scholarship trip, which he had gathered on Vancouver Island. He thought his work would benefit from a change of scene.

After Mrs. Norton had purchased a Hughes painting from the Dominion Gallery, she had taken an interest in the artist and offered to pay

for a trip so that he could discover the Interior of the province, particularly the South Thompson River area that she knew and loved.

In the catalogue for the exhibition, entitled *The Vast and Beautiful Interior*, held at the Kamloops Art Gallery in 1994, Pat Salmon explained in more detail how this trip to the Interior came about: "In May of 1955, Hughes and his wife, Fern, were surprised by the arrival at their Shawnigan Lake home of an art collector from West Vancouver, Mrs. Doreen M. Norton [wife of Robert J. Norton] . . . Mrs. Norton and her son drove Hughes and Fern to some of the artist's Vancouver Island sketching spots. Hughes appreciated this very much because he did not own a car."

Mrs. Norton told Hughes about her fondness for the Interior and recommended some locations he might enjoy. Hughes agreed to go in the following year. Salmon wrote that, for his trip to the Interior, "Mrs. Norton had offered Hughes the use of her station wagon which she offered to leave at the Vancouver Airport but he couldn't drive. (In fact, he did not learn to drive until two years later, when he was forty-five)." Hughes had only one regret about the trip sponsored by Mrs. Norton—that he would have to leave Fern at their Shawnigan Lake home. The $200 provided by Mrs. Norton, though a generous sum, was not enough for two.

Salmon continued: "Hughes got off the train at Ashcroft, noted the scenery and got a bus to Vernon, looking for sketching spots on the way. He made some sketches at Vernon and nearby Kalamalka Lake. He was intrigued and very pleased to learn that 'Kalamalka' means 'many colours.' Hughes experienced cool, unseasonable weather on the trip . . . After that he went by bus to Chase on the South Thompson River just where it drains out of Little Shuswap Lake. Hughes produced only thirteen pencil drawings from this two and a half week trip, just one third of what he had anticipated."[31]

Hughes wrote to Stern from his hotel room in Chase on June 21, 1956: "I may have to cut this trip short as meals and lodging have come to much more than I planned. One problem I ran into this week, the first week up here in the Interior, was that it rained intermittently during the whole week—money was going out, pretty fast, and no sketches coming in. All I succeeded in procuring were 4 sketches when I should have had at least 12 or 14. The weather at last has cleared and I have done a couple more which may result eventually in paintings you may like, as they contain that 'distance' which you have requested in the past. I had at home just about run out of sketches with distance in them."

Hughes stayed for a few days at Chase, and after visiting other locations, he walked eight kilometres out of town along the north side of the river. That hike resulted in his painting *South Thompson Valley near Chase, BC*, one of his finest compositions. On another day, he headed out along the south side of the river and made the study for that piece.

He then spent a few days in the Kamloops region and prepared two drawings for paintings of that city, one looking east and one northwest. But, by then, he had quite run out of money. As Pat Salmon reported, "though he had a train ticket to Vancouver and a boat ticket to Victoria and a bus ticket to Shawnigan, he had no money for food. When he reached Vancouver, he went directly to his sister Irma's Point Grey house to stay for the night."[32]

Hughes had been away for two and a half weeks, returning home by July 4, 1956. At that time, he told Stern that he was "disappointed about the sketching trip just completed. It was unusually cold for June and raining a great deal of the time, shrouding the scenery in haze. Only 1/3 of the sketches I hoped to obtain, resulted." But on the same day, he reported in a different tone to Doreen Norton: "The scenery was wonderful and I hope to return there some day to sketch.

A Farm Scene North of Chilliwack (1958). Ink. Courtesy of Shawnigan Lake Museum.

Especially around Pritchard, over which area you seemed very enthusiastic, I only produced two not-too-good sketches . . . Was intending to spend more time around Kamloops and Ashcroft, but funds ran out after two days in Kamloops and all I got there was one tiny sketch, as rain and wind prevented more . . . Would like to say once again that I can understand your enthusiasm in the country up there. The views were really magnificent." After this introduction, Hughes returned to the Interior many times in the next eleven years.

What follows is a record of the Interior of British Columbia as seen by the artist in the course of four separate trips he took between 1956 and 1967. At first, he went by rail and bus, and walked a lot. On subsequent trips Hughes drove in his own car and had the company of his wife, Fern, when he went in search of motifs to paint. Hughes was not an intrepid wilderness hiker, and his travels were not like the canoe trips of Tom Thomson, the "boxcar trips" of the Group of Seven, or Lawren Harris' days in the Canadian Rockies. The places Hughes chose to draw from are all on public property and are easily accessible by road. Nevertheless, the selection of these sites gives proof that Hughes had an infallible eye for what makes an interesting landscape.

Chilliwack and the First Canada Council Fellowship (1958)

On February 4, 1957, Hughes wrote to Stern: "I have some amazingly good news to report. I received a telegram from Ottawa yesterday stating that the Canada Council has awarded me a $4000 senior fellowship." In June of 1958, he and Fern used the money to travel by bus to the farmland of the Fraser Valley in search of subjects for painting. Chilliwack is located 102 kilometres east of Vancouver and south of the Fraser River. At the time Hughes and Fern stayed there, Chilliwack was still an agricultural community.

Arriving by bus, they stayed in a motel in downtown Chilliwack from which Fern could walk to restaurants and shops. In a letter on November 25, 1958, Hughes wrote to his sister Zoë: "Yes, Fern liked the trips. They were a change for us both and as we didn't have to skimp this time on meals and lodgings it was much more enjoyable for both of us."

The artist found plenty of subject matter within hiking distance of town in both directions. The idea of walking to scenic locations and drawing what he found there was not new to Hughes. He had a long art training behind him, having learned to make on-the-spot studies both at the Vancouver School of Decorative and Applied Arts and during six long years as a war artist.

Max Stern, as a dealer, was familiar with the Group of Seven. He encouraged Hughes to make some plein-air oil studies like they did, while he was in the field drawing. Stern knew that those would sell, but when he was before his subject, Hughes had a different method. Hughes took along his oil sketch box on his first trip to Chilliwack, but was unable to use the oil panels. It took all his time to make his detailed pencil drawings with written-in colours, which he used to produce his paintings at a later date.

In his letter of April 14, 1958, Hughes explained to Stern that he intended "to concentrate especially on a study of clouds in relation to land and water masses this summer, from Nature." In search of fine clouds, he mentioned that he was about to leave for two weeks of sketching near Chilliwack on May 1. For the first time, Hughes had received a grant from the Canada Council. "My wife will be going for company and as it will be a change for her," he noted. "Two thirds of her fare is supplied by the fellowship."

The painting titled *The Highway East of Chilliwack* (1961) shows exactly what attracted Hughes to this part of the Fraser Valley. The snowy peaks of Mount Cheam make a backdrop for farms along a curving roadway. Hughes explained to Stern that the subject was about two or three miles east of Chilliwack, looking east. He had set up to draw on the old Yale Road, the original wagon road leading to the town of Hope. "It eventually curves to the left and goes around the base of the big mountain on the left, and heads for Hope and the East," Hughes wrote to Stern on December 30, 1961. "I did the sketch for this one from a hill, one of the few in the midst of this flat Fraser Valley farming area, and I was sitting among some Pioneer tombstones, which were partly neglected and overgrown but, I felt, steeped in History."

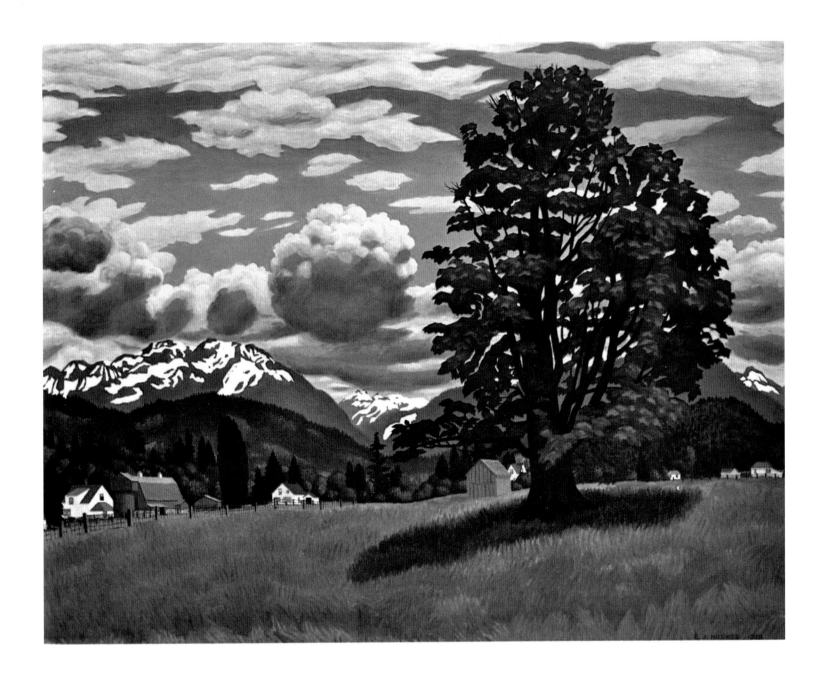

Farm Near Chilliwack (1959). Oil, 25" × 32" (63.5 × 81.0 cm).

In the picture, a comfortable old house stands amid mature trees, and all is quiet. A scattering of telephone poles, a pile of firewood, and a couple of mailboxes punctuate this very peaceful summer afternoon. The Cheam Range, which is the northern edge of the Cascade Mountains, is wreathed with a few low clouds. A close bough of fir needles adds a fresh filigree to the upper right corner.

In the early days of their business relationship, Stern and Hughes were quite candid about artistic issues in a way that conveyed the respect they had for one another. When Stern received one of the first Chilliwack paintings, he offered some advice to the artist in his letter of April 26, 1960: "We always like of course, much better paintings with water, but I leave as always the execution and the choice of subject matter to you."

Hughes wanted to follow Stern's advice, and he understood that his dealer shared important communications with his audience. He took this information to heart and replied on May 9, 1960, "Most of my future paintings will have water in them, but the occasional one will not. However," he continued, "the ones without water should not number more than one or two a year."

South of Chilliwack (1973) is one of those few paintings without water. Yet it is a striking picture, beautiful in composition and colouring. The cobalt blue of the mountains sets off the clear red, white, and black of the barn. The soaring peaks, the flowers by the roadside, and everything between are depicted with great care. Hughes painted the maple tree on the right with his unwavering patience, though it had been brutally pruned and accommodated two telephone wires with ceramic insulators.

Hughes usually chose a subject that was within sight of water. A walk north of Chilliwack along Young Road led him to the slow-moving Hope River, a waterway eight or nine kilometres long that runs into the Fraser River. Of the Hope River he made a sort of impressionist dream, a leisurely stream overhung with trees and, in this case, majestic mountains. A couple of the artist's trademark red roofs contrast with the blue of Mount Cheam in the southern distance. Soft reflections of the woodlands close by lend to this painting a powerful tranquility.

The most powerful of the Chilliwack subjects is *Mt. Cheam and the Fraser River* (1959). In the summer of 1958, Hughes took the bus from Chilliwack up the Fraser Valley toward Hope. He mentioned to the driver that he was an artist looking for a subject to paint. The driver understood just what he wanted and stopped the bus so Hughes could get out near the pyramidal Mount Cheam, which rises 6, 903 feet (2,104 m) in height.[33]

"The subject is a view looking south toward the base of Mount Cheam," Hughes told Stern on January 13, 1959. "This is where the Fraser River leaves the mountain canyons and is now entering the flat farming area of the lower Fraser Valley. The shoreline in middle distance is an island so the river at this point is actually wider than it appears in the painting."

Much later in the day, when he had finished his drawing, Hughes waited by the side of the road. Before long the bus came back, with the same driver. Hughes got on and rode back to Chilliwack. This was the last trip he made without a car.

After two weeks in Chilliwack, Fern and Hughes went to Penticton, where they stayed another two weeks. Then they returned to Shawnigan Lake, for Hughes had to get to work on a commission he had accepted. He was going to paint a mural for the Royal York Hotel in Toronto.

In the beginning of their work together, Stern suggested projects to Hughes to help him earn some extra money. Through Stern's agency, in the summer of 1958, the Royal York Hotel in Toronto commissioned Hughes to paint a mural for its British Columbia Room. He soon sent off

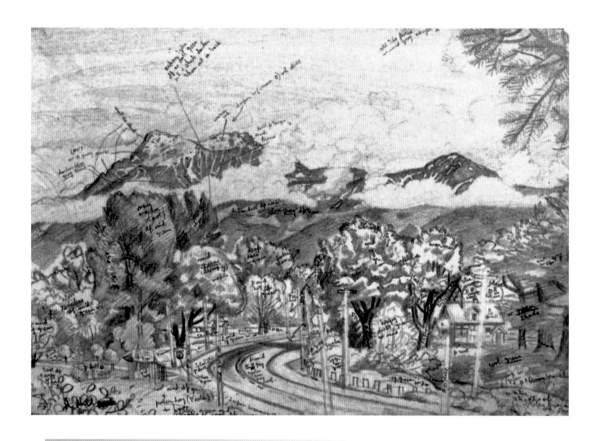

" The pencil sketch for this painting was produced on location during the summer of 1958. With thanks to a Canada Council Fellowship, I was able to spend the summer outdoors sketching. My wife and I spent two weeks at Chilliwack, in the Fraser Valley, B.C. and I produced this sketch. This was one year before I learned to drive so walking was required to the various motifs. "

The Highway East of Chilliwack (1958). Graphite.

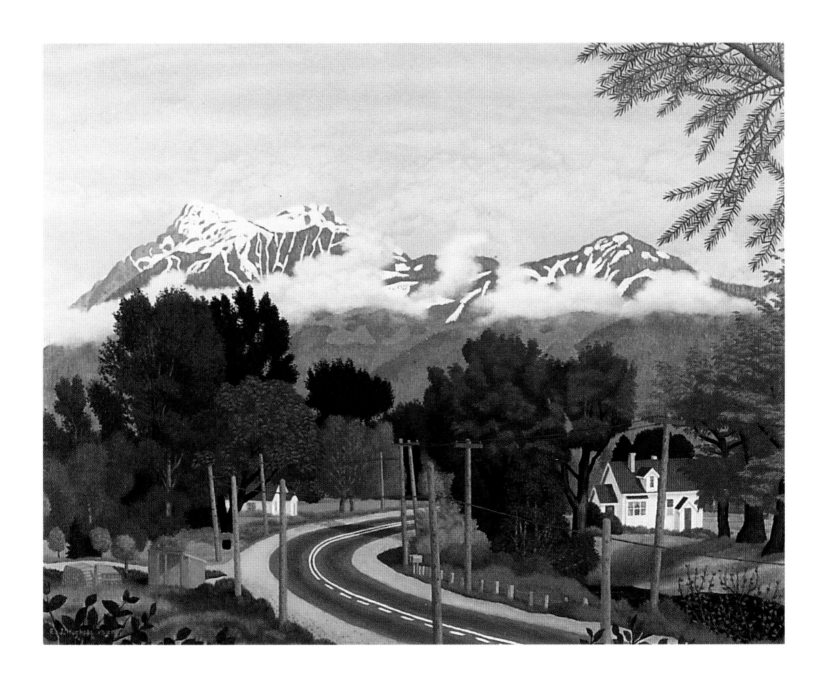

The Highway East of Chilliwack (1961).
Oil, 12" × 16" (30.5 × 40.5 cm).

four small proposed images for the mural. Mount Cheam and the Fraser River was not the image chosen by the hotel, but Hughes soon painted it in oil paint on canvas in his studio at Shawnigan Lake. With the money he earned, it became possible for him to buy a car. "During the month," he wrote in a letter to Stern on August 4, 1959, "I learned to drive a second-hand car ('52 Pontiac), which we have purchased." This was a turquoise and white 1952 Pontiac Strato Chief sedan, with an eight-cylinder engine and an automatic transmission. He was forty-five years old.

"I believe it will save us time going to and from the village, etc. I find it very enjoyable also, driving," he concluded, "and hope probably next summer or the summer after to drive to the Rockies and BC Interior, and on the new road to Long Beach on the West Coast of Vancouver Island." The great period of the building of modern highways throughout British Columbia coincided with this artist's discovery of the province.

"South of Chilliwack". E. J. Hughes, 1973.
 In the summer of 1968, I sketched in pencil, for two weeks, in the area surrounding the city of Chilliwack, in the Fraser Valley, especially looking for interesting farms, with the beautiful snow capped mountains of the Coast Range, in the background. The farm pictured here is about 3 miles south of the city. The old Maple on the right was probably cut down a few years earlier, and new shoots are appearing.

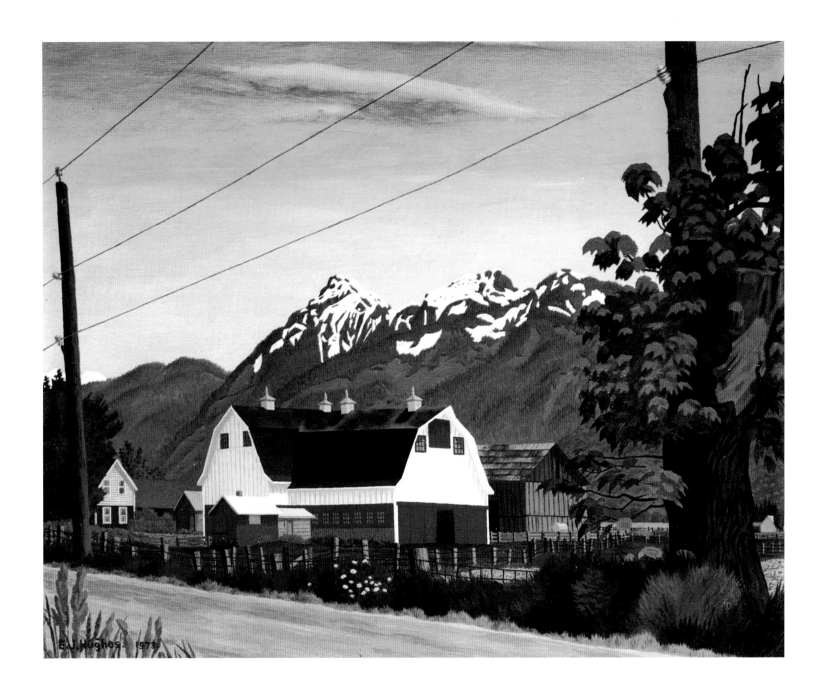

South of Chilliwack (1973). Oil, 32" × 40" (81.3 × 101.6 cm).

Hope River at Chilliwack, site photograph 2017.
Photo by Robert Amos.

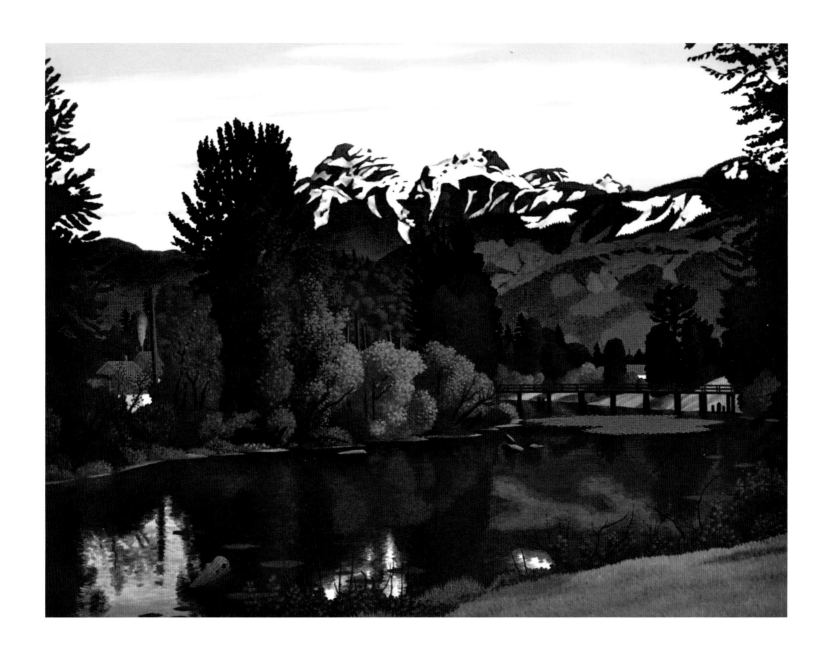

Hope River at Chilliwack (1961). Oil, 25" × 32" (63.5 × 81.3 cm).

LAYOUTS FOR B.C. ROOM MURAL.

STEEL BLUE + PALE WARM GREY

BLUE GREY

COOL + WARM GREENS

WARM GREENS

RIVER GREEN-BROWN + PALE BLUE

"MT. CHEAM" AND THE FRASER RIVER. (NEAR CHILLIWACK, B.C.)

Above: *Mt. Cheam and the Fraser River* mural study (1958).
Pencil. Photo by Pat Salmon.

Facing page: *Mt. Cheam and the Fraser River* (1959).
Oil, 25" × 32" (63.5 × 81.3 cm).

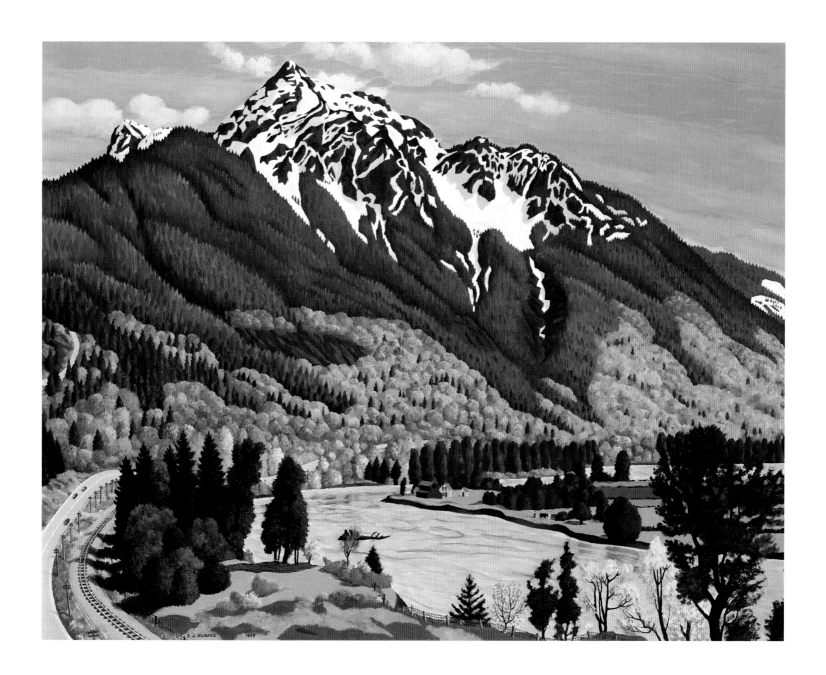

The Artist's Reputation

Under Max Stern's astute management, Hughes's artistic efforts were showing every sign of success. His paintings were in all the best collections. They were chosen for prestigious exhibitions, and sometimes received critical acclaim. There was a demand for his work at ever-increasing prices. Even so, Hughes remained anxious about his position as an artist. On January 10, 1964, he wrote to Stern: "I notice from the catalogue of the latest Biennial Exhibition of Canadian Paintings that none of my work has been accepted. I don't know if the reason is 'different judges' or 'inferior work on my part,' as my work was accepted for the preceding Biennial."

During his life, Hughes had very little contact with the art world. Except for Stern, he rarely spoke with anyone who was part of it: neither the collectors, the curators, nor the critics. This was a time when large abstract paintings were the order of the day, and despite his success, Hughes wondered how he fitted in. "I was classified by one critic as a magic realist," Hughes remarked in a rare 1967 interview. "In one way I still represent a primitive—I still get every shape finished sharply," he noted. "I began to get more atmosphere in my work and a little less design."[34]

Hughes went on to define his intentions: "I am deliberately painting what is picturesque. Many painters try to avoid the beauty of nature. They are so afraid their paintings will be called pretty and picturesque."[35] Despite the picturesque subject matter that he habitually chose, his paintings rose above that category. Hughes was able to bring to many of his paintings what Ian Thom has called, "a tremendous intensity."[36]

At about this time, the corporate collection of the Canadian chemical giant CIL was having a national tour and was shown at the Art Gallery of Greater Victoria. Ina D. D. Uhthoff wrote about it in the *Daily Colonist* on January 9, 1964. Of the forty paintings in the show, Uhthoff selected the canvas by Jean-Paul Riopelle for notice as "richly clotted paint and enormous vitality," and she found the work by Alex Colville to be "somewhat disappointing." In conclusion she noted that "the only Western Canadian painter is Ed J. Hughes, who lives at Shawnigan Lake and shows added richness in his handling of paint in a farm scene near Chilliwack. There is some lovely painting in the mountains and trees in this. The stark white of the buildings and snow belongs to the Hughes style, which is meticulous in its attention to detail, and arresting in its emphasis."[37]

In his usual incognito way, Hughes attended the show, and wrote to Stern on January 10, 1964, saying he was pleased that his painting "seemed to hold up well in company of some of the work of the leading Canadian non-objective, abstract and realist painters."

Hughes wrote about his feelings more fully in a letter to his sister Zoë Foster on October 24, 1960: "I am still plugging along in my old realistic manner, out of style with the times. I don't like being out of style as I am more of a conservative than a rebel, but I like Nature in its many forms so much that I feel it is a shame to leave it all to the camera and commercial illustrators.

Facing page:
Hughes in his studio painting the SS *Umatilla*, 1958.

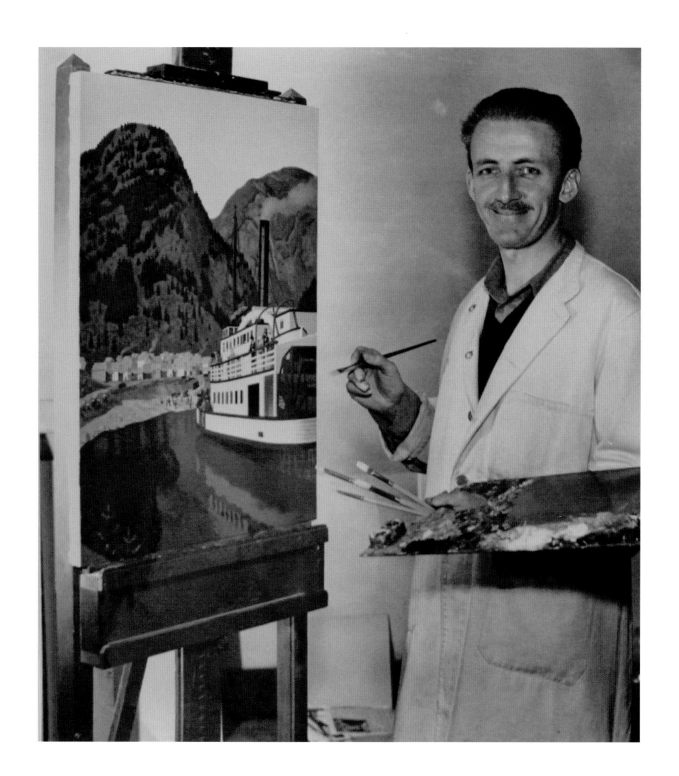

An antique postcard of Yale, BC.

Yale (1958)

In September 1957 Hughes was surprised to receive a visit from an advertising agent working for the BC Telephone Company. The agent came to Shawnigan Lake to ask if Hughes would paint a picture for the cover of all the telephone directories for the province, to be published for 1958. For the first time, the telephone book would have a colour picture on the cover, and this would be part of the company's celebration of the centennial of British Columbia becoming a colony.

For this purpose, the telephone company selected an historical subject. Yale was effectively the head of navigation on Fraser River, before the impassable turbulence of the river in the Fraser Canyon. That settlement was the starting point of Cariboo Wagon Road, which ran north to the newly discovered gold fields. Hughes was asked to envision the arrival of the first sternwheeler at Yale, BC, on July 21, 1858. This was the ss *Umatilla*.

Earlier, Hughes and his associates, Paul Goranson and Orville Fisher, had painted historical reconstructions for their murals in the Malaspina Hotel in Nanaimo in 1938, and then for the British Columbia Pavilion at the San Francisco Golden Gate International Exposition in 1939. As Hughes wrote to Stern on September 27, 1957: "This gold rush scene was to be done from photos and costume notes which is a little out of my line these days, but I'll do the best I can. I realize that now I am a straight nature painter by temperament so have to strain a point to do a type of subject which isn't quite what I'm used to."

In fact, the subject appealed to Hughes, as it included scenery he had recently passed through, and centred on an old-fashioned steamboat. But Hughes was not altogether comfortable doing commissioned work. The thought of going to Vancouver to see the staff at the telephone company upset him, and he felt under pressure to resolve the complex issues of the sale of the painting, as well as the commission fees, reproductions rights, and so on.

Max Stern wrote immediately on October 1, 1957, to reassure the artist: "in general we try to take all such written work from your shoulders. If you do not wish to do this order, I do not insist on it at all, and leave it entirely to you. Let me repeat," he underlined, "we are very pleased with what you are doing, and are not interested in these orders as they are normally more work than they are worth, but have accepted them in the past in order to increase your income." Stern also realized that this telephone book commission would put his artist squarely in the public's eye.

To help with the project, the telephone company provided copies of historic photos of Yale. Combined with memories of his recent trip through the Fraser Canyon, these enabled Hughes to deliver the painting on time.

Their deadline was just five weeks away. "Mr. Leonard [of the BC Telephone Company] offered to pay my expenses for a trip up to Yale to sketch the actual scene," Hughes informed Stern on September 27, 1957, "but as much as I'd like to do this, it is almost out of the question, as it would mean a loss of time on the actual painting and also am afraid, with the fall rainy season just commencing, that the characteristic mountains

at Yale will be lost in mist." Hughes did not go to Vancouver or to Yale, but he completed the painting on time in his Shawnigan Lake studio.

When it was ready, the attractive directory cover was in all the papers. On January 22, 1958, the *Victoria Daily Times* published a photo of Hughes with his palette and brushes in front of the painting of the ss *Umatilla*. In the accompanying article, Gordon Farrell of the BC Telephone Company noted they were distributing "a total circulation of 676,000 throughout the province, in addition to many copies that will find their way to various other parts of Canada and the United States."[38] This project would place a Hughes picture prominently in every household in the province.

Wilf Bennett, a columnist in the *Vancouver Province*, wrote on February 25, 1958 that "orchids are due to the British Columbia Telephone Company for its fine, bright Centennial cover on its new 1958 directory . . . I don't know if any other phone company has ever dressed up its drab directory with a coloured cover—I've never personally seen or heard of one—but it definitely adds colour to the homes. (Even to the homes in which this is the only book!)."[39]

Three years later, the BC Telephone Company commissioned another cover from Hughes. The 1961 edition of the phone book showed his painting *The Cowichan River in July* (1959).

Yale, BC in 1858 (1957). Oil, 30" × 25" (76.2 × 63.5 cm). Reproduced as the cover of a telephone directory.

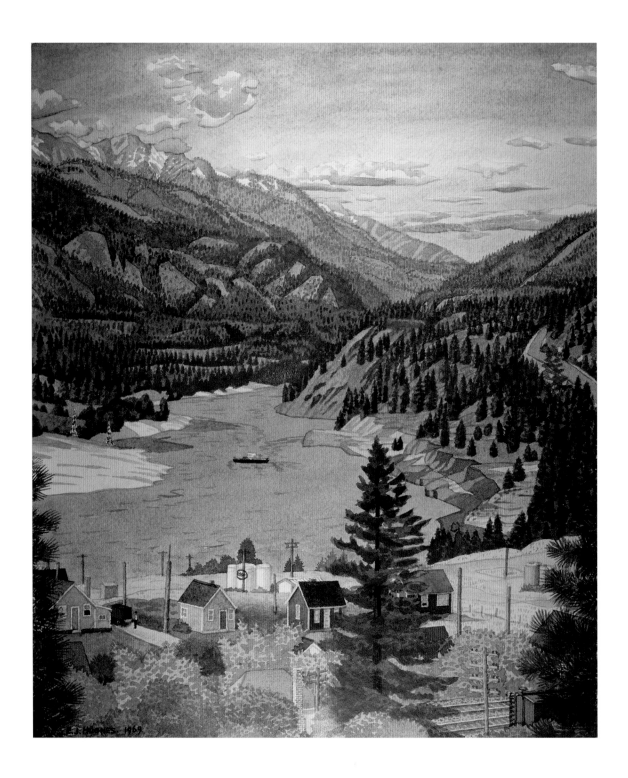

The Fraser River at Lytton (1959).
Oil, 24" × 20" (61 × 50.8 cm).

The Fraser and Thompson Rivers (1956, 1963)

The North Thompson River flows from the Cariboo Mountains. The South Thompson flows west from Shuswap Lake. The two converge at Kamloops. There, these two tributaries become the Thompson River, which flows into Kamloops Lake.

Draining westward from Kamloops Lake, the Thompson River meanders through wonderfully eroded "dry belt" hills, then continues through the town of Ashcroft, rolling westward and eventually joining the mighty Fraser River at the town of Lytton. In the Hughes painting *The Fraser River at Lytton* (1959) the river flows south, pouring through the Fraser Canyon. That tumultuous watercourse becomes navigable downstream at the settlement at Yale, and then at Hope the river emerges from its passage through the canyon and flows out over the alluvial farmlands around Hope and Chilliwack. From there it makes its way to its delta and out into Georgia Strait.

Hughes's first trip to the Interior in 1956—sponsored by Mrs. Norton—was somewhat disappointing. He travelled by train and by bus, leaving Fern at home. The weather was poor, and he ran out of money. But he was inspired by the landscapes that he discovered along the Fraser and the Thompson rivers. He wrote to Zoë on March 8, 1963, "I have some good news to report regarding my work. I applied again this year for a Canada Council Fellowship and was just advised last month that I have been awarded one!" This time he would venture forth in his own car and with his wife along for company

Hughes and Fern set up their base at Cache Creek, and he made day trips to different locations to work. First he went to Lytton. There the Fraser River is joined by its largest tributary, the Thompson River, and all road and rail routes pass through the town: the Trans-Canada Highway, the Canadian Pacific Railway, and the Canadian National Railway.

Junction of the Thompson and Nicola rivers, 2017. Photo by Robert Amos.

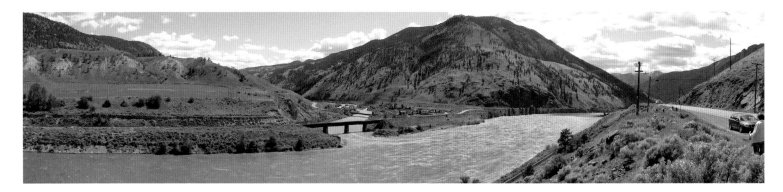

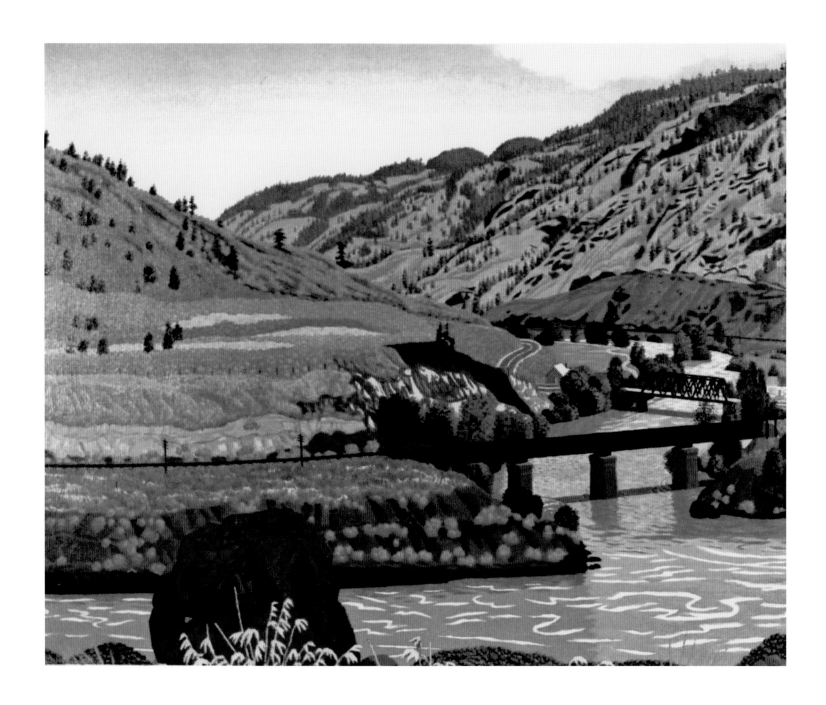

Junction of the Thompson and Nicola Rivers (1986).
Acrylic, 25" × 32" (63.5 × 81.3 cm).

On another day trip from Cache Creek, he travelled south on the Thompson River and discovered the junction of the Nicola River and the Thompson, a couple of kilometres north of Spences Bridge. In his painting, he depicted the sparse vegetation on the arid hillsides. At the centre of the picture is the bridge across the Nicola, which carries the Canadian Pacific Railway line. The bridge that appears just behind it carries Highway 8 from Lytton to Merritt.

Carefully and patiently, Hughes drew this expansive view from the front seat of his car. There is a great amount of detail to observe and include, and it seems reasonable that Hughes gave himself two days to make such a drawing. He reserved a third day to annotate it with the information he would use to select tones and colours.

Back in his studio, the drawings often sat on the shelf for years, awaiting their turn. Sometimes he asked Pat Salmon to help him choose what to paint next. She remembered that, when it came time to create this painting, he particularly enjoyed the changing colours where the emerald green of the Thompson across the foreground meets with the pea-soup-turning-beige colour of the Nicola River.

Beneath the bridges are strong shadows of cobalt blue, and this was the subject of discussion between the artist and Pat Salmon at the time he painted it. She reported this in the catalogue from

E. J. Hughes with his painting of the junction of the Thompson and Nicola rivers, 1986. Photo by Pat Salmon.

"Junction of the Thompson and Nicola Rivers" by E. J. Hughes. 1986.
During a Canada Council sponsored sketching trip to the B.C. Interior in 1963, my wife Fern and I stayed for a week at Cache Creek, a small town on the Trans Canada Highway west of Kamloops. From there I drove out daily to sketch, in pencil, the surrounding scenery. South of Cache Creek, where the highway runs alongside the Thompson River, I came upon this view, and sketched it from beside the highway, writing in the colours on the sketch. E.H.

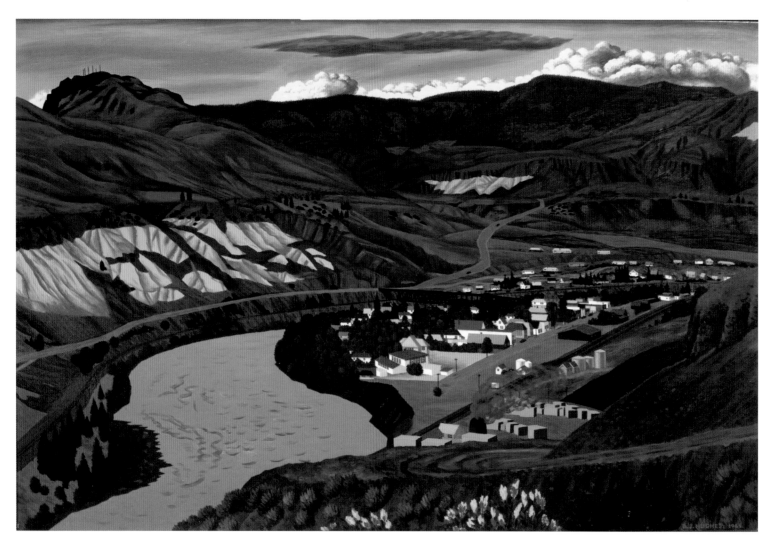

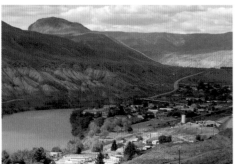

Above: *Ashcroft* (1965).
Oil, 32" × 48" (81.3 × 121.9 cm).

Left: Ashcroft, 2018. Photo by Robert Amos.

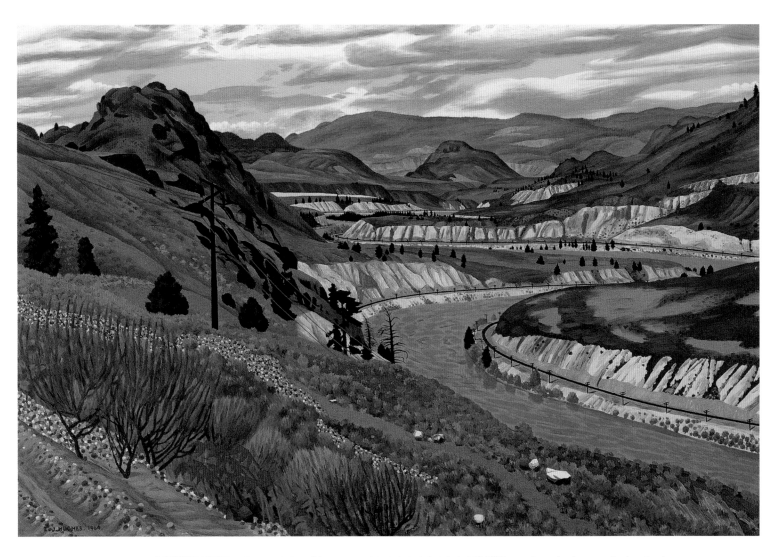

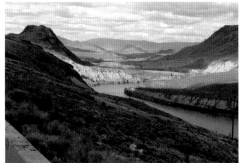

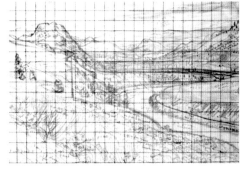

Above: *The Thompson Valley* (1964). Oil, 32" × 48" (81.2 × 121.9 cm).

Bottom left: The Thompson Valley, 2018. Photo by Robert Amos.

Bottom right: *The Thompson Valley* (1963), original drawing wrapped with thread.

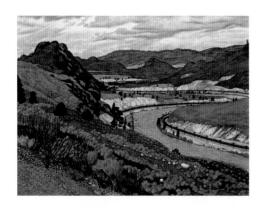

Top: *The Thompson Valley* (1994).
Watercolour, 18" × 24" (45.7 × 61 cm).

Bottom: *The Thompson Valley* (1994). Photo by Pat Salmon.

Sketches to Finished Works by E. J. Hughes: "The first things painted in this scene were the shadows cast by the bridges. It was hard to believe that blues looking that bright could ever be shadows. Yet slowly, as he painted the warm greens around them, they took their place appropriately. Hughes observes: 'I didn't think it would work either, but just thought I'd trust my colour notes. This shows the importance of painting colour as it is observed in nature . . . and not simply painting from memory or imagination.'"

She saw that he had painted the shadows of the bridge first, "and I said to myself that is far too bright a blue for the shadow. But I didn't feel I should say that to you." But Hughes knew exactly where he was going with the painting and he replied, "I thought it was far too bright also, but I relied on my colour notes, and they said 'blue,' and it did work out." In the end, the effect was perfect.[40]

Hughes had discovered the town of Ashcroft on his 1956 trip, and he returned to draw it in 1963. When he delivered the painting, on May 29, 1965, he described it to Max Stern: "It is of a dry Interior of BC landscape which, although so different from the coastal and Rocky Mountain scenery, has a great beauty of its own, which I hope I have in some small measure, captured in this painting."

As were Yale and Lytton, Ashcroft was part of the Cariboo Wagon Road, which carried men and materials to the Barkerville gold rush in the 1860s. Later on, railways were crucial to Ashcroft's development. In Hughes's painting, the Canadian National Railway runs along the far side of the Thompson River. The Canadian Pacific Railway is a prominent feature on the near side, passing behind smoke billowing up from the lumber mill. In the centre of the picture, a steel highway bridge carries Highway 97C from Cache Creek down from the hills and into the heart of the town.

Based on drawings he made during his travels, Hughes later painted a number of intricate townscapes, presenting littles town and their settings from high points of view. These include Kamloops, Chase, Revelstoke, Kaslo, and Banff. To find a good place to paint the town of Ashcroft, the artist made his way to the east and climbed up a rise of land, from which he could look back across the town and up the valley of the Thompson River.

Like many of Hughes's paintings, this one documents the industrial history of the province's recent past. At the lower edge of the picture he has painted newly sawn stacks of lumber with their butt ends painted red. Smoke is coming out of a "beehive burner" at the mill. The town and river are tucked into a bend in the river, beneath the distinctive bare hills and under a lowering sky.

Hughes's second trip to the Thompson Valley, in 1963, was sponsored by the Canada Council. By this time Hughes had his own automobile, so he and Fern were able to explore the valley east of Ashcroft more fully than he had in 1956. At two different locations, Hughes stopped to draw the eroded riverbanks that are such a prominent feature of the valley of the Thompson. The river follows a serpentine path and those riverbanks made a wonderful subject for an artist dedicated to landscape.

When he was ready to "work up" the drawing at home, he would set it on a piece of corrugated cardboard. He then wound black thread horizontally and vertically around it to create a grid, which was part of the process he used to copy the drawing onto a larger piece of paper. A photo shows the next stage, his underdrawing for the 1994 painting, with many of the tonal areas established. This underdrawing would be overpainted with glazes of colour to become a finished watercolour. Hughes used the same technique with oil paint on canvas on an even larger scale.

The Thompson Valley painting required a distinctive colour scheme, predominantly tawny hues of yellow ochre and burnt sienna. Though these are set off with turquoise water and the

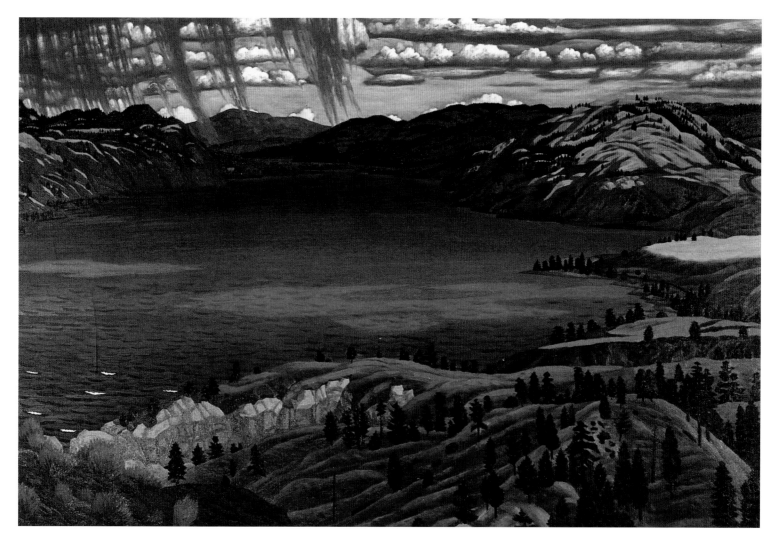

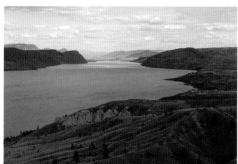

Above: *Kamloops Lake* (1968). Oil, 32" × 48" (81.3 × 121.9 cm).

Left: Kamloops Lake, 2017. Photo by Robert Amos.

cobalt blue hills in the distance, on receipt of the painting on January 30, 1964, Stern had something to say. "While I like the large painting The Thompson Valley very much," he began, "may I mention that the khaki colour you used in it is disliked by many people. In spite of it, we submitted it to the Spring Exhibition of the Montreal Museum of Fine Arts . . . I hope you do not mind my observations with reference to the colour."

Following the Thompson River east from Ashcroft, the highway ascends to Kamloops Lake, where a convenient lay-by at the west end of the lake provides a splendid view. The author's photograph shows that Hughes likely pulled into this same scenic viewpoint on his 1963 trip. The lake spread out below is 1.6 kilometres wide and 29 kilometres long.

As Hughes wrote on June 19, 1968, this was "a view of the more open BC Interior landscape for a change." Before him were the dry belt interior grasslands, composed of bunchgrass and sage grass. Hughes set ranks of clouds marching through an unusual ochre sky. The nearest and lowest clouds drag sheets of rain across the landscape, and the hills to the right are dappled with a play of sunlight. In the distance, the lake has a brooding darkness, which is relieved by squalls of gleaming green as it nears the foreground. Small whitecaps appear on the waves driven toward the shore by an oncoming breeze. This sun shower is a weather effect unique in all the pictures Hughes painted, and there is not a person in sight.

Following his training under Charles H. Scott at the Vancouver School of Decorative and Applied Arts, Hughes developed an approach to painting the landscape that might be called "observational realism." Rather than use photographs as his source, he patiently sat and observed the subject carefully. The drawings he then made were not "sketches" as we understand the term—they were not done for practice nor in a casual way. They were carefully crafted with the intention of becoming the sole reference

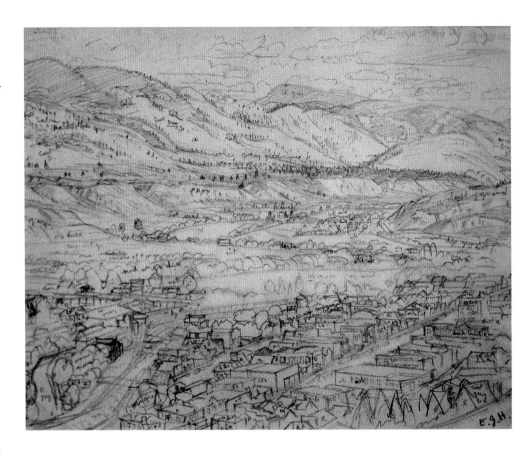

source for a large and highly finished oil painting. The studio paintings vary hardly at all from the on-site drawings.

Upstream from Kamloops Lake is the city of Kamloops, located at the confluence of the North Thompson and the South Thompson rivers. At the end of his first trip in 1956, with what remained of the $200 Mrs. Norton had given him, Hughes made a stop in Kamloops. The drawing for *Looking East Over Kamloops* (1994) shows a "toy town" townscape spread across the lower half of the page, the Thompson River running across the middle, and the eroded hills of the dry belt landscape rising above. On a recent visit to Kamloops, I could find no viewpoint high enough, or near enough to the buildings

Above: *Kamloops* sketch (1956). Pencil.

Below: *Kamloops* (1994).
Watercolour in process, 18" × 24" (45.7 × 61 cm).

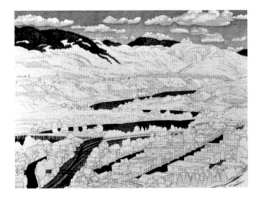

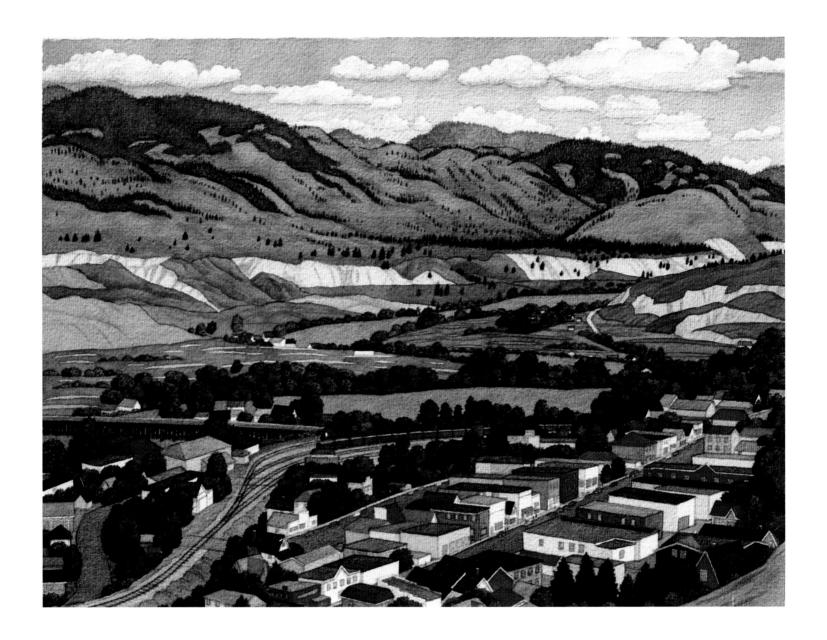

Kamloops (1994). Watercolour, 18" × 24" (45.7 × 61 cm).

Box 2, HUGHES
Shawnigan Lake, B.C.,
July 3, 1963.

Dear Dr. Stern :-

Receipt is acknowledged, with thanks, of your letter of June 14, enclosing cheque for $225., payment for the canvas "Above the Yacht Club, Penticton."

I am now home for two weeks in between the just finished three week Interior Dry Belt trip and the forthcoming Rocky Mt. trip. But first I must report some sad news; both the V.M.D, and Bank of Commerce commissions have fallen through; the first, because V.M.D was not awarded the ship-building ~~commission~~ contract, and the second because another local artist was awarded the calendar ~~commission~~. This is all unfortunate, as I was planning on at least one coming through, with of course the extra amount, from a commission. It will mean "skimping" on my last two trips

even with the generous allowance from Canada Council. However, I will not have to cut down on the amounts I have planned for the first two trips, so that is important as they are the longest and most distant trips.

Our first trip, to the Interior, was to Cache Creek for one week, Williams Lake for a week, and the last week at Kamloops (this last week is a change from my original plan of spending it at Hazelton in Northern B.C., as I decided it better to make it an all-Dry Belt trip and save Northern B.C. for some year in the future). From Cache Creek (a highway junction fast becoming a large town) I was able to drive out and obtain some spectacular scenes of the Thompson R. canyon, and the Fraser R. canyon near Lytton. From Williams Lake, I obtained some different Fraser canyon scenes, and some of beautiful Williams Lake, itself.

453

(3)

And from Kamloops I was able to
complete a series of sketches of the
South Thompson valley, commenced years
before, around Chase, B.C., you may remember, and also
some lake and ranch scenes. With our
own car I was able to drive 50 or 60
miles or more in all directions from these
three B.C. Interior centres, looking for motifs, and go back
later to sketch what I felt were the most
appealing subjects, and thanks to the
shelter of the car, even on rainy days,
or windy.

Most of the subjects I will be
doing in the Rockies are well known,
but I feel that, as beautiful as coloured
photos of these scenes are, that the
artist has much of significance to add.

Although it was mostly work,
the change and the going and coming
made it a partial holiday for both
Mrs. Hughes and myself. Mrs. Hughes
is now with her mother for these two weeks

(4)

in Kelowna, where I left her on my way
home here, and on July 11, when I start
out for the Rockies, I will pick her
up there en route. Besides being company,
Mrs. Hughes is a great help in making
lunches, etc., as I sometimes require two
lunches during a long day at a distant
motif. She is accompanying me on these
first two trips and probably partly on
the later Mainland Coast trip.

Enclosed are the two photos
which you so kindly lent me to
forward to the Bank of Commerce.

Best wishes to you and Mrs.
Stern for a pleasant summer.

Yours sincerely,
E. J. Hughes.

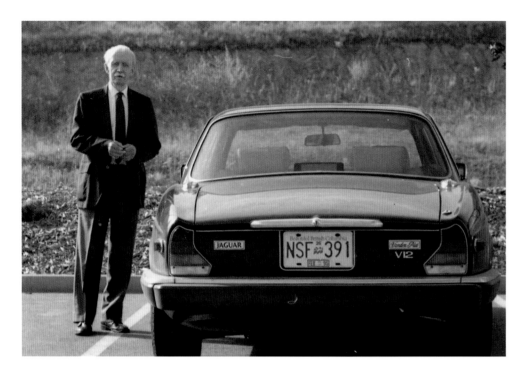

portrayed, to afford any view similar to Hughes's painting. In real life, from the nearest height of land, the river and the town seem much further away. When one matches what Hughes drew with what one sees on the spot, or what a camera sees, it becomes clear that the artist always brought to the subject his own unique emphasis.

In his interpretation of Kamloops, Hughes painted twenty-seven simple and individual buildings all along one side of the main street, and as many again on the other. He displayed infinite patience in rendering the mundane and the necessary. The sheer ordinariness of the structures that he depicted is relieved only by the rainbow of colours Hughes chose for their walls: yellow, ochre, red, green, grey, and white with black accents. The windows are, in every case, blank and free of reflected light. Along the river's edge, thirteen rusty red freight cars stand in a row.

In the early 1990s, Salmon suggested to Jann LM Bailey the idea of an exhibition of Hughes's paintings of the Interior of British Columbia. Bailey was a Hughes enthusiast, and she ably and eagerly curated the exhibition. Through 1994 and 1995 it was seen in six locations around the province and was accompanied by a catalogue with colour illustrations. Entitled *The Vast and Beautiful Interior*, the show included paintings and drawings derived from all the sketching trips Hughes had made to the interior of British Columbia.[41]

The exhibition was arranged with the help of the Dominion Gallery, and fifteen lenders are listed in the catalogue, including the Jacques and Margaret Barbeau Foundation, Stephen Jarislowsky, David Lemon, The London Club (London, Ontario), The University Club of

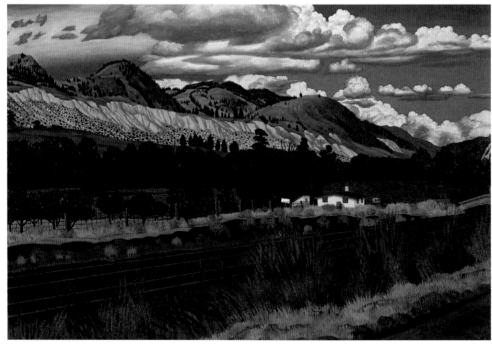

Top: E. J. Hughes on the road near Kamloops, 1994. Photo by Pat Salmon.

Bottom: *East of Kamloops* (1965). Oil, 32" × 45" (81.3 × 114.3 cm).

Montreal, The Vancouver Club, The British Columbia Archives, The Edmonton Art Gallery, and the National Gallery of Canada, among others.

In anticipation of the show, Hughes returned to some of the drawings he had made on his earlier trips and created new watercolour versions. The aerial townscape of Kamloops was created in 1994 for this show.

Hughes made a policy of not attending public events where his art was concerned. He was shy and anxious, and he didn't like public speaking, feeling he might say the wrong thing. But perhaps emboldened by the pleasant experience he had attending his very modest exhibition at the Auld Kirk Gallery in Shawnigan Lake earlier that year, Hughes asked Salmon to accompany him to the opening of the Kamloops show in September 1994.

They drove there together in his maroon Jaguar Vanden Plas. Concurrent with the Hughes exhibition, another show at the Kamloops Art Gallery featured the work of a painter who was also a teacher at the local high school. One child wrote in the guest book that he liked the teacher's work better than that of Hughes. But when Hughes learned of the comment he was upset. Salmon attributed the comment to the child's loyalty rather than to his artistic judgement, but, in his retired life, Hughes had rarely had to face any criticism.

In her introduction to the catalogue, Jann Bailey wrote: "E. J. Hughes, unlike most West Coast painters who have been drawn to the sublime landscapes of coastal rain forests, rugged coastlines and vast interiors, celebrates a very nostalgic, picturesque and somewhat sorrowful vision." She continued: "Possessing a detached sense of composition, his boldly coloured canvases, detailed drawings and delicate watercolours have a very personal unsettling sense of order: a sense of order that seems both natural and unnatural—methodical in execution,

didactic in feeling—an order which both celebrates and mourns a sense of place that is rapidly vanishing."[42]

Not everyone has found such sorrow and mourning in Hughes's paintings. Perhaps Bailey was reacting to her own sense of the disappearing features in her local landscape, changes to the views that Hughes had documented in his images gathered thirty years before. The exhibition travelled to six regional art galleries in British Columbia.

Hughes followed the valley of the South Thompson River toward the east, stopping beyond the edge of Kamloops at a convenient place by the side of the highway. The railway tracks are an important part of this Canadian story, and looking north over them, he painted the eroded dry belt landforms on the far side of the river. Above them the rolling green hills stand beneath an array of clouds. The river and its eroded banks seem to be the focus of this image, though Hughes has also painted a modest house by the water, with a shed out back. Four trucks and cars are randomly parked nearby. It's all as folksy and rural as one could want. Hughes, as ever, has painted the true appearance of British Columbia.

Between Kamloops and Chase, Hughes stopped at Pritchard, the location of a bridge across the South Thompson River. His drawing from 1963 represents the scene exactly as it appears today.

Hughes had stayed in Chase on his first trip in 1956, and he made a point of returning. Chase is a small town located at the west end of Little Shuswap Lake, fifty-seven kilometres from Kamloops, and during the summer season it comes alive as a beach resort. The beaches of Chase face up Little Shuswap Lake to the northeast. While on his first trip, in 1956, Hughes drew the lake and the town from a height of land to the west, but no painting of this detailed drawing is known.

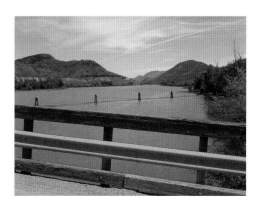

Top: The Bridge at Pritchard, 2018. Photo by Robert Amos.

Bottom: *The Bridge at Pritchard* (1956). Pencil.

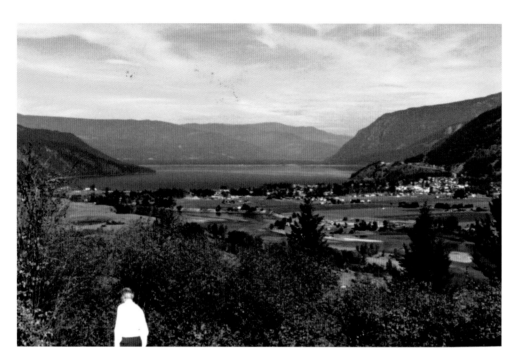

E. J. Hughes near Chase, BC, 1994. Photo by Pat Salmon.

South Thompson Valley Near Chase, BC is a British Columbia idyll. The South Thompson flows out of Little Shuswap Lake beneath a bridge in the town. To the left of the bridge is a white church with a spire, at the centre of the Squilax reserve community. Hughes walked out of town along the Kamloops-Shuswap Road past some mysterious circular ponds in farmers' fields, and then he turned to rise higher up on the hillside.

The foreground of the scene he painted is complex, with a rough assortment of stones, weeds, and wild roses. Log booms float on the river in the valley below. Tiny black cattle and little red barns dot the patchwork fields in the distance. It seems to be a perfect summer day, and all is right with this world.

In 1957, not long after his visit to Chase, Hughes painted this scene in watercolours during the winter. That winter was exceptionally long and cold at Shawnigan Lake, and Hughes spent most of his time in his studio, on the top floor of the house. He felt that the light there wasn't good enough for oil painting. Since for watercolours he could use a table rather than an easel, he could move to where the light was good. It was during that cold season that he sent the watercolour of *South Thompson Valley Near Chase* to Stern. When it arrived in Montreal, on February 15, 1957, Stern wrote: "I love your painting . . . I would be very happy if you could paint this for us in oil too. It is a lovely scene where you get a magnificent depth and lovely details."

Hughes was happy to comply. When, on April 12, 1957, his oil painting *South Thompson Valley Near Chase,* BC arrived at the Dominion Gallery, Stern again reported: "We are very, very pleased with it. I love the picture very much, it is one of your best."

And Stern wrote to Hughes again on the very next day, April 13, 1957. "I want to express to you how much we enjoy the way you lead us from the hilly foreground through different small ponds, the river, and lakes into the distance, as

To the west of Chase, the South Thompson Valley is a prosperous farmland, and it seemed to Hughes to be a location ripe with pictorial possibility. While there, the artist gave his full attention to two views along the river. On the label that he attached to the back of the painting *South Thompson Valley at Chase* (1982), the artist recalled that he "stayed for one week at a hotel in Chase on the South Thompson River, and walked up the hillsides for the views, sometimes five miles. This was before we had our first car. The far side of the valley [on the north] is ranch land, and the near side is irrigated farm land. The pale grey road in the centre is the Trans-Canada Highway."

First Hughes drew the view near Chase from the crest of a road winding up the north side of the river and titled that composition *South Thompson Valley Near Chase.* Then he drew the valley from the opposite side of the river, and he named that picture *South Thompson Valley at Chase.*

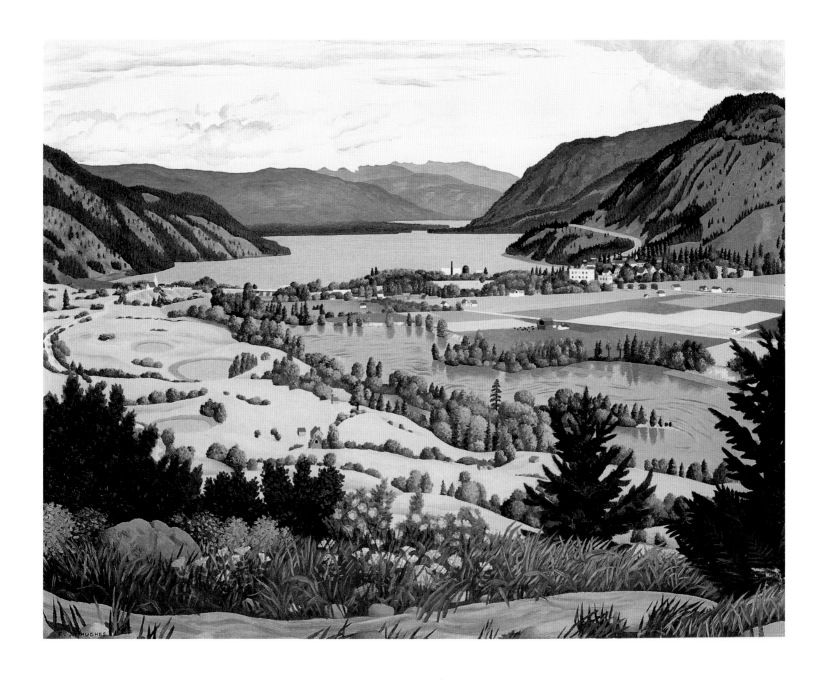

South Thompson Valley Near Chase, BC (1957).
Oil, 25" × 32" (63.5 × 81.0 cm). Vancouver Art Gallery.

well as guiding us from flower to flower, tree to tree and mountain to mountain into the depth. I love especially the wooded mountainside, also the meandering road leading us from the left foreground to the right in the distance. We wanted therefore, to raise the buying price of this painting another $10." In total, the Dominion Gallery paid the artist $130 for this fine painting.

In his book on Hughes in 2004, Vancouver Art Gallery curator Ian Thom reproduced the oil painting of *South Thompson Valley Near Chase, BC* (1957) and described it as "a magnificent panoramic view . . . proof that Hughes could produce masterful work when the subject matter was not the coast." Thom continued: "This painting, like all of his work, presents the world in an idealized manner. It is the world as it should be."[43]

On the same trip in 1956, Hughes walked westward out of Chase following Highway 1 along the south side of the river. Leaving the main road,

he found his way up the along the valley, where he could look over homes and farmland and draw the expansive view, taking in the river below and the bare hills in the north.

In her essay for the catalogue for *The Vast and Beautiful Interior*, Pat Salmon wrote of these two paintings, *near* Chase and *at* Chase: "These are companion pieces, in the sense that the viewer can travel, as it were, from the centre of one canvas straight into the centre of the other, each showing the other's sketching site and the route Hughes took out of town from vista to vista."[44]

Though he had drawn it in 1956, it was not until February 25, 1977, that Hughes painted *South Thompson Valley at Chase* in oil paint on canvas. When he sent it along to the Dominion Gallery, Stern paid him $2,950—a new record price—and wrote that "Mrs. Stern and I both like it immensely, and the rest of the staff joins us in our admiration of this painting."

"The South Thompson Valley at Chase, B.C. E. J. Hughes 1982
In 1956, a Vancouver lady, Mrs. Norton, sponsored my first sketching trip since 1948, to the area where she had formerly lived in, the Interior of British Columbia. During the trip I stayed for one week at a hotel in Chase, on the South Thompson River, and walked up the hillsides for the views, sometimes five miles. This was before we had our first car.
The far side of the valley is ranch land, and the near side is irrigated farm land. The pale grey road in the centre is the Trans-Canada Highway. E. J. H.

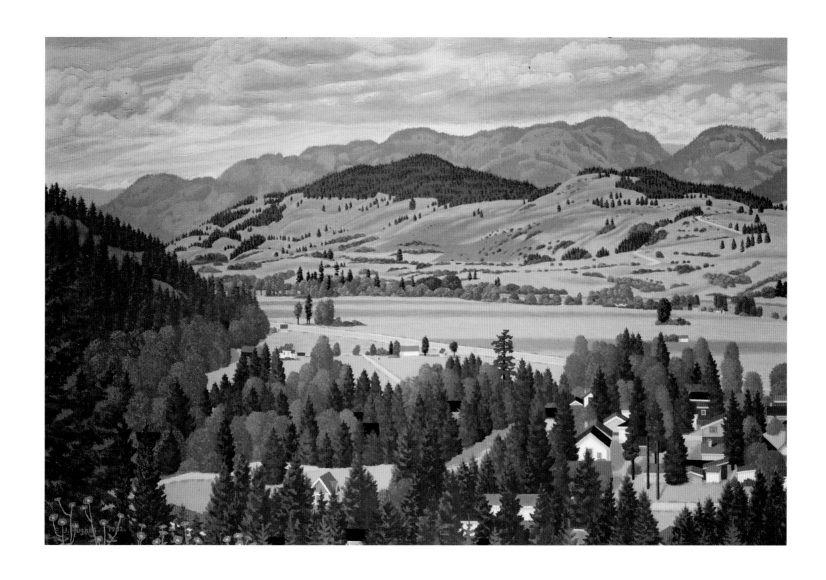

South Thompson Valley at Chase, BC (1982).
Oil, 32" × 36½" (81.3 × 92.7 cm). Vancouver Art Gallery.

Okanagan Lake (1958)

Robin Laurence, writing in the *Vancouver Sun*, offered a perceptive review of an exhibition of Hughes's paintings. "Characteristic of Hughes's paintings are a flattening, tipping or distorting of perspective and an obsessive attention to tiny details within the wider realm of his landscape views. These details, whether waves or pebbles or tufts of grass, are not handled naturalistically, but are reduced to stylized motifs and endlessly repeated, creating rhythmical patterns. Larger forms, such as boats or houses, are simplified, almost toy-like."[45]

Laurence continued: "Hughes's 'postcard' views have an extreme orderliness, a rearranging of nature to his own fastidious taste, as well as a fondness for the pastoral and for a bygone age. Our century's golden age. Looking at his drawings of the Okanagan valley, I felt a rush of nostalgia for my own childhood holidays there, and for the seeming simplicity of those times."

On his first trip to the Interior in 1956, under the sponsorship of Mrs. Doreen Norton, Hughes discovered the city of Penticton and the beauty of Okanagan Lake. Two years later, in June of 1958, he returned on a trip, paid for by his first grant from the Canada Council. This was a fellowship specifically offered to provide the artist with time to gather subject matter for future paintings. Hughes and Fern spent two weeks in Penticton, and to their good fortune, they were able to stay at a conveniently located motel. Just a block away was a park with a wide view over Okanagan Lake, and distant views of the dry landscape. Many potential subjects beckoned.

But first he gave his attention to a large old steamship.

Hughes knew that his most popular paintings were the ones with ships in them. In Penticton, he found a ship to paint. The landlocked ss *Sicamous* had been a popular attraction on the waterfront of Okanagan Lake at Penticton since 1951. Once a charming steamship, it can still claim to be the largest steel-hulled sternwheeler in Canada.

The two-hundred-foot (61 m) ship was launched in 1914, and for twenty-two years served remote communities along the shores of Okanagan Lake. The development of the rail and road transportation networks increasingly overtook the usefulness of the lake boats. The ostentatiously deluxe passenger service of the ss *Sicamous* made it especially vulnerable to the austerities of the Depression, and she was taken out of service in 1936.

The retired ship sat idle near Vernon until 1951. At that time, the Penticton Gyro Club bought the steamship from Canadian Pacific Railways for one dollar. Then, with a tugboat, they pushed it back to Penticton, where a band of supporters had dug a trench in the beach. The ship was eased into its new home on the beach, and it has been there ever since. It is now operating as a tourist attraction and a banquet facility.

Hughes sent his painting of the museum ship to the Dominion Gallery on December 14, 1959, with an apology: "Sorry I was so long on the lake-steamer painting," Hughes wrote. "The detail on the boat takes a lot of time and I couldn't even get this one done in my usual six weeks." Hughes

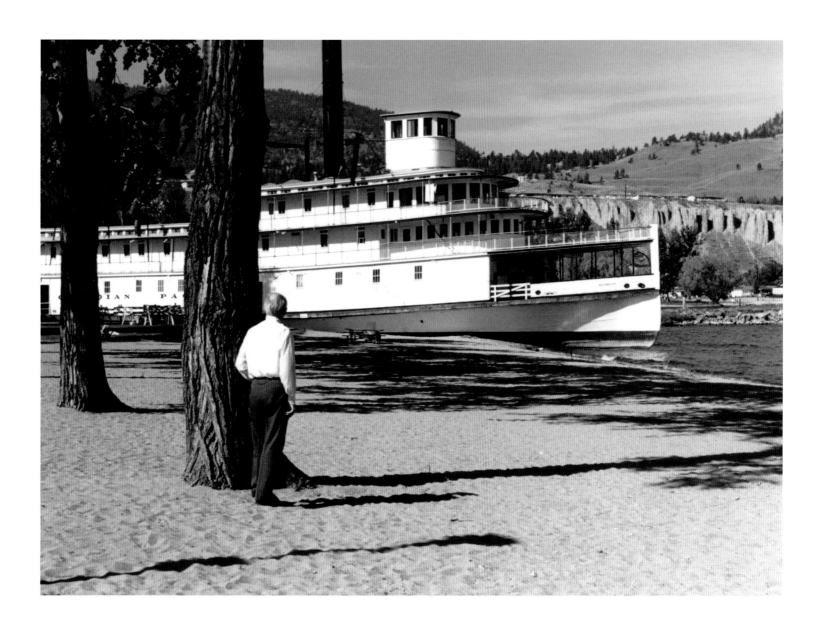

Museum Ship, Penticton, with E. J. Hughes, 1994.
Photo by Pat Salmon.

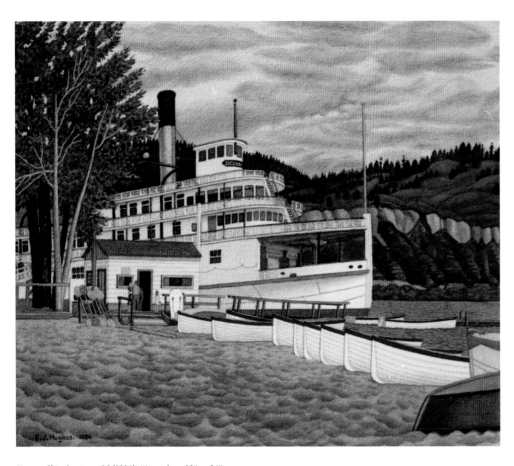

Museum Ship, Penticton, BC (1994). Watercolour, 18" × 24"
(45.7 × 61 cm). Photo by Pat Salmon.

was paid $215 for the canvas, which Stern then sold to the Alumni Association of the University of Western Ontario within the year for $1,100.

In the exhibition catalogue for *The Vast and Beautiful Interior*, Salmon said that *Museum Ship, Penticton BC* (1959) was done "at closer range than his usual vast Interior panoramas." She continued: "In this study, with surprising details of human activity, Hughes acknowledges the reality of the commercial tourist trade with characteristic honesty. From the line of rental row boats he leads the viewer indirectly to the old sternwheeler, S.S. Sicamous, by then a museum."

When Hughes was preparing for his Kamloops exhibition in 1994, he decided to take up the SS *Sicamous* as a subject again, this time painting it with his highly resolved watercolour technique. Pat Salmon photographed the artist holding the finished painting outside his home on Heather Street in Duncan, where he had moved in 1977.

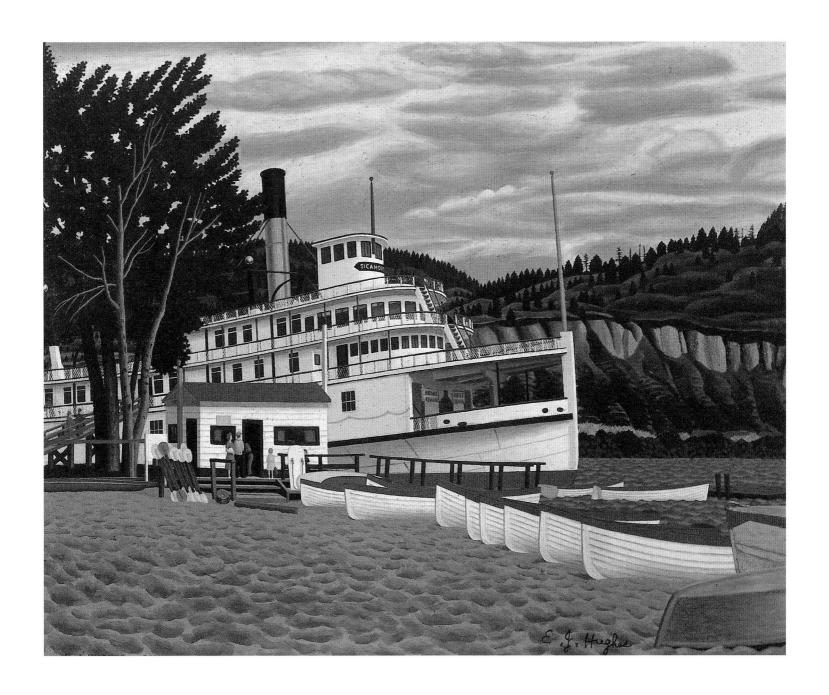

Museum Ship, Penticton (1959). Oil 25" × 30" (63.5 × 76.2 cm).
McIntosh Gallery, University of Western Ontario.

Graphite Cartoons

This book shows many of the drawings Hughes patiently made on location in the early days of his career. Hughes subsequently made fully detailed tonal studies for some of his paintings in the studio. He began this practice at the end of his war art service, while posted to Ottawa from March 1945 until October 1946. The field studies he had created during the war were brought back to the base to be developed as the full-scale paintings. Part of this process was a complete tonal rendering of the subject.

Pat Salmon explained that "these tonal studies were about sixteen by twenty inches, a size between the original sketch and the completed painting. They were executed on Hi-Art illustration board which is actually a thin sheet of cartridge paper mounted on cardboard for stability so it can stand up to a great deal of eraser work."[46]

Using a soft pencil, the artist shaded in every detail of the painting he was developing, blending, and removing the graphite with an eraser. Working without colour, he was able to fully develop the strong tonal effects, which lend form and weight to his compositions. It was time-consuming work, but the preparation gave him great confidence as he proceeded.

Hughes referred to such a drawing as a "cartoon," a term that properly describes an artist's drawing that is used as a guide for weaving a tapestry. In Hughes's case, no tapestry was anticipated. Many of his cartoons were made in the evening at Shawnigan Lake. Hughes would be drawing at the kitchen table while his wife, Fern, attended to their needs, and they both listened to the radio. Salmon reported that, "when he was forty-five years old he realized that this was becoming too much for his eyes, and so abandoned night work."[47]

In fact, by this stage it had become clear to Hughes that he knew how to proceed, and the laborious cartoon stage was no longer necessary. This drawing of the museum ship was the last of his cartoons.

For a while he painted highly resolved watercolours in his studio. In his December 30, 1960, letter, Hughes wrote that "I find the watercolours as a secondary stage are working out all right in place of the black and whites. I can see how both tones and colours, and composition as well, will look, in this way. However, composing cartoons in tone only is something I am glad to have spent so many years doing, and I think it would be advisable for many young student-painters to do so, at some stage of their career."

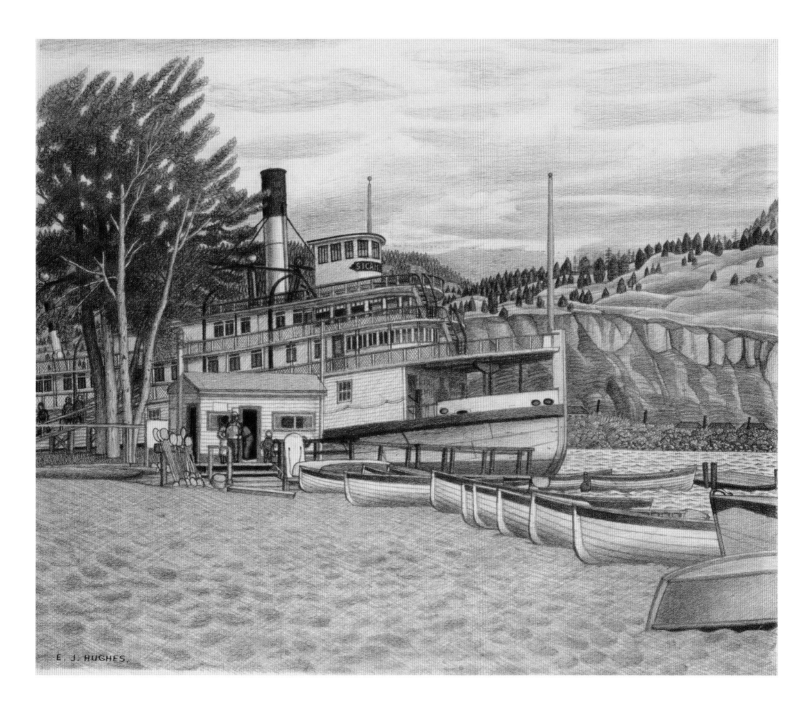

E. J. HUGHES.

Museum Ship, Penticton (1959).
Graphite cartoon, 18" × 21" (45.7 × 53.3 cm).

Painting with Watercolour

There were many reasons why Hughes, from time to time, painted with watercolour. In the winter of 1961, he decided that the light in his attic studio was too dim for concentrated oil painting, and so he painted watercolours at a table somewhere else in the house. At other times, he took up the medium as a change of pace from oil paint and would paint four watercolours in a row. Each of his watercolour paintings is painted on a full sheet of one hundred percent cotton paper, twenty-two by twenty-eight inches. These paintings are always highly finished.

Hughes painted with watercolours intermittently throughout his career. And then, beginning in 1993, he became unable to stand at his easel for the hours required to paint with oil or acrylic on canvas. From that time on he painted sitting down, working exclusively in watercolour.

Arriving in Penticton by bus in June of 1958, Hughes and Fern chose a motel on the east side of town. Almost on their doorstep, there was a park with extensive views looking north over Okanagan Lake. This park is located above Marina Way, to the north of Vancouver Road, and from the park Hughes was able to draw a number of compositions that resulted in excellent paintings.

Throughout his career, every time Hughes sent a painting to the Dominion Gallery, he also sent a letter. The gallery replied almost immediately with a cheque and a letter. Those letters back and forth make up our primary source of knowledge about Hughes's production, and this unique artist/dealer partnership. In the letter that accompanied *Okanagan Lake at Penticton* (1961), the artist described this painting succinctly. He wrote to Stern on November 9, 1961: "Blue is predominating as it is a mid-summer clear day. The wharf on the right is the Yacht Club, and the one in centre is the C. N. R. Wharf. The bright green in the mid-distant right is the Summerland fruit growing district."

Okanagan Lake at Penticton (1958).
Pencil, 9" × 12¼" (23 × 31.3 cm).

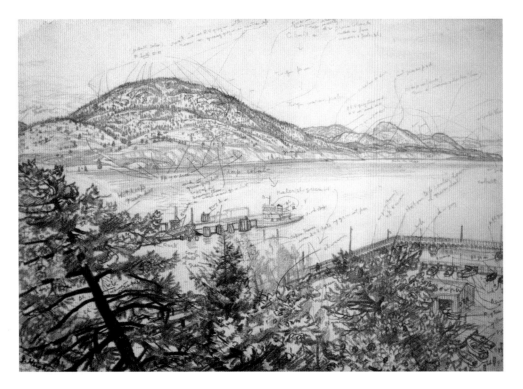

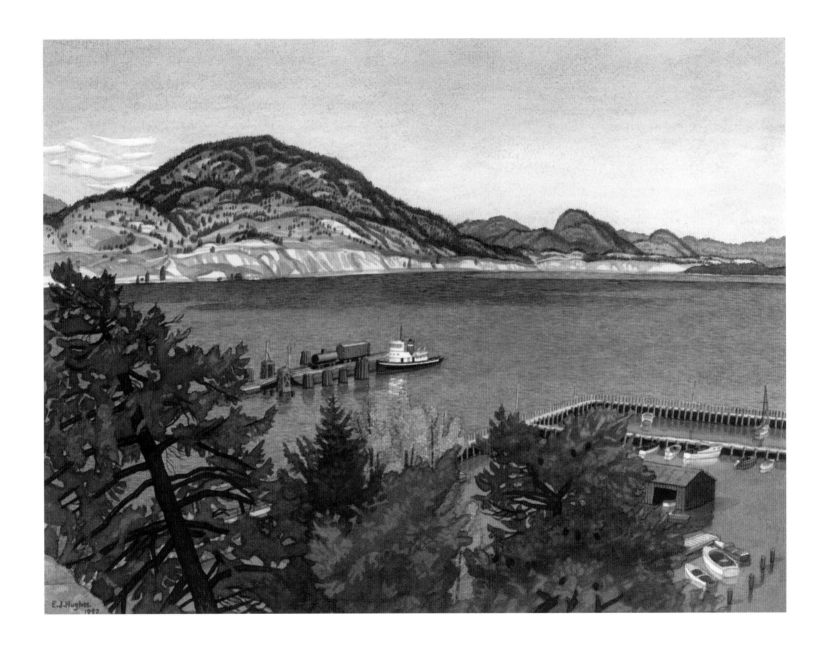

Okanagan Lake at Penticton (1992).
Watercolour, 18" × 24" (45.7 × 61 cm).

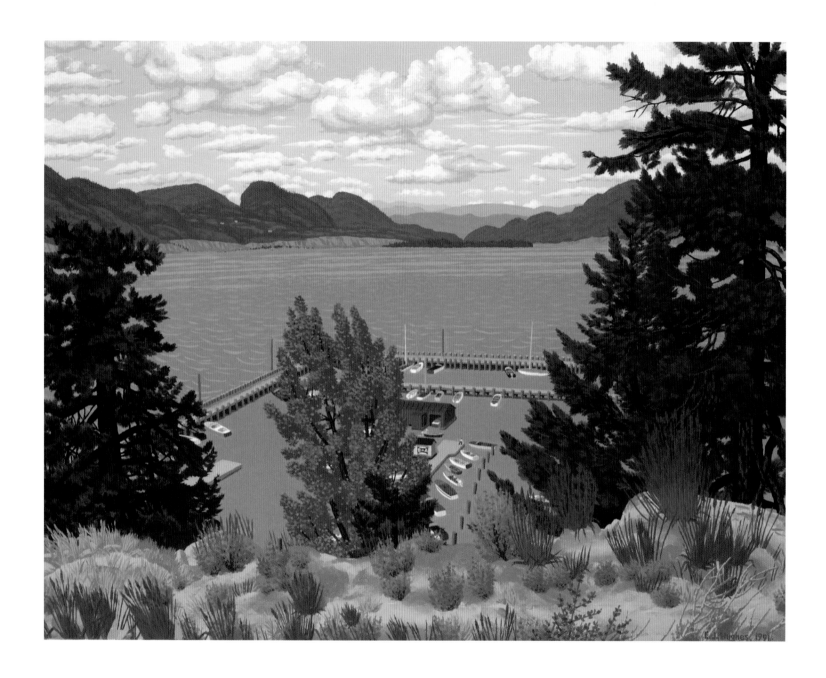

Above the Yacht Club, Penticton, BC (1991).
Acrylic, 25" × 32" (63.5 × 81.3 cm).

This painting includes many of Hughes's favourite motifs—a day at the lake with a foreground of clearly defined trees. He's even found a working boat for the centre of the composition.

In 1992 Hughes again took up the 1958 sketch to produce the watercolour version of *Okanagan Lake at Penticton*. The lake is painted with a surprising richness of colour. Beneath a summer sky of blue, he set out the dramatic shapes of the eroded banks coming sharply down to the water. The lake itself is a jewel, with rich deep blue at the far edge, fading to a jade green in the foreground. The artist achieved this effect by repeated application of many layers of paint, finished with a delicate veil of tiny ripples across the surface.

The wharf at the left has an adjustable ramp that brings railcars to the end of the pier. An oil tanker and a goods wagon wait there, beside a jaunty little white tug with a black hull and touches of red at the waterline. Again, Hughes gave his full attention to the boats tied up at the docks: a small sailboat, a motorboat with a cabin, runabouts with small outboard motors. Vessels in red, blue, and yellow surround a floating boathouse sheltering a small white boat. Each of the dozen boats has an individual character. Boats were on his mind in 1958 for, back home at Shawnigan Lake, Hughes had become the owner of a little runabout.

The acrylic painting *Above Okanagan Lake* (1960) may be the finest expression of the desert conditions Hughes painted. Fittingly, it was purchased for the collection of the Archives of British Columbia. In composition, it is an unusual landscape, with much of the picture given over to a bristling and windswept pine tree growing high above the lake's edge. The rich brown trunk of the central tree bends toward the shore, and its branches end in "bottle brush" clusters of large pine needles. For accent, reddish cones are set on many of the boughs.

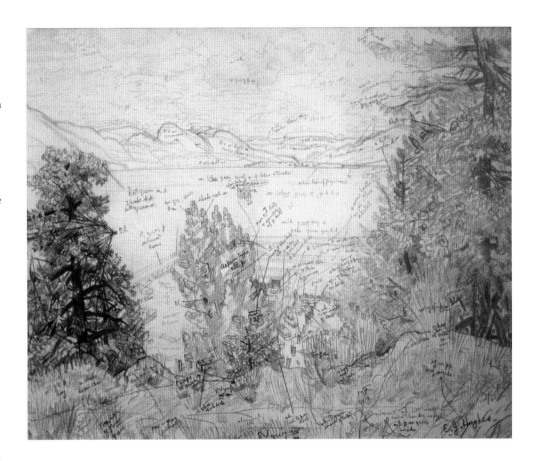

Above the Yacht Club, Penticton, BC (1958). Pencil.

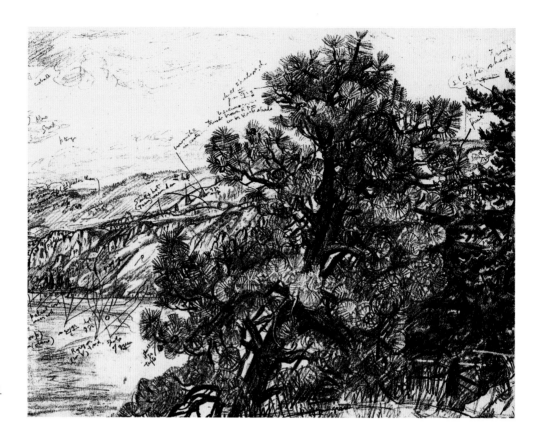

Above Okanagan Lake (1958).
Pencil. Photo by Pat Salmon.

When Max Stern first saw the painting, he wrote that *Above Okanagan Lake* was a bit heavy on the right side, and then apologized for his criticism. In response, on November 9, 1960, Hughes replied: "No, I do not mind your criticism when something in a painting disturbs you. I welcome it, as you are seeing the paintings with a fresh viewpoint and with a comparison at hand of many more paintings, and at this end sometimes only my wife and myself see my painting before it is sent away."

That statement reveals an extraordinary fact about Hughes's life. Until Pat Salmon became his biographer in 1977, he had no one to talk with about art. He didn't subscribe to any art magazines, and the flood of imagery we now take for granted was not available to him. There was no public library in Shawnigan Lake, and there were no other artists among his few acquaintances. The market for his work was entirely in Montreal—Max Stern bought it all. The regular letters he exchanged with the Dominion Gallery were the only conversations Hughes ever had about his work and, remarkably, the correspondence was all preserved.

Hughes concluded his letter of November 9, 1960, with a sincere appreciation for Stern's professional advice: "Also I always keep in mind your years of training and experience, and (as I have found out myself) ability in judging pictures. It is funny, but in this case [*Above Okanagan Lake at Penticton,* BC], the balance did not disturb me, even with the upside down and mirror test. However, I will give especially to this aspect of pictorial composition (balance) some extra attention from now on."

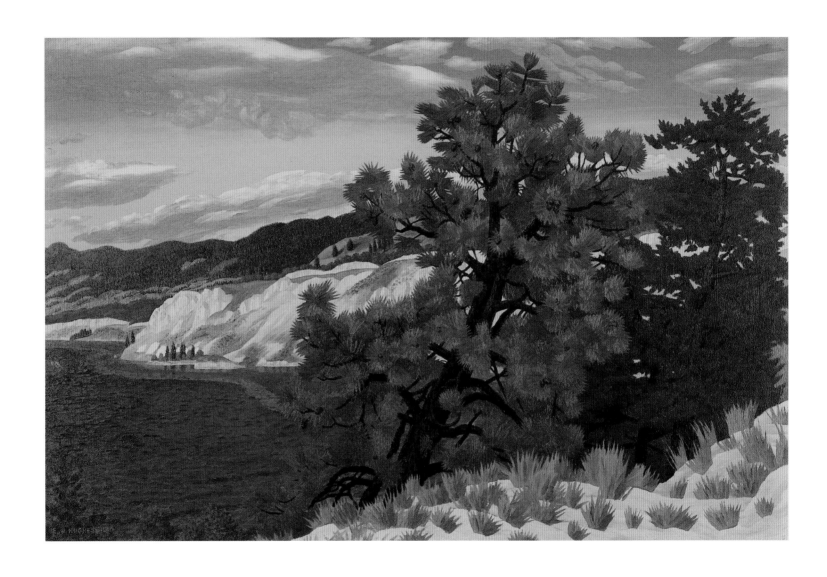

Above Okanagan Lake (1960).
Oil, 24" × 36" (61 × 91.4 cm). Royal BC Museum.

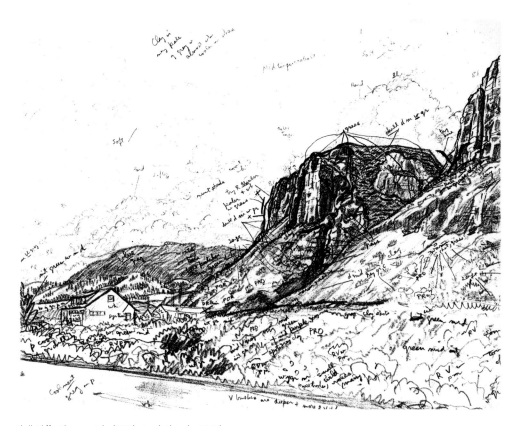

Chalk Cliffs, Okanagan Lake (1958). Pencil. Photo by Pat Salmon.

Kalamalka Lake lies just east of the north end of Okanagan Lake, and Kalamalka Lake Provincial Park—established in 1975—is situated on its northeastern shore a few kilometres of Vernon. Hughes spent some time there on his trip to the Interior in 1958. Across the lake, a new highway cuts across the face of a pyramidal mountain with a graphic simplicity. Facing the viewer directly, a red and white boat with a red outboard motor is drawn up on the shore. The lower edge is a horizontal sandy beach, pockmarked with footprints, but there is no one in sight. This is a Hughes painting of unusual simplicity.

Before he left the Okanagan Lake area in 1958, Hughes went to visit the Skaha Bluffs. This geological feature located southeast of Penticton has long attracted rock climbers, and Hughes made a fine rendering of the very interesting rock face. When asked why he didn't paint the image, Hughes told Salmon it was because it didn't have enough colour for his purposes.[48]

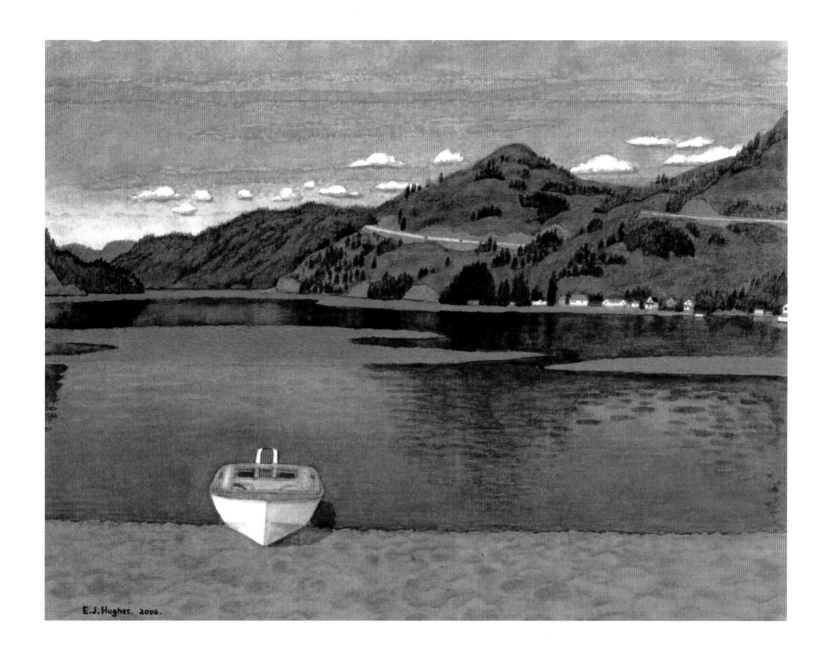

The Beach at Kalamalka Lake (2006).
Watercolour, 18" × 24" (45.7 × 61 cm). Photo by Pat Salmon.

The Kootenays (1967)

During the summer of 1967, Hughes made his last sketching trip to the Interior of British Columbia, sponsored by his third—and final—grant from the Canada Council. As he wrote to his sister Zoë in March of 1967, "I applied for the full amount of $5500 but was awarded $3700. However this will still allow about seven months of sketching and help us finance a newer car for the thousands of miles of driving under pressure. This time I'm sketching in territory I haven't covered in former trips," he concluded. "Fern is coming on the longest trips with me."

During June of 1967, Hughes and Fern spent a week in the Kootenay Lake area based in Cranbrook. Hughes found a good subject at Wasa Lake, forty kilometres to the north. In a letter to Stern in January 2, 1973, the artist described the situation. "The locale of this painting is in the Kootenay area of BC, not far from the cities of Kimberley and Cranbrook, and I was surprised to see, when I looked up a map recently, that the mountains in the background are in the 'Hughes Range.'" These are part of the Rocky Mountains, which form a backdrop to the east.

This small lake is situated in an area of bunch-grass meadows and is known as the warmest "swimming lake" in the Kootenays. Hughes often shows many tiny people animating the scene in the middle distance. In the drawing *Wasa Lake*, at least twenty people have been introduced behind the pine tree on the left. In his letter of January 2, Hughes explained that "the group of people on the beach in the middle distance are probably on an outing from one of the two above-mentioned cities." On the drawing he tagged them as "bathers in bright coloured costumes."

It is most likely that Hughes completed this detailed drawing in the comfort and privacy of the front seat of his own car, his favoured arrangement for drawing on location. The parking lot of the public park on the northwest of the lake provided him with a perfect place to sit and draw. The view of snow-capped mountains, with the forest in front reflected in calm water and framed

Wasa Lake, 2018. Photo by Robert Amos.

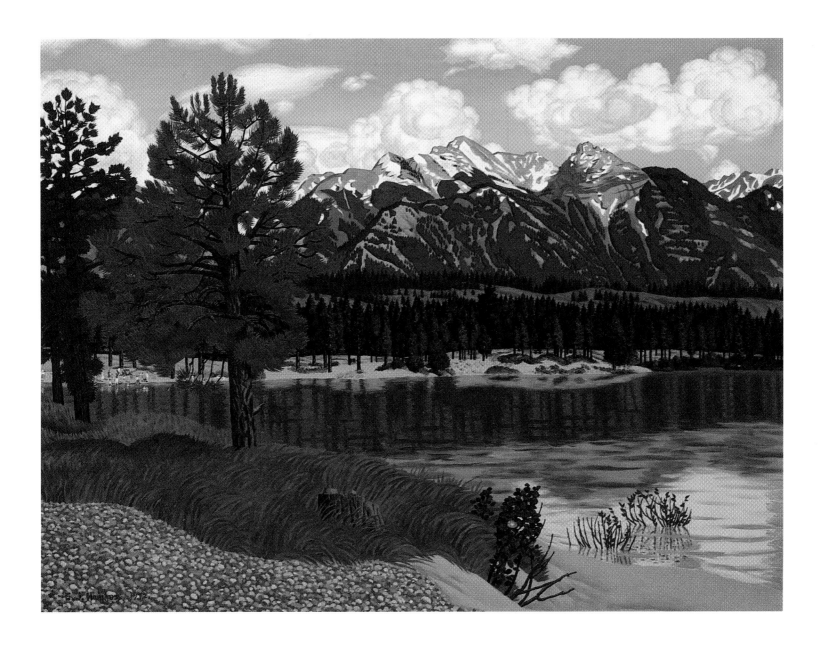

Wasa Lake (1973). Oil, 38" × 51" (96.5 × 129.5 cm).

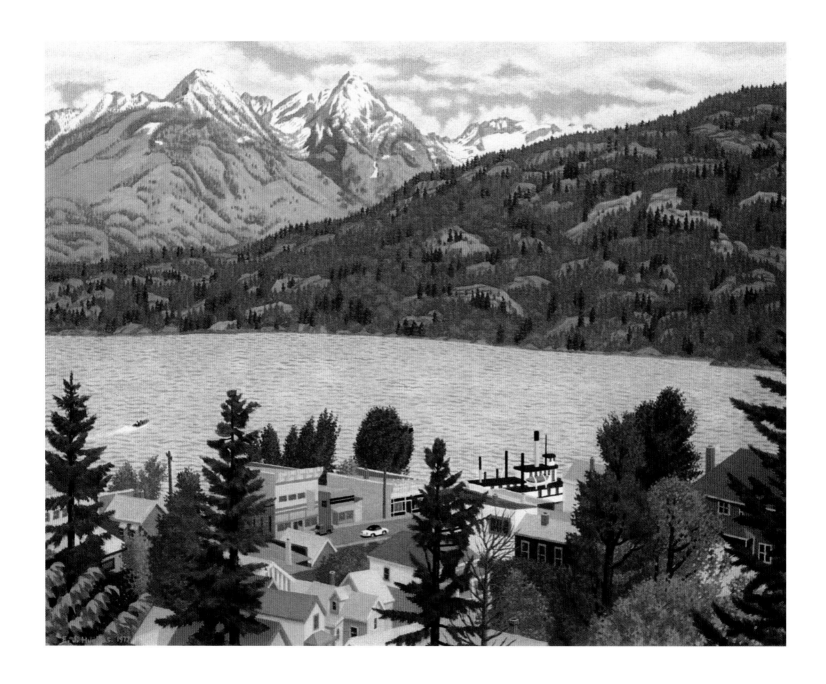

Kaslo (1977). Oil, 32" × 40" (81.3 × 101.5 cm).

by distinctive natural vegetation, were just what he was looking for.

It was five years later that Hughes produced an oil painting from his drawing of Wasa Lake. Stern immediately sent him a cheque and, on January 30, 1973, commented: "I love the three quarter upper parts, especially the clouds, the mountains, the trees on the edge of the water, the water and the bathers. I also find your pebbles beautifully painted." He didn't bother to mention the single wild rose that glows out from the dark leaves near the bottom edge, but he went on: "Only the grass and sand in the foreground are a bit empty. I wanted to mention this to you and hope that you don't mind, as you did such outstanding work in the rest of the painting." Whether or not Hughes minded, the comments did not result in any change in the painting. In fact, for the *Wasa Lake* (1973), Stern paid the artist $1,350, the highest amount Hughes had ever received for a painting.

After their stay in Cranbrook, the artist and his wife drove on to Nelson, and from there Hughes made a number of sketching expeditions north beside Kootenay Lake. The most picturesque destination he discovered in the vicinity was the small town of Kaslo.

Located seventy kilometres north of Nelson, Kaslo was incorporated in 1893 when a sawmill was established there. Subsequently the town provided access to the mining camps set up to extract galena (lead ore) and silver from the surrounding mountains. In those early days, Kaslo also became world famous for its cherries and apples. But by the time Hughes arrived, all the industry had long since moved on. Today Kaslo is known as a recreational centre, and it is a living testimony to the boom years of British Columbia's history. Many quaint period buildings still line the streets of this charming "wooden town."

Hughes approached Kaslo by road along the west side of Kootenay Lake and began his work from a height of land to the north of the town.

"Kaslo" E. J. Hughes '77

The small city of Kaslo is on the edge of Kootenay Lake in British Columbia, and this view of it, from the school grounds, is looking towards the north-east.

The pencil sketch from which the above painting was produced, was done from nature in 1967, when my wife and I were staying for two weeks at an auto court near Nelson, B.C., during one of my sketching trips in the BC Interior.

E. J. H.

He drew the view toward the east, overlooking Kootenay Lake and framed by the Purcell Mountains on the far side.

In his letter to Stern of January 2, 1973, Hughes made reference to his practice of writing labels for the paintings: "I hope you won't mind if I just occasionally mention in my letters something out of interest regarding the paintings I am sending, rather than write out a little separate card, as it is sometimes hard to think of what to write. However, if you feel it is important enough, please let me know, and I'll continue to write the small labels to go with the paintings every time." The labels were appreciated, and Hughes continued providing them for some years to come.

Hughes included the ss *Moyie* in the centre of his painting of Kaslo. Its yellow and black smoke-stack was visible on the shoreline, while its hull is out of sight amid trees and buildings. A lone pleasure boat cuts across the lake, with a spray in its wake. On the far side of Kootenay Lake, the distant slopes are an essay in the graduation of tone, which was one of Hughes's constant studies.

On April 10, 1969, Hughes sent another painting of Kaslo to the Dominion Gallery, this one entitled *Kaslo on Kootenay Lake* (1969). It is one of the rare vertical compositions in Hughes's work, and a justly famous one. This view centres on the steamship ss *Moyie*, which

Kaslo from the north. Photo by Robert Amos.

sits permanently grounded on the shoreline of Kootenay Lake near the centre of town.

Kaslo tourism describes the ss *Moyie* as "the oldest intact passenger sternwheeler in the world." It was built in 1898 for the Canadian Pacific Railway and is 161 feet (49 m) long, with a paddle wheel 19.4 feet (6 m) in diameter. In the beginning, the *Moyie* saw service pushing barges of materials across the West Arm of Kootenay Lake, between Nelson and Kootenay Landing. When, in 1958, it was finally retired from active duty, the ship was purchased for one dollar by the city of Kaslo. Volunteers there pulled it ashore

with capstans and, since that time, it has been the town's leading tourist attraction. It is designated as a National Historic Site.

Hughes specifically created this painting as his "diploma piece," in support of his application for full membership in the Royal Canadian Academy of Arts (RCA). Before Hughes painted his diploma piece, Stern gave some advice in his letter of February 17, 1969. "I would not advise you to use the 32 × 48 inch painting [*Receding Tide, Departure Bay*] for the Academy, as this will be given to the National Gallery which hardly ever hangs large paintings . . . should you wish to paint

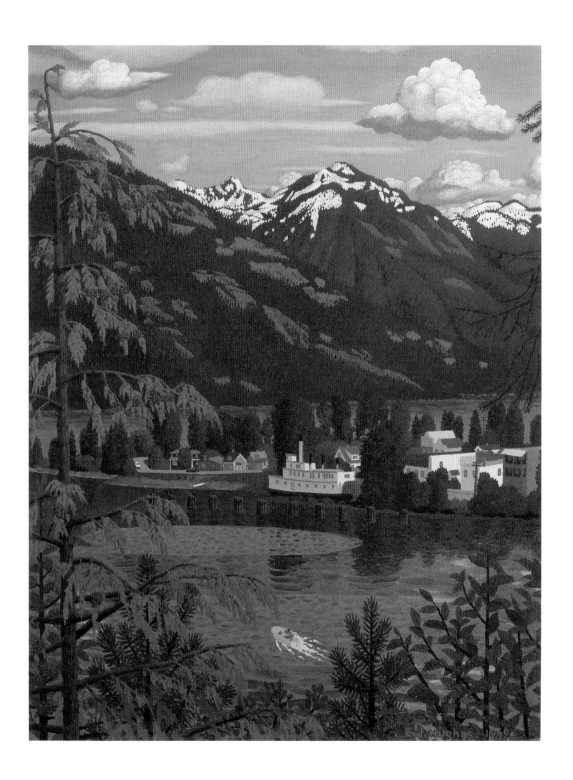

Kaslo on Kootenay Lake (1969).
Oil, 32" × 25" (81.3 × 63.5 cm).

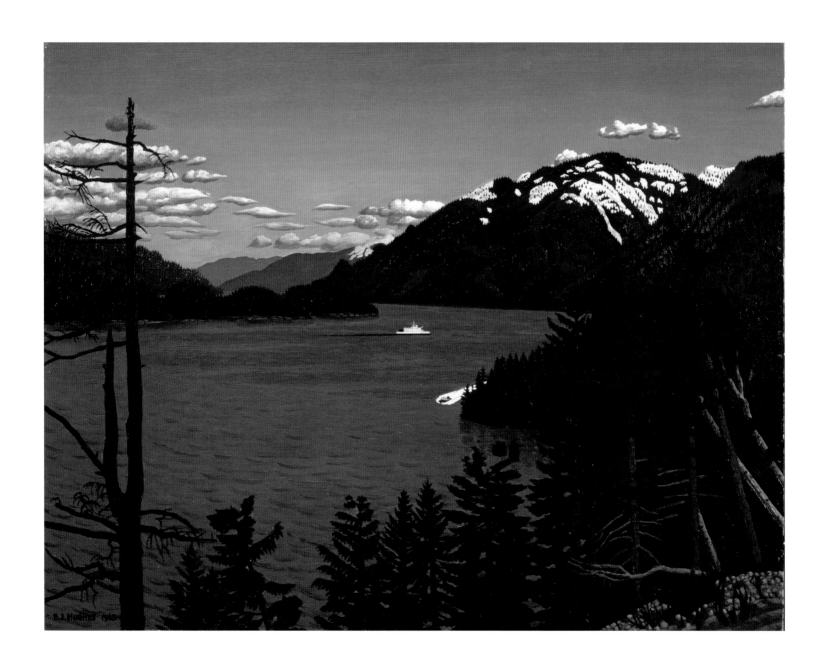

Above Kootenay Lake (1968). Oil, 25" × 32" (63.5 × 81.3 cm).

an upright painting for the Academy this would not be negative for a museum."

Not only was it accepted by the RCA, but when Rebecca Sisler published her book *Passionate Spirits: A History of the Royal Canadian Academy of Arts* (Clarke, Irwin & Company, 1980), this painting was chosen for the cover.[49] The RCA subsequently deposited its collection of academicians' "diploma pieces" with the National Gallery of Canada, and *Kaslo on Kootenay Lake* (1969) joined a number of other Hughes paintings in the collection.

Above Kootenay Lake (1968) presents Kootenay Lake from the west side looking south. This is a view Hughes would have seen as he returned from Kaslo, heading south to Balfour, and he drew it as he sat in his car, on the shoulder of the highway. The ferry that runs between Kootenay Bay and Balfour can be seen in the centre of the painting,

making its way across Kootenay Lake. Even in July, there is snow on the nearby peaks.

Hughes continued his reconnaissance of the area around Kootenay Lake with visits to the east shore. To get there he drove thirty-five kilometres from his base in Nelson to the town of Balfour and then crossed to Kootenay Landing on the ferry, a thirty-five-minute passage. The evidence of his paintings indicates that he sought a height of land above Procter, a village a little to the south of the landing—from there he could look up the length of Kootenay Lake and see Balfour in the distance. Hughes made a habit of including boats in his paintings where possible, and the ferry featured prominently in his drawing, but then Hughes erased it. It did not appear in the painting. On May 27, 1974, Hughes dispatched the oil painting *Kootenay Lake* (1974), which was based on the drawing he made there.

Balfour on Kootenay Lake from the ferry, 2018. Photo by Robert Amos.

Kootenay Lake (1967). Pencil.

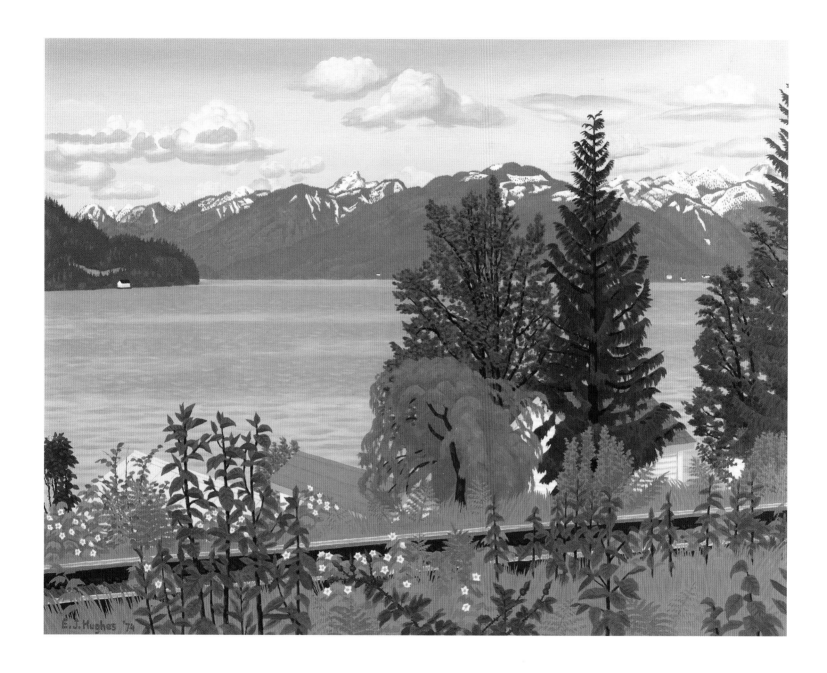

Kootenay Lake (1974). Oil, 25" × 32" (63.5 × 81.3 cm).

On July 6, 1967, Hughes drove about six kilometres up the east shore from Kootenay Landing to Riondel, where he continued his research for painting subjects. Riondel (pronounced ree-on-del) was established as a community a century ago to serve the nearby silver, lead, and zinc mines. Today this village of three hundred people is best known for its access to wonderful outdoor activities.

Hughes sent his oil painting *Kootenay Lake from Riondel* to the Dominion Gallery on October 28, 1968. It is a painting that repays concentrated study. At the north end of the lake, the jagged snowy peaks of the Purcell Range stand over dark hillsides that close in on the end of the lake. Under boldly sculpted cumulus clouds, the water surface shows alternating patches of reflection and squall. The middle distance is given over to a cluster of little boat sheds with peaked roofs that echo the shape of the mountains beyond. Eleven carefully painted boats are tied to the wharf, each patiently waiting for its owner. Not a person is in sight, though some sort of narrative is suggested by the tailfins of a red car with a white roof heading off to the right.

The boat sheds, docks, and car are connected to a rough sandspit studded with rather large rocks. At the lower margin of the canvas, the foreground is given over to weeds and stones; these are fronted by a huge tree trunk that has washed up on the shore. The remains of its cut and broken branches stand out bare and pale in contrast to its dark, heavy bark.

Upon receipt of this painting, on November 6, 1968, Stern wrote to Hughes: "You will note that we have raised your original price 40% instead of 20% and will do so in the future. When a painting is extremely attractive we may give you a further bonus." Stern made it his business to drive up the prices for Hughes paintings, both in what he was charging to his customers and what he was paying out to the Shawnigan Lake artist. Hughes replied to Stern on December 9, 1968, that "this will

mean that we can be ahead each month with our budget instead of a little behind."

Hughes was on a tight budget, and on July 27, 1967, he wrote to explain to Stern that he "could urgently use some extra money at present, due mostly to an unfortunate and unavoidable accident I had on our last trip to the Kootenay area, in which I killed a poor deer, which jumped in front of our car, which was travelling at 60 m.p.h. The front of the car was extensively damaged and, of course, our trip was cut short and our sketching budget upset."

He reported further: "Mrs. Hughes was not with me in the car at the time of the earlier accident with the deer. The deer was killed instantly, of course, and the front of the car damaged to the extent of over $450, but, strange to say, I hardly felt the impact myself."

Despite the accident, Hughes never lost his love of driving. Back at Shawnigan Lake, while he was painting Kootenay Lake from Riondel, on October 9, 1968, Hughes again wrote to Stern about cars and money. He thought back to 1965, when, due to unforeseen circumstances, "my average monthly income of over $300 suddenly stopping, caused me (later) to have to trade down from our late model car to an older one, with a loss of hundreds of dollars (we have a late model again now [a Pontiac Strato Chief]) . . . We would, of course, like to buy that new Buick or Oldsmobile full size car some day, but at present thanks to your 20% increase in the prices you pay me, since the retrospective show, we are meeting our expenses. I just hope the cost of living doesn't go up any more, as it has been. It is like the Gold Rush days."

Now that he was able to drive wherever he wanted to, Hughes continued exploring the province for landscapes he wanted to paint. Between his first trip to the Interior in 1956 and his last in 1967, Hughes estimated that he had covered over eleven thousand kilometres throughout the province.

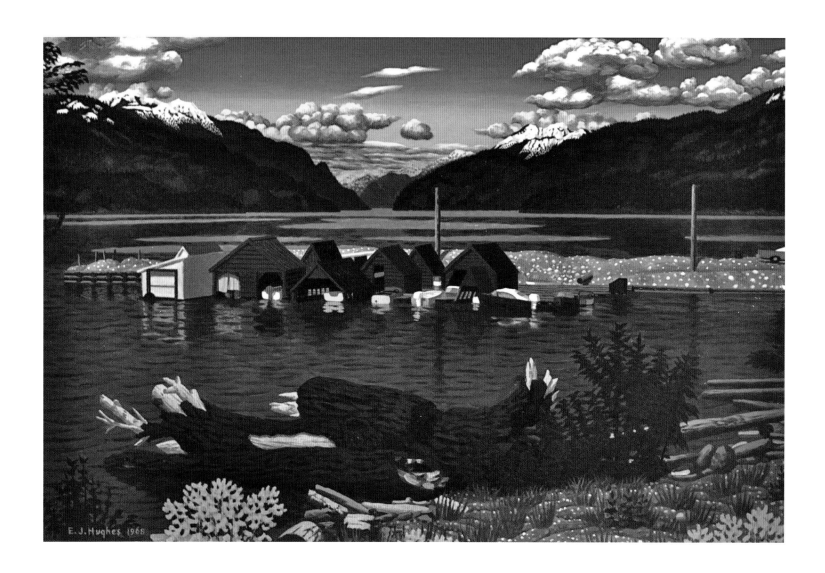

Kootenay Lake from Riondel (1968).
Oil, 24" × 36" (61 × 91.5 cm).

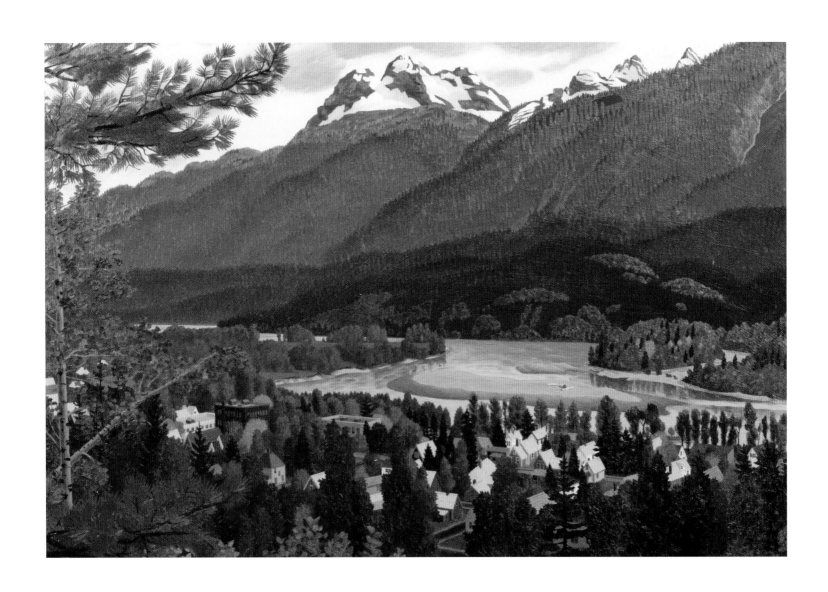

Revelstoke and Mount Begbie (1962).
Oil, 24" × 36" (61 × 91.5 cm).

Revelstoke (1958, 1967)

As an art dealer with an international clientele, Max Stern was an inveterate traveller, and he tried a number of times to get Hughes to expand his horizons. He offered to send him to visit the museums of Europe or across America, but Hughes didn't want to go. Finally, in response to Stern's encouragement, the artist undertook a six-week bus trip across Canada with Fern in 1956, but that experience was not a success. First, there was the discomfort of riding thousands of miles sitting in a bus. Hughes also felt the anxiety of tight schedules and uncertain finances. He found that the series of short stays in a series of unfamiliar cities (Calgary, Regina, Winnipeg, Toronto, Montreal, Ottawa) was not the best way for him to create artworks. In addition to these expected stresses, at this time Fern was suffering from the onset of muscular dystrophy.

But Hughes was a landscape painter, and to pursue the career that Stern had laid out for him, he would need to expand and refresh his repertoire of subject matter. Stern suggested that Hughes might paint archetypal Canadian subjects like Banff and Lake Louise, or that he could include an RCMP officer in his distinctive red jacket. He believed that when the Dominion Gallery's European clientele came to Montreal, they would respond well to images that were distinctly Canadian.

Hughes was concerned about what effect such obvious subjects would have on his reputation. On March 8, 1963, he wrote to his sister Zoë: "It will be a problem and a task to make art out of such beautiful and picturesque subjects as the

Rocky Mountains, but I feel it can be done if they are only well-painted and composed on the canvas. It is not necessary, like many painters and art authorities think, to avoid nature, but to reveal its mood. On the other hand of course, it is not necessary to paint nature in order to produce art as modern art has shown."

To a degree, it was to please Stern that Hughes and Fern left in 1958 on a reconnaissance mission to see the places the dealer had recommended. They planned to be away for three weeks, visiting Revelstoke, the Rockies, and possibly Banff. The weather had been good through July, and they set off travelling by bus. After their stay in Revelstoke, on August 24, 1958, Hughes told Stern that he would not be able to go to Banff, Lake Louise, and Jasper.

No matter what the weather conditions, Hughes always spent his time profitably. Despite rain, clouds, and a forest fire, he managed to draw nine "usable mountain, river and town sketches," as he wrote on August 24, 1958. Even when the weather was overcast, he could still observe the outlines of the landscape and note its forms with precision. He spent hours—usually days—making these drawings. The hours he spent on the scene meant that, unlike most plein-air artists, he was not subject to the vicissitudes of the ever-changing play of light across the landscape. Sitting patiently, looking purposefully, and slowly drawing what was before him, Hughes simply outlasted those passing effects. Thus his studies, and the resulting paintings, have a solidity to

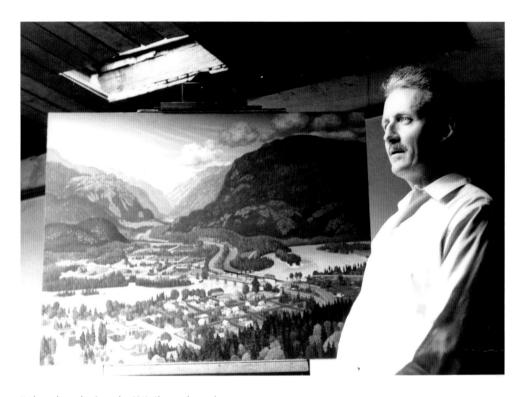

Hughes in his studio, September 1961. Photographer not known.
Courtesy of the E. J. Hughes Archive.

Trail, etc. I didn't do any sketching," he wrote, "but know of many excellent spots to go to in 2 or 3 years when my present sketches get used up. It will be easier to get to these scenic spots in the Rockies by private car as fine new hard top roads are being constructed throughout between Banff and Lake Louise and Jasper."

The town of Revelstoke had come into being with the building of the Canadian Pacific Railway in the 1880s. When, in 1962, the Trans-Canada Highway was opened, the town changed. Since then it has become largely a recreational destination. It is perhaps no coincidence that Hughes's most extensive trips to the Interior of British Columbia coincided with the opening of this new major autoroute.

Inspired by a drawing he had made in 1958, Hughes completed one of his best-known paintings, *Eagle Pass at Revelstoke, BC* (1961). He explained to Stern, in a letter on August 19, 1961, that its delivery was a little delayed, saying that "it is more detailed than recent paintings I have sent, as the edge of the city of Revelstoke is showing at the bottom of the picture."

When at last he shipped the painting, on September 11, 1961, he described it to Stern. "This view of the outskirts of Revelstoke and the Columbia River is from the famous Mt. Revelstoke Ski Jump, which of course is deserted in the summer time. I believe soon, or even already, a third bridge is being built to the right of the 2 in the picture for the new Trans-Canada Highway . . . the domed building is the Court House and the main part of the city is out of the picture to the left."

Hughes made the pencil drawing on location in Revelstoke in August 1958. Then, after he took the drawing back to his studio, as a preparation for the painting, he drew a complete tonal study in graphite—his "cartoon." Only after that did he begin the oil painting.

Hughes was at work on this canvas when, on September 11, 1961, a television crew arrived at

them that is, in part, a result of the time spent in their realization.

The town of Revelstoke is situated at the confluence of the Columbia River and the Illecillewaet River, at the western end of Rogers Pass. Hughes felt that his first experience of drawing in the Revelstoke area in 1958 hadn't been a complete success, and he wrote about the experience in a letter to Stern on September 9, 1958.

Two years later, in the summer of 1960, Hughes and Fern tasted a new freedom—travelling in their own car. No longer were they dependent on the bus for transportation, and they went back to Revelstoke for a more considered look. As he reported to Stern on September 12, 1960, "We had a week's holiday driving to Banff and Jasper and back, going by the Revelstoke route and returning by the south route through

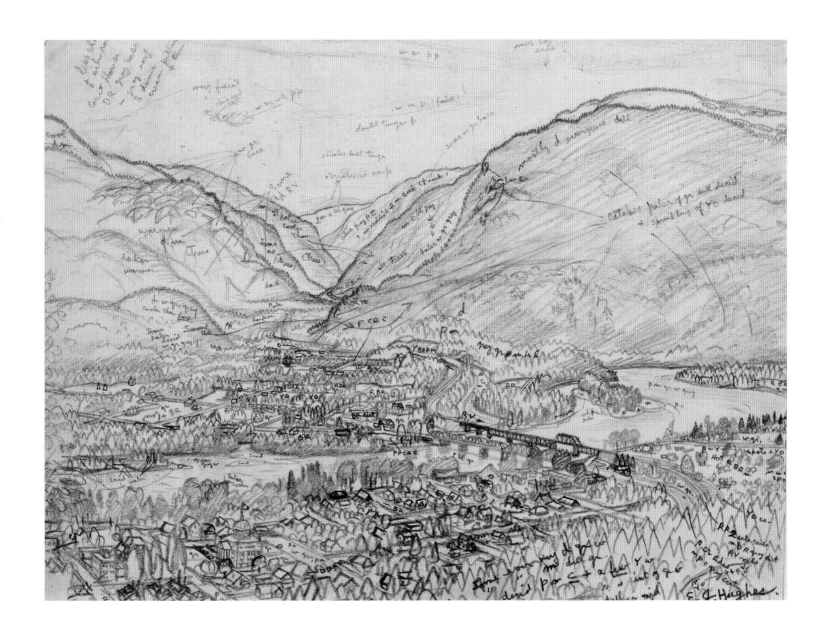

Eagle Pass at Revelstoke (1958). Pencil.

Shawnigan Lake to film him. He reported to Stern that "this painting with its cartoon and original small pencil sketch will be featured along with their producer [Hughes] in a CBC TV production along with three other BC artists and their work, on the programme The Lively Arts." In addition to Hughes, the series produced programs on four other artists: Jack Shadbolt, B. C. Binning, Takao Tanabe, and Gordon Smith. It was in this way that E. J. Hughes made his first appearance on television on Boxing Day, December 26, 1961, at 10:30 PM.

The film shows the artist picking up his mail at the store and walking home along Shawnigan Lake Road. It then joins him in his studio on the top floor of his home. The painting *Eagle Pass at Revelstoke BC* is on the easel, beneath the new skylight he had installed in his quiet painting room overlooking the lake.

In a voice-over Hughes spoke about his work: "I occasionally do a painting which appears much like a coloured photograph, and sometimes when I see a coloured photograph of a scene that is well composed it almost knocks me for a loop, and I can't paint after for sometimes two days—it's just wondering what is the advantage for my going on painting realistic things like this. But eventually I realize like I always do that a painter can add something that a photograph hasn't got, and that's probably what makes the painting durable. One of the main reasons I paint is because I think Nature's so wonderful that I want to try to get my feeling down about that on canvas if possible. I feel that when I am doing my painting it is a form of worship. I see how wonderful nature is and how wonderful art is and by men in the past. And by trying to produce these works of art, I feel I am showing my appreciation to these Creations."[50]

Remarkably, the crew travelled not only to Shawnigan Lake but also to Revelstoke, a long way away. There they filmed that city from the very point of view Hughes chose for his painting. The film merges its reality with Hughes's black and white drawing of Eagle Pass at Revelstoke, and then to his fully coloured painting. The film is a fascinating window into a time gone by.

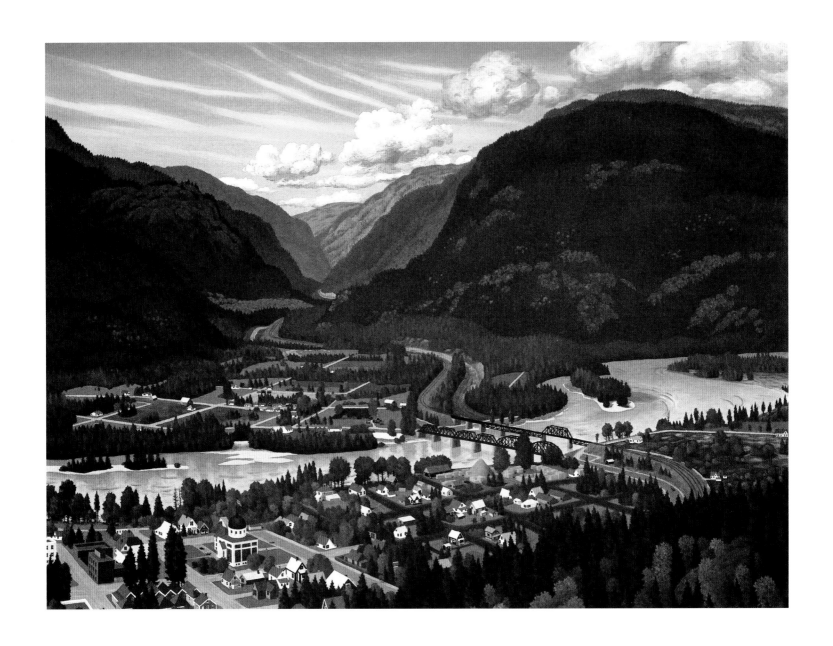

Eagle Pass at Revelstoke, BC (1961).
Oil, 18½" × 24" (47 × 61 cm), Vancouver Club.

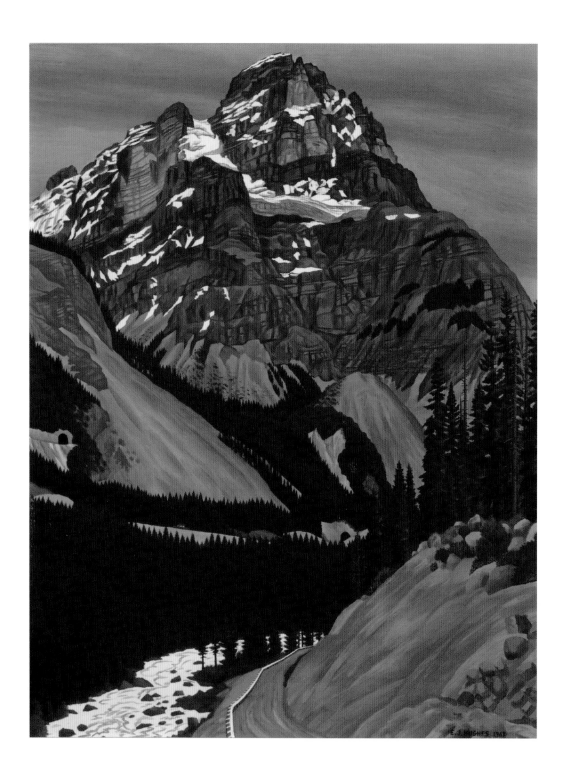

Mt. Stephen (1963).
Oil, 32" × 25" (81.3 × 63.5 cm).

The Rockies (1963)

In 1963 Hughes received his second grant from the Canada Council, an award of $3,000. He was one of twenty-two people who received grants that year, and he thought that sum would cover his expenses for five or six months. He would be out drawing and not in the studio creating the paintings from which he earned his living. Thanks to this government award, he planned and conducted a highly productive season in the field. During the summer of 1963, from his home at Shawnigan Lake on Vancouver Island, Hughes made separate trips to Williams Lake, Kamloops, and the Rockies.

As ever, on March 2, 1963, Max Stern encouraged Hughes to visit the famous Canadian beauty spots, and in the spring of 1963, the artist laid out his plans for the first part of the summer: "In June I will be sketching in the Rockies at Banff and Jasper. I am sorry I won't be sketching, as you once suggested, from the steps of the Banff Springs Hotel. There would be too many spectators. But I may obtain a similar view from a more secluded vantage point."

Soon after his return from the summer's trips, the first of Hughes's paintings from the Rocky Mountains was ready to send to the Dominion Gallery. On October 17, 1963, he shipped the boldly vertical view of Mount Stephen, an iconic peak near the town of Field. Mount Stephen, at 10,495 feet (3,199 m) tall, stands near the Continental Divide, in the Kicking Horse River Valley of Yoho National Park.

Hughes painted it from the side of the road looking across the Kicking Horse River. Its vertiginous grandeur looms above a tiny red car on the highway below. To its left and right, he has painted the circular mouths of two tunnels, which are an important part of this painting.

Another iconic peak is Mount Burgess in Yoho National Park. This canvas shows Mount Burgess soaring above Emerald Lake and presents

> 456
>
> Box 2,
> Shawnigan Lake, B.C.,
> Oct 17, 1963.
>
> Dear Dr. Stern:—
> I will be sending to you on Monday, Oct 21, if the paint and varnish have properly dried by then, the oil painting, "Mount Stephen", 32" x 25".
> The greenish-whiteness of the Kicking Horse River in the foreground is not caused by foam but by a white sediment brought down by its tributary, the Yoho River. The tunnel entrance on the left is the famous C.P.R. spiral tunnel, and the tunnel entrance on the right is, I believe, just a small tunnel. The small red car between these is on the main Trans-Canada Highway, and the gravel road at the bottom of the painting is the Yoho Valley road.
> Kindest regards to you and Mrs. Stern from Mrs. Hughes and myself.
> E. J. Hughes.

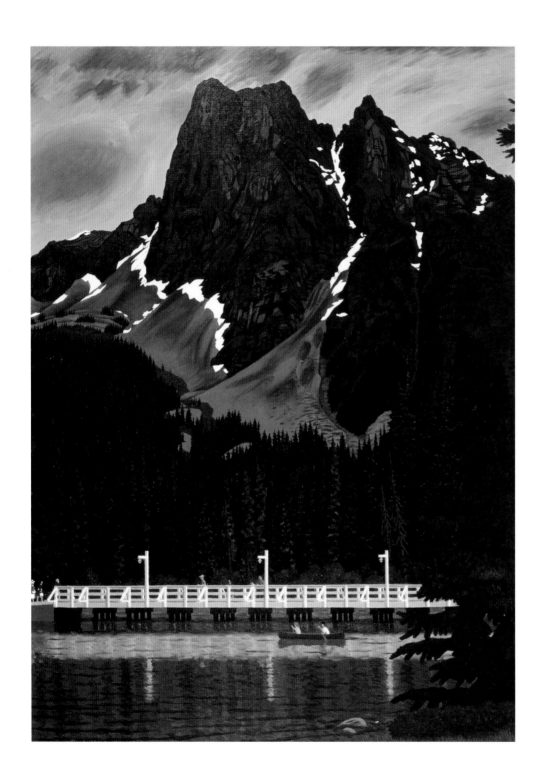

Mt. Burgess and Emerald Lake (1967).
Oil, 30" × 40" (76.2 × 101.6 cm).

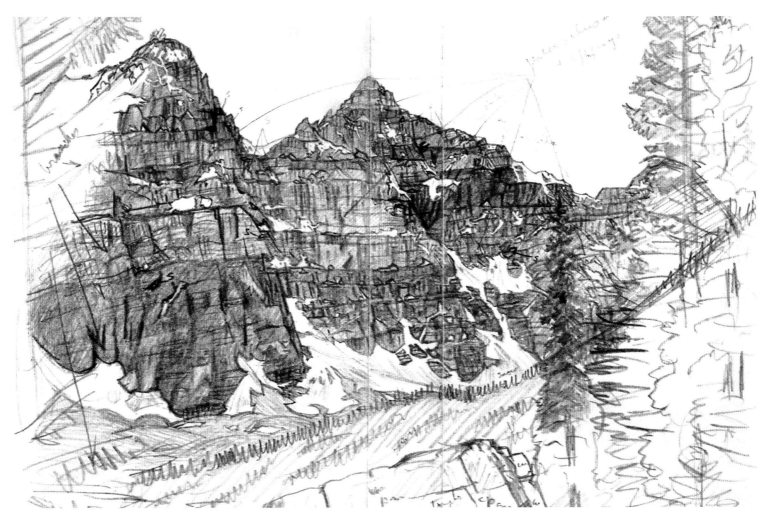

Moraine Lake (1963). Pencil.

the huge vertical expanse of geology, carefully observed, in contrast to a crisply horizontal footbridge. Across its geometric rigour, seven tourists take in the sights of Emerald Lake. On the calm water of the lake in front of them, a man and a woman paddle a red canoe.

This lake was named Emerald because of its remarkable colour, caused by fine particles of glacial sediment suspended in its water. The name of Burgess is known to geologists around the world, for it was here, in 1909, that the Burgess Shale was discovered. It is one of the more important fossil beds in the world and was declared a World Heritage Site in 1980.

Moraine Lake is fourteen kilometres from Lake Louise, and is in the spectacular Valley of the Ten Peaks. During the summer, this lake is a vivid and ever-changing blue and is surrounded by craggy mountains and plunging waterfalls. Hughes took up a position at the end of the road and drew the Ten Peaks in a wonderful pencil study.

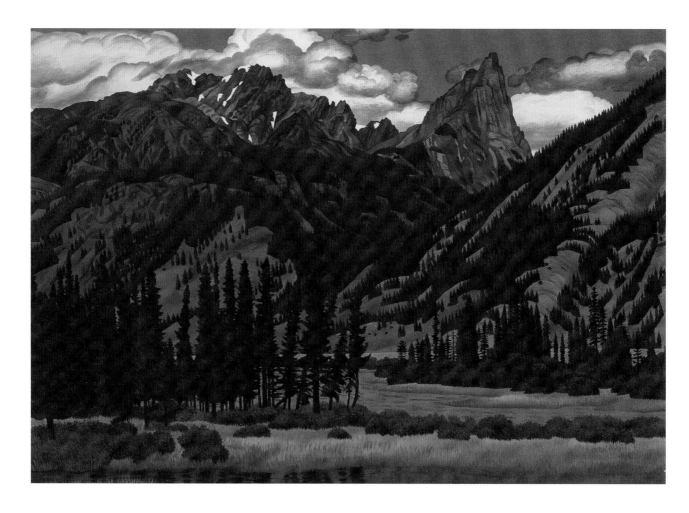

Hughes delivered another dramatic mountain landscape, *Mt. Edith* (1963), to the Dominion Gallery on November 8, 1963. "This is not Mt. Edith Cavell," Hughes noted at the time, "which latter mountain I hope to sketch some years in the future. It, Mt. Edith Cavell, is in the Jasper district as you may know, having visited there. Mt. Edith is not far from Banff. You may have seen this view of it from the drive west past the Cave and Basin along the Bow River. The river is quite a pale viridian from this angle." In the foreground of this painting, Hughes has depicted the reed beds of the Bow River.

Mt. Edith (1963). Watercolour, 18" × 24" (45.7 × 61 cm).

Hughes and Fern stayed in Banff while making drawings of various sites nearby, and he took some time to complete a very detailed drawing made from a high viewpoint looking over the town. *View of Banff* shows the town among the Rocky Mountains within Banff National Park. The image is dominated by the rugged peak of Mount Norquay, which rises over the town, and standing alone in the valley to the right is the Banff Springs Hotel.

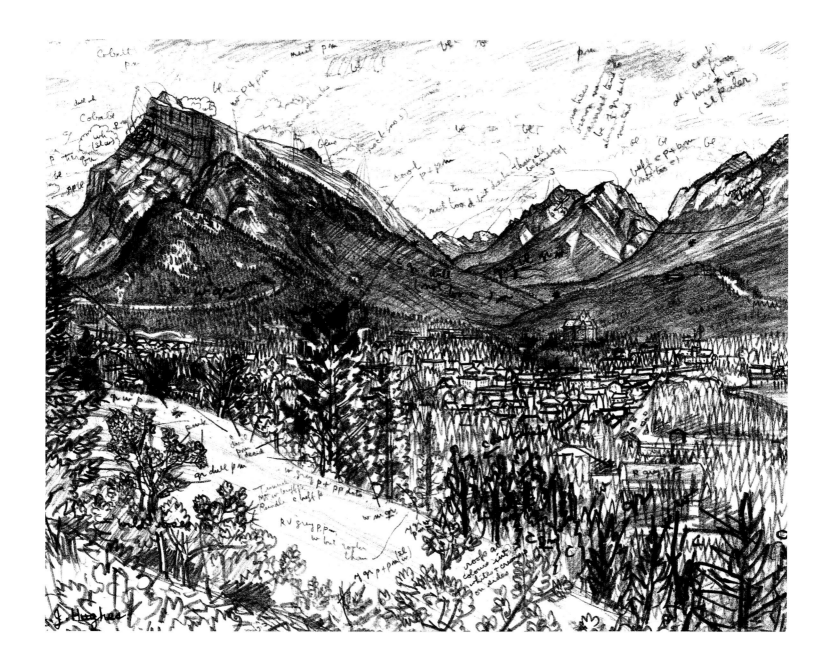

View of Banff (1963). Pencil, 32" × 48" (81.3 × 122 cm).

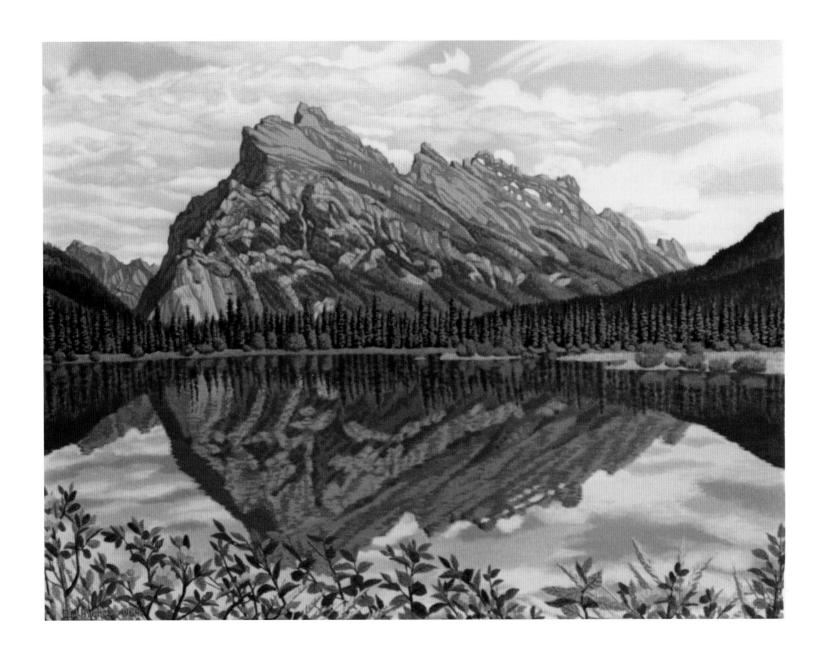

Mt. Rundle and Vermilion Lake (1964).
Oil, 25" × 32" (63.5 × 81.3 cm).

Another of Hughes's subjects from the Banff area was Mount Rundle and Vermilion Lakes, which he drew in 1963 and then painted in 1964. He parked his car on the roadside at a place known as the Vermilion Overlook. Looking to the south from there, one gets the "postcard" view of Mount Rundle. A peak that slopes in this way is sometimes referred to as a "writing desk" mountain. Wild roses and dry grasses wave in the foreground before Vermilion Lakes which calmly reflect the striking geological form of this massif.

People often wonder if Stern was taking advantage of Hughes, financially. The artist was paid a mere $250 by Stern when he sold this painting in 1964. But, eighteen years later, on December 7, 1984, Hughes delivered a slightly different view of *Mt. Rundle and Vermilion*

Lake to the Dominion Gallery, and he was paid $10,000. Thanks to Stern's management, Hughes's income continued to rise to heights that were, eventually, well beyond his needs.

The subject of Rundle came up again in a letter of February 28, 1985, when Hughes asked Stern: "Did you see the latest *Vanguard* magazine? On the back is a dark but clear reproduction of Hughes's *Above Kootenay Lake* and inside a good repro. of *Mt. Rundle and Vermillion Lake* in your Dominion Gallery ad. You will remember, in our phone conversation, I mentioned a slight worry on my part that it may look 'postcardy' (because of the subject). Well, the reduced down reproduction has greatly dispelled this worry, as it seems to me to be quite balanced and solid enough."

"Mt. Rundle and Vermillion Lake." acrylic #7 E. J. Hughes. 1984

The pencil sketch from nature for the above painting was produced in 1963 during a sketching trip sponsored by Canada Council.

The scene in the painting seems remote but actually is on the outskirts of the busy city of Banff, Alberta. The sketch was made from my car, parked on the side of a dead-end road along the lakeside. To the rear of the observer is the Trans-Canada Highway, from which a similar view is obtained.

25 × 32" E. J. H.

On the eastern edge of the Rocky Mountains, eighty kilometres west of Calgary, is the town of Canmore, Alberta. Like many other Rocky Mountain towns, its history began with the building of the Canadian Pacific Railway in the 1880s. In subsequent years, mining was developed in the vicinity. These days, it is best known as a destination for recreational tourism.

It may come as a surprise to find that Hughes painted the bold silhouettes of the Three Sisters mountains from a position on a little bridge over a side channel of the Bow River. Spring Creek is located right in the heart of the town. The only hint of the urban nature of this location is the inclusion by Hughes of a single telephone pole in the centre of the picture.

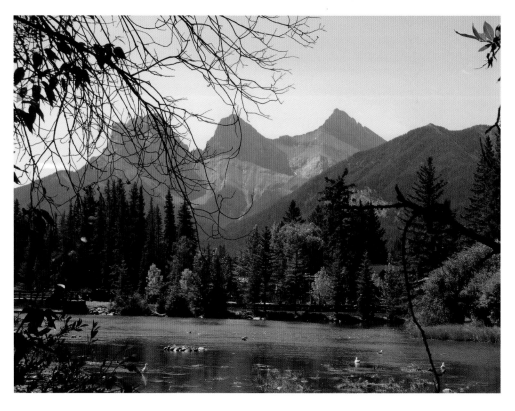

The Three Sisters, from the town of Canmore, Alberta.
Photo by Robert Amos, 2018.

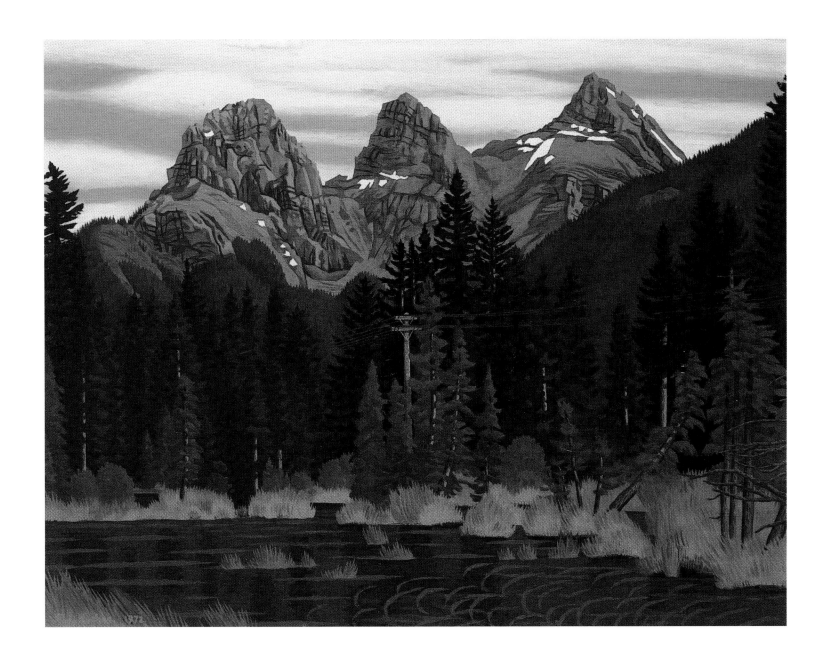

The 'Three Sisters', Canmore, Alberta (1972).
Oil, 25" × 32" (63.5 × 81.3 cm).

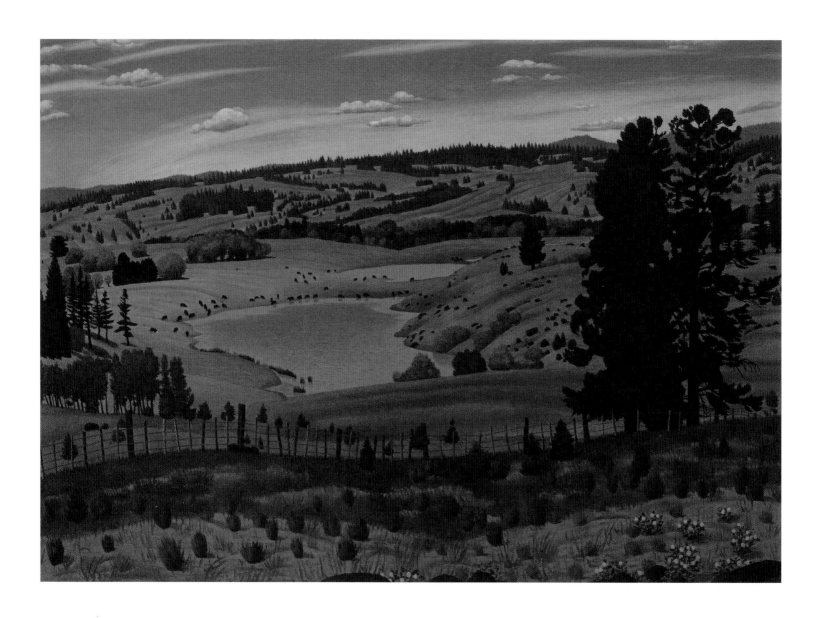

Above: *West of Williams Lake* (1964), 32" x 45"
(81.0 x 114.3 cm). Oil.

Facing page: *The Fraser River Near Lillooet* (1969).
Oil, 40" × 30" (101.5 × 76.2 cm).

Williams Lake and Hazelton to the North (1963, 1967)

The summer of 1963 was a period of intense field study sponsored by Hughes's second Canada Council grant. He and Fern began with a week-long stay at Cache Creek and used it as a base from which to make drawings at Lytton and Ashcroft. Then they moved north to Williams Lake where they spent another week. Travelling south again, the last week of that adventure was based at Kamloops.

On July 3, 1963, Hughes wrote to Stern about the trip: "With our own car I was able to drive 50 or 60 miles or more in all directions from these BC Interior centres, looking for motifs, and to go back later to sketch what I felt were the most appealing subjects, and thanks to the shelter of the car, even on rainy days, or windy. Although it was mostly work, the change and the going and coming made it a partial holiday for both Mrs. Hughes and myself . . . Besides being company, Mrs. Hughes is a great help in making lunches, etc., as I sometimes require two lunches during a long day at a distant motif."

The desert-like terrain of central British Columbia interested Hughes, and on his way north from Lillooet, he left the highway at Chasm to go across country. Driving through expansive ranch lands, Hughes stopped to draw where the dry hills of Dog Creek meet the Fraser River. Continuing on their way up the Fraser, he stopped to draw the "dry belt" just east of a small settlement called Riske Creek.

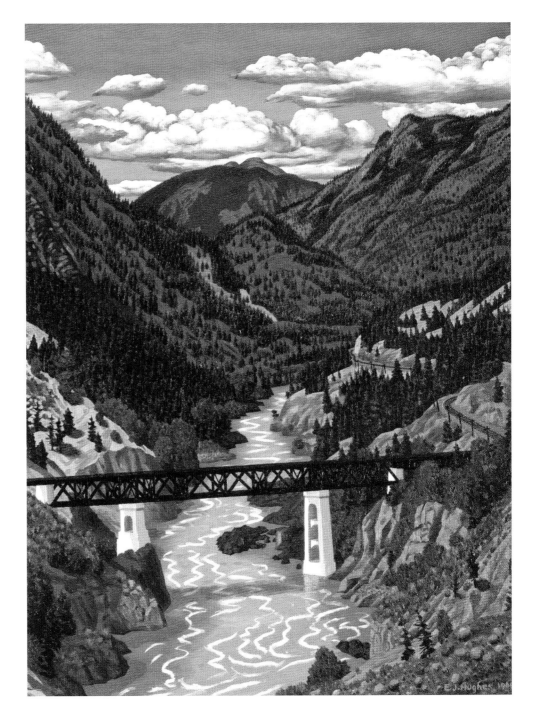

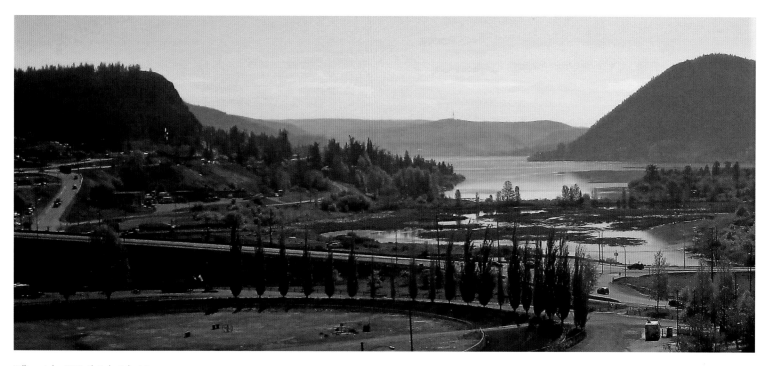

Williams Lake, 2018. Photo by Robert Amos.

Hughes painted the dramatic Sheep Creek Bridge, which is situated conveniently close to Williams Lake, and he titled his painting *The Fraser River Near Williams Lake* (1966). The bridge spans the Fraser River at a bend in a striking valley. Long views of the road Hughes travelled are shown descending to and rising from the bridge and running off far into the distance. Max Stern liked the painting so much that he gave Hughes a fifty-dollar bonus.

Hughes stayed at Williams Lake in 1963, and he made a painting of the north end of the lake. He drew from a hill that provided an unimpeded view to the south. The town has changed considerably over the years, but the park where he walked is still there. Along a ridge, the view looks out over the lake where the wooded hills at the south end of the lake stand in the distance. Between points of land at the near end of the lake is Scout Island, known as one of the best bird-watching marshes on the continent.

The Hughes painting differs from a photograph of the place, and the artist has livened up the neighbourhood by adding touches of bright colour to a number of historic buildings along the lakeside road. The lower left corner of the painting can be identified by the unmistakable shape of the "far turn" of the Williams Lake Stampede racetrack.

The Williams Lake Stampede is a three-day event, held annually on the first weekend in July. In addition to the racetrack, Hughes has carefully painted a ramshackle cluster of sheds, one of which was known to locals as a notorious dance hall. It was perennially the scene of merriment during the annual stampede in earlier days.

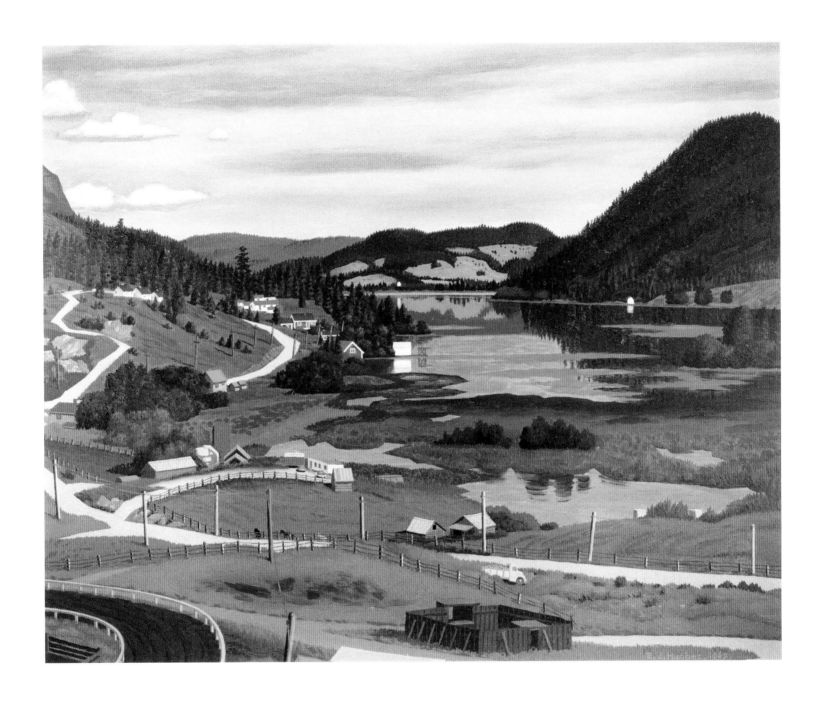

Williams Lake (1969). Oil, 32" × 40¼" (81.3 × 102.2 cm).

Third Canada Council Grant (1967)

To be able to take time away from his studio and go travelling required Hughes to find extra money, and though he was certainly a successful artist, money continued to be a concern. On November 2, 1966, he wrote to his sister Zoë: "We haven't been to the mainland once to see Mum this year, mostly due to financial reasons. I have applied for another Canada Council award and will know in February if I receive one. If so, it would by all means relieve us of the pressure of 'Bills, Bills, Bills.' It is four years since my last Canada Council fellowship award, and instead of waiting for the five-year period I had intended to, I am applying this year for another award, as I could especially use some more boat subjects from the mainland and Vancouver Island coasts."

To support his application for this third grant, Hughes was backed up by a letter of recommendation from Doris Shadbolt, curator of the Vancouver Art Gallery. She was, at the time, planning the first major exhibition of Hughes's work. Colin Graham, the founding director of the Art Gallery of Greater Victoria, was also happy to recommend Hughes.

Additionally, Hughes's dealer and confidante, Max Stern, forwarded a "Statement by Referee" to the Canada Council. In a letter dated November 25, 1966, he named some of Hughes accomplishments, and mentioned that his paintings were in the collections of the National Gallery of Canada and the Department of External Affairs. "Hughes is perhaps the most poetic of our Canadian painters," Stern declared, and went on to describe the value the grant would have for this artist: "he is an artist who will make use of the sketches he will bring back from such trips for years to come. He is a poet who can make notes on the spot, and then write his poems at home in his studio." Stern continued with his praise: "I have such a high regard of Hughes that I believe that many of the spots the artist will sketch and paint during such a trip will later be remembered from his paintings like Mont Victoire is remembered from the canvases by Cezanne."

This was high praise indeed. In thanking Stern, Hughes wrote on February 16, 1967, that "I found it most gratifying, indeed, to be compared in any way to Cezanne, who, I feel still, is the greatest painter since Rembrandt. I only hope my work can live up to your recommendation."

After the Council's adjudication was complete, Hughes was awarded not the full amount of $5,500 but was given $3,700. With the money available, in late June of 1967, Hughes was able to set out on the northern trip. Travelling via Lillooet and Williams Lake, Hughes and Fern then went farther north up to the "three Hazeltons" area. In the essay she wrote for the Kamloops Art Gallery's catalogue from 1994, Pat Salmon provided more detail: "Hughes fulfilled a long-delayed dream," she began. "In their new Pontiac the couple drove north to Hazelton on the Skeena River. They stayed in New Hazelton for two weeks in a modern motel where Mrs. Hughes became friends with the chamber maid."[51] During the time they stayed there, Hughes was away all day sketching.

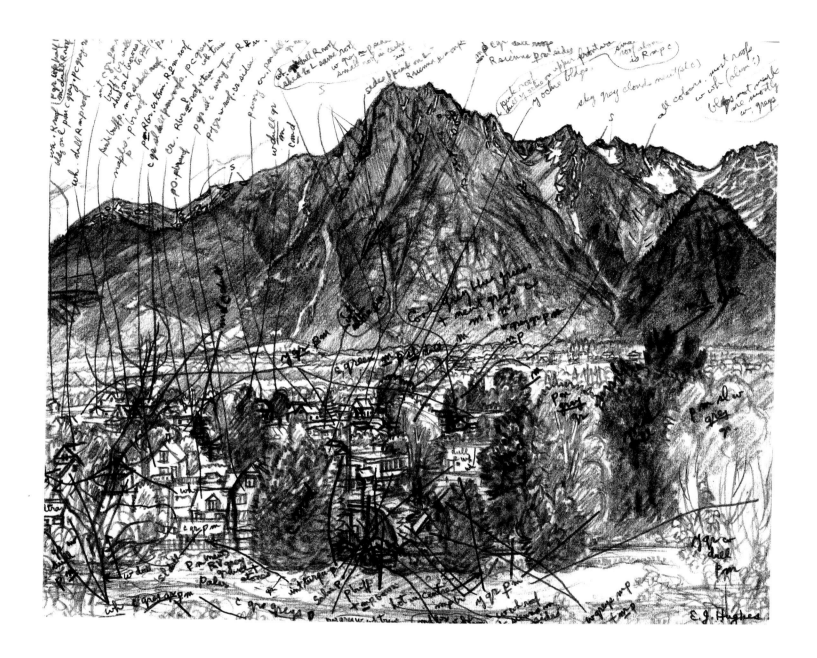

Hazelton (1967). Pencil.

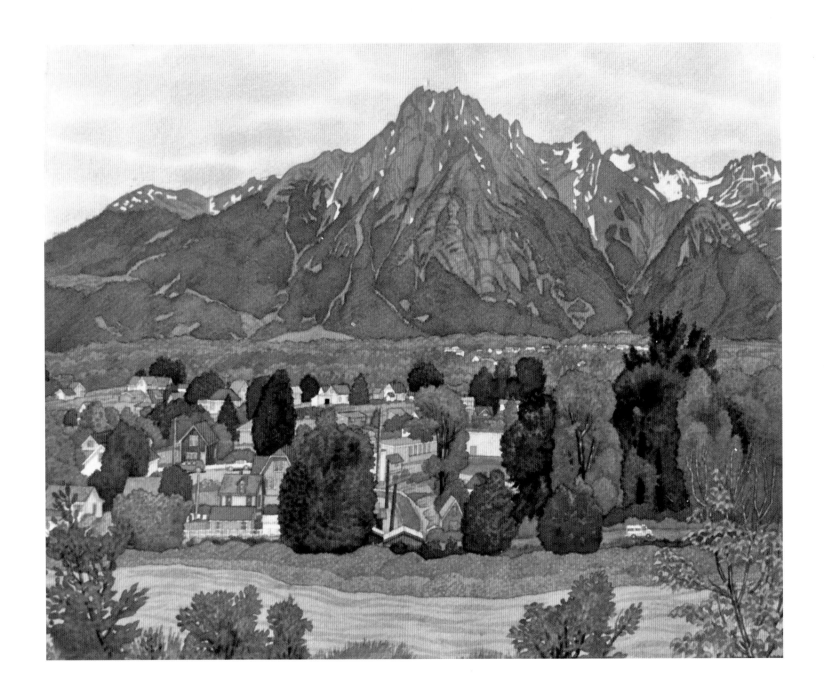

Hazelton, BC (1985).
Pencil and watercolour, 20" × 24" (50.8 × 61 cm).

In July of 1967, Marie Cadorette was a newspaper reporter with the *Prince George Citizen*. As it happened, when she was a child, she had been Hughes's "newspaper boy," delivering the daily paper to Ed and Fern at their Shawnigan Lake home. Now she was assigned to interview the artist while he was visiting the region. Because of this pleasant former association, Hughes granted her a rare and extensive interview.

"Academy Artists Visits Here on Sketch Tour" ran the headline. "A weekend visitor to the Prince George region was BC scenic artist E. J. Hughes, who only a few months ago was selected to the Royal Canadian Academy of Art . . . Mr. Hughes describes himself as 'a bit out of style'. Some critics have described his work as 'primitive' or 'magic realism'. But Mr. Hughes considers himself 'just a realist.'

"The couple continued to the three Hazeltons where Mr. Hughes made detailed pencil sketches of colourful native totem poles and the outlying Indian villages. . . . The couple left their south Vancouver Island home in early July. Previously they toured the east Kootenay district . . . So far, Hughes has covered 7,000 miles throughout the province and Vancouver Island."[52]

While staying at Hazelton in 1967, Hughes completed a richly complicated pencil drawing of the town, with a full tonal description of the powerful mountain range in the background. A dense line drawing of the houses of the town spreads out below. All is elaborately annotated regarding colour and tone, with a maze of cryptic notes. Eighteen years later, he took up this sketch and produced a painting of the subject in watercolour.

Pat Salmon took a photo of this painting in process. Hughes used his primitive grid system to enlarge the drawing onto a full sheet of watercolour paper, and then drew in the design carefully and completely with a pencil. Using a neutral tint of watercolour, he washed in the sky and the river in a cool grey monochrome and then began shading in the mountain slopes.

Next Hughes added coloured washes to his scene of Hazelton, and the colour of the grey sky grew softer and warmer. The townscape is populated with rows of the sort of simple little houses that might be seen with a model railway set. The only significant change between the drawing and the finished painting seems to be the addition of a tiny red and white truck making its way along the riverside road. In the foreground, a wide gravel bank separates the river from the town.

With his next letter, of August 21, 1985, Hughes sent along two more watercolours and an apology. "Sorry took so long to complete these. I kept finding small and medium areas of the compositions that required reworking." Such carefully finished townscapes required quite a bit of time to bring to a satisfactory conclusion.

For an entirely unexpected reason, this was to be a good year for watercolour. In his letter of May 23, 1985, Hughes reported to Stern: "I feel you will be interested to know that last week I was awarded an honorary diploma by the Emily Carr College of Art and Design in Vancouver. I attended in person, as all I had to say was 'thank you', and to help dispel the recluse image some writers are trying to give me. It was a bit of a worry going there but Mrs. Salmon, who was visiting her daughter in New Westminster, went with me for moral support, and all went well.

"Along with the diploma, I received a large quantity, 50 sheets, of good quality French watercolour paper, the same size and weight as Green's Pasteless Board that I have been using. The brand name is Arches, and in order to try out this paper I'll be doing 2 more w.c.s before returning to acrylics."

In an earlier letter, dated September 21, 1961, Hughes had written how he felt about watercolour. "I find that watercolours depend a great deal on accident to make them successful in an Art sense, while in oils you can alter if necessary and obtain more technical effects in order to reach the qualities of a work of Art. However, as

A Bridge North of Hazelton (1967). Pencil

This bridge was built near the site of a vital link between First Nations communities. Hagwilget, a village of the Wet'suwet'en people, is on the south bank of the river, and the Wet'suwet'en are a people of the Interior. The Gitxsan on the north side are coastal people with Tsimshian language and traditions. This river crossing was for millennia a vital connection on the Grease Trail, a major transportation route over which oolichan oil was traded from the coast to the Interior.

When she visited there in 1912, Emily Carr painted the village of Hagwilget deep in its precipitous canyon setting. She concentrated on the dramatic setting, with the old poles and fishing shacks and smokehouses enclosed by steep cliffs.

For Hughes, *A Bridge North of Hazelton, BC* began with a pencil drawing that he made on his 1967 trip with Fern. He concentrated on the bridge and the surrounding countryside, with Mount Rocher de Boule in the distance. His drawing has more colour notes inscribed on it than almost any of his other studies. Because of the copious details the artist has included, it is worth transcribing the longest, written across the lower third of the page.

On the left edge it begins, "grass around bldgs. is mostly gr p + pm sl dull + p yo hay esp. to R of church". Then, with an arrow to the lower left corner and the centre, "y br p m dirt and stones." A small note in a circle reminds the artist "ONE BUS OR TRUCK ONLY ON BRIDGE," though in the drawing and the painting none was included. The longest annotation reads, "church is wh c green trim, wh roof on steeple, w p dull R roof y ochre c, dull p m walls, Bldg to R of it has p dull w side R grey w p roof. Bldg behind bridge has wh trim + dR dull sides. Bldg to R of it has cR (rose) mp + c m grey duroid small Roof o L (by bridge) is dR w + B. sides in grey p m." With a small break, the next note, which is toward the lower right reads, "Bldg in centre is gr c—p (al dull) roof same only more gr. Wh trim + all wh door. Bldg to R of it is

Turner, Girtin and John Varley, for example, in earlier English art, have proven, along with more recent painters like Winslow Homer, Audubon, Burchfield & Hopper of the U. S. school, and Charles Comfort & Goodridge Roberts for some examples of the Canadian school, watercolours can be raised to a high level, alongside oils, as works of Art."

One of Hughes's finest watercolours is *A Bridge North of Hazelton, BC* (1985). The bridge painted by Hughes was built in 1932 and carries traffic on Highway 62 between the village of Hazelton three miles away and the District of New Hazelton. It is a single-lane suspension bridge over the Bulkley River that, though not visible in the painting, flows through a canyon eighty metres below.

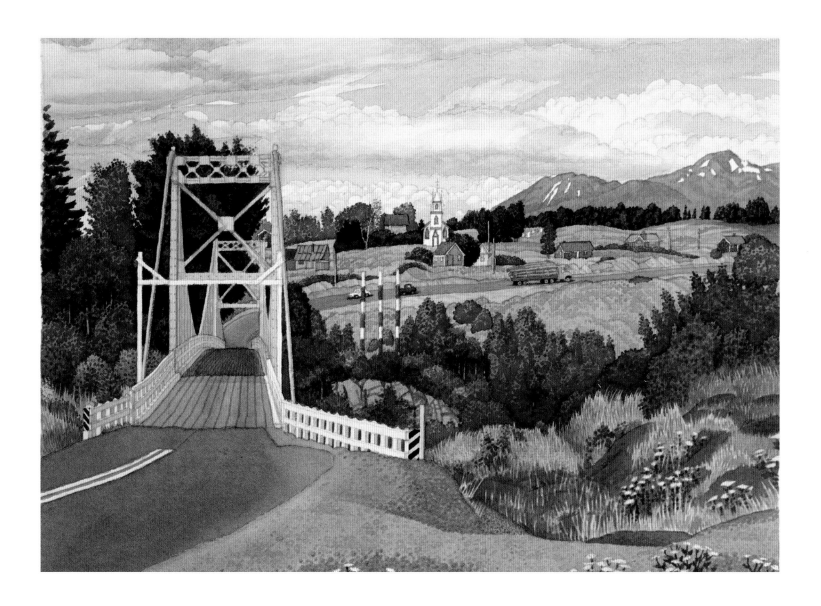

A Bridge North of Hazelton, BC (1985).
Pencil and watercolour, 18" × 24" (45.7 × 61 cm).

Kitwanga, 1967. Photo by E. J. Hughes.

p salm O, naples trim pm c gr (sl dull) roof. Bldg to L of nO - wh pole is green mp (sl dull) on trim. Bldg on extreme R is dm R wh trim."

It is possible to understand what these notations mean by comparing the artist's coded messages with what was eventually painted. Beyond this logical note taking, Hughes managed to add a special sense of atmosphere in this watercolour. The sky is a light blue fading to turquoise, with cumulus clouds rising above the strong cobalt blue mountains in the distance. In the centre of this expansive landscape is St. Mary Magdalen, a wooden gothic-type church painted white, with blue trim. This beloved local landmark was built by Father Morice in 1908.

A scattering of typically rural houses appears among the folds of the hills. The colours of each building—walls, trim, and roof—are noted, and in the resulting painting these colour choices make fine clear combinations. The dominant feature of the painting is the steel suspension bridge, spanning a river that is never seen. A road approaches from the lower left corner and heads across the two-lane blacktop onto the one-lane bridge. On the far side of the bridge, a yellow logging truck hauls a load of huge timbers up another long hill toward the mountains in the distance. It is a beautiful composition.

Even the simplest of Hughes's pictures took a great deal of preparation and thought, not to mention hours of time for their execution. The artist wrote, in that letter of August 21, 1985, "Due to my having to rest more as I get older [he was now 72 years of age], I am able now to paint only in the afternoons for 5 hrs., 5 days a week, and do my household chores, correspondence, etc., in the mornings, and gradually get into a painting mood by afternoon. This is another reason it takes me longer to complete my paintings and watercolours. The above is just an explanation, in case you were wondering why you heard from me less often."

The reply came from Stern on September 12, 1985. He was just back from his annual trip to Europe and wrote that he had "spent a very nice afternoon tea with Henry Moore together who is 86 years old and unfortunately not very well." He went onto say, "While I enjoyed the two watercolours which you sent us very much . . . I miss getting paintings [on canvas] from you." Hughes and Stern had much to look back upon, two men who had supported one another and grown old together.

From Hazelton, Hughes planned to visit Kitwancool/Gitanyow, home to the largest and oldest collection of totem poles in their original location in British Columbia, but when he arrived in Hazelton, he learned that there were almost no totems to be seen in that historic village. Philip Ward, an ethnologist at Canada's National Museum, wrote to Pat Salmon on November 3, 1989, to say, "At Kitwancool in 1967, Mr. Hughes would have found only two poles standing because all the others had been taken down for restoration."[53]

So Hughes drove fifteen kilometres north to Ans'pa yaxw (Kispiox) in Gitxsan territory, at the confluence of the Bulkley and Skeena rivers. There, he found twenty-four poles in place but discovered they were unpainted, simply a natural wood colour. Ward explained that "The poles at Kispiox had been restored two years earlier and were unpainted (as they still are) because except for some details of the eyes and mouths, they never had been painted."[54] This was not what Hughes had been hoping for.

The artist proceeded to Kitwanga/Gitwangak, which is located forty-five kilometres to the east of New Hazelton at the junction of Highways 16 and 37. Kitwanga is part of the Gitxsan nation, an important village of about four hundred people located where the Kitwanga River runs into the Skeena River. This community is the site of the oldest collection of totem poles still standing in their own village.

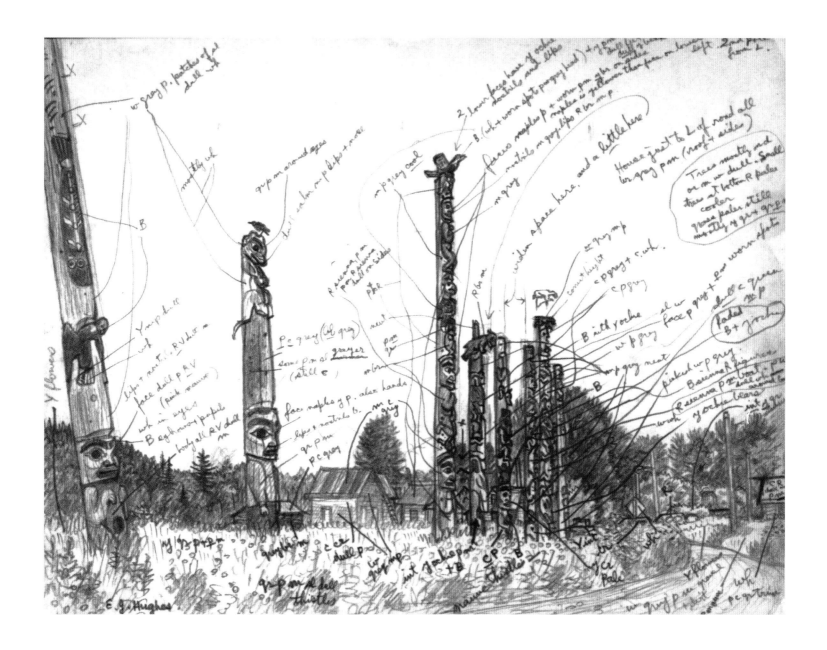

Kitwanga (1967). Pencil.

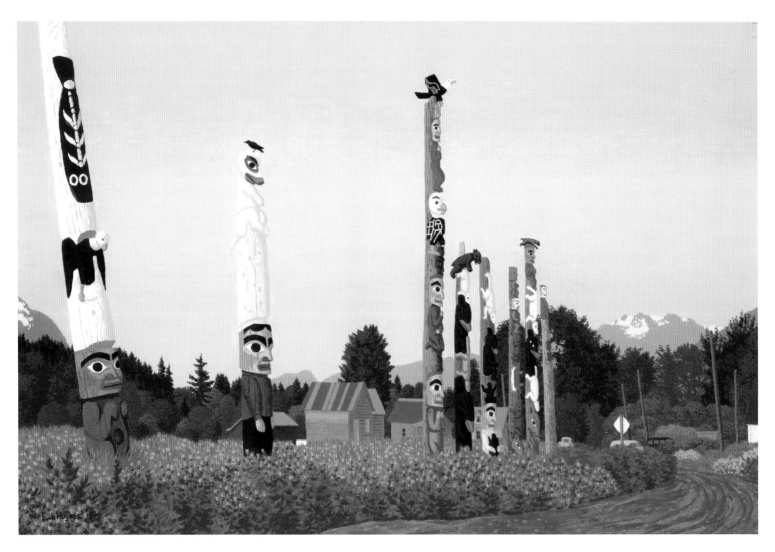

Kitwanga II (1991). Acrylic, 24" × 36" (61 × 91.4 cm).

"Kitwanga II" 24×36" acrylic # ~~33~~ 32 E. J. Hughes. 1991.

This painting was produced from a 1967 pencil sketch from which an earlier painting was produced in 1981. The pencil sketch was from nature at the Indian village of Kitwanga, a few miles west of Hazelton, in northern B.C.

This row of totem poles at one time faced the nearby Skeena river, but as the river bank eroded, the poles were moved. E. H.

Once again, on this trip to the Skeena River, Hughes was following in the footsteps of Emily Carr. In 1912, Carr had made Kitwanga/Gitwangak her first stop in her original trip to the "totem forests," and she returned in 1928. Gerta Moray, in her book *Unsettling Encounters*, described what Carr found: "In 1912 she had made several views of this village and its poles as they stood on the high bank facing the river. Because the village was on the railway line, it had been chosen as the first target for the Department of Mines/Canadian National Railways totem-pole restoration scheme that had been operating during the three years prior to Carr's return. Its poles had been fitted with reinforcement posts, coated in grey paint with details picked out in bright colours, and re-erected in a straight line at the centre of the village."[55]

The totems Carr painted in her watercolour *Gitwangak* (1912), in the National Gallery of Canada, are the same ones Hughes drew in 1967—but for Hughes they were standing in their new location.

Hughes painted his picture of Kitwanga in oil and delivered it to Stern. When Stern received the painting in 1981, his enthusiasm for Hughes's work, which had continued for thirty years, remained undiminished. In his reply of March 18, 1981, he wrote: "What impressed me most was the quality of the atmosphere rendered and I was amazed to see how versatile you are in selecting your subject matter. I found it a very successful painting."

Though Hughes often painted an image both in oil and in watercolour, he rarely repeated anything in the same medium. In this case, Hughes took up the subject of the oil painting of *Kitwanga* (1981) again in 1991. This time he painted it in acrylic and titled it *Kitwanga II*.

Philip Ward, who was at the time ethnologist at Canada's Museum of Civilization, corresponded with Pat Salmon about the painting and, in his letter of November 3, 1989, he made

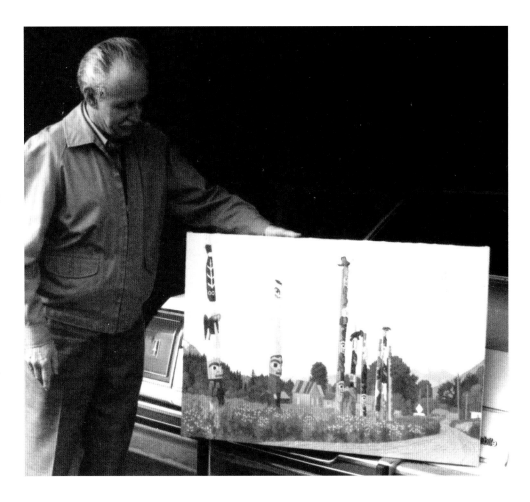

mention of the atmosphere the painting captured: "It is the oil painting of Kitwanga that really delights me. Mr. Hughes has not only represented the poles accurately, but he has recaptured the subtle atmosphere of the place. Even the quality of light and the sense of stillness are exactly right. Kitwanga is very evocative for me, depicting the village exactly as I first saw it (in the same year, 1967) and recalling the happy hours I have spent there since. It has changed a little now. Unfortunately the tall pole ("Drum Hangs On") fell last December and was badly damaged, while the little group of houses behind the poles were replaced by modern bungalows early this year."[56]

E. J. Hughes with his painting *Kitwanga II* (1991). Photo by Pat Salmon.

While visiting Kitwanga in 1967, Hughes also drew the same totems as he painted in *Kitwanga* and *Kitwanga II*—but looking at them in the opposite direction. Hughes took Kitwanga as he found it. In a 1994 essay for the Kamloops Art Gallery, Salmon relayed more information: "Finally he settled in Kitwanga and made sketches of the poles from the north and south. Hughes had been warned that the Indians were hostile. However, while he was sketching at Kitwanga a native approached Hughes, saying he was in the process of carving a totem. He gave Hughes exact directions on how to get there should he want to paint it. Hughes, grateful for this display of interest, went to the man's yard. The totem, however, proved an unsuitable sketching motif being partly hidden in tall grass."[57]

By coincidence, in the foreground of Hughes's image of *Totem Poles at Kitwanga* he has, in fact, painted a carving lying supine and partly hidden in tall grass. While the totems are the main theme of the painting, life at the village of Kitwanga is beautifully evoked. Smoke rises from a chimney in the middle distance, while the totems stand watch amid wildflowers. This, like all Hughes's paintings, was created with respect.

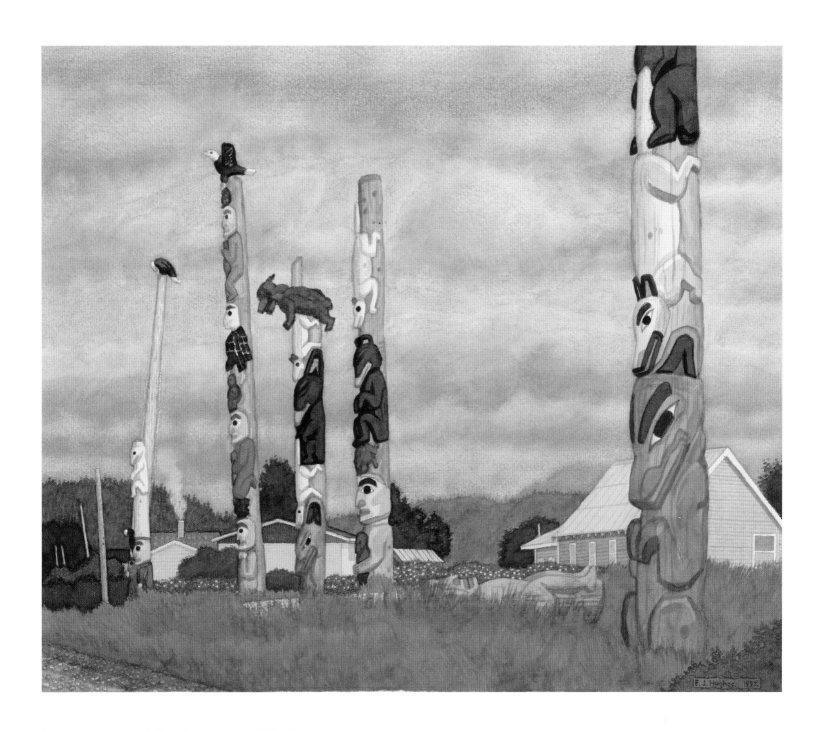

Totem Poles at Kitwanga (1994). Watercolour, 19½″ × 23½″ (49.5 × 59.8 cm).

Further Biographical Notes

Hughes continued to paint almost until his death in 2007 though, after 1967, he never left Vancouver Island for that purpose. His was a quiet life, and there is not much to report. At the same time, his career went from strength to strength.

Hughes's meeting with Max Stern at Shawnigan Lake in 1951 was the most important event in the artist's career. Stern bought everything Hughes produced—paintings, drawings, and prints, no matter when they were made. As the years went by, Hughes and Stern may have met only four times. Yet they enjoyed a deeply respectful professional relationship that was carried out almost entirely by mail. Their correspondence has been preserved in its entirety, and those letters are the basis for an understanding of Hughes's work. When Stern died in 1988, he left the Dominion Gallery in the hands of his assistant, Michel Moreault, who in his own way, continued the relationship. Moreault visited Hughes twice on Vancouver Island; he purchased everything Hughes sent him; and he maintained the correspondence. But he lacked the acumen of Stern, and the Galerie Dominion (as it came to be known) closed its doors in 2000. After that, Hughes had no trouble finding customers for his art, and Pat Salmon stepped in to connect patrons and paintings.

For many years, paintings and drawings by Hughes, from every period and in all his mediums, have turned up regularly at auction across Canada, maintaining interest in and increasing the prices for all of his work. The painting *Fishboats, Rivers Inlet* (1946), which sold for almost a million dollars in 2004, again came to auction in November 2018 and brought a record price—this time $2.04 million.

Throughout his life, the paintings of E. J. Hughes were presented in a series of exhibitions, the first curated by Doris Shadbolt at the Vancouver Art Gallery in 1967. Shadbolt already knew of Hughes in 1946, when he was just back from the army. She and her husband Jack visited Hughes at 410 Quebec Street and saw the cartoon for *Fishboats, Rivers Inlet*. According to Salmon, they praised it lavishly. "That is your masterpiece," Jack Shadbolt told Hughes.[58] Doris Shadbolt kept the Island artist in mind and created the first major exhibition of his work, at the Vancouver Art Gallery in 1967. For this she gathered fifty of his artworks, including sixteen drawings, and produced a fully illustrated catalogue.

The well-respected local critic Joan Lowndes reviewed the show in the *Vancouver Province* under the dramatic headline "The Hughes Revelation": "Suddenly as you step into the large Emily Carr gallery, you are overwhelmed by the strength of the artist's forms, by the supernatural quality of his light, and by the intensely personal nature of his vision. That Geiger-counter sensibility which art lovers develop starts to tick furiously. Here is a painter whom we must revalue upwards . . . To stand among Hughes's paintings is to experience mind-expansion as the doors of perception swing open."[59] This was a powerful response to the artist's first major public exhibition.

Facing page: E. J. Hughes on the day he was made a member of the Order of British Columbia, September 2005. Photo by Pat Salmon.

A. Y. Jackson had nominated Hughes for membership in the Canadian Group of Painters (CGP) in 1948, but Hughes was disappointed with that group, citing its favouring of abstract art. More importantly, the group refused to exhibit his paintings because of their requirement that submissions must not be owned by commercial galleries, but under contract he sold all his work to the Dominion Gallery. Hughes resigned from the CGP in 1958.

Hughes was elected to the Royal Canadian Academy of Arts in 1968. At the time, *Victoria Daily Times* writer Donna Clements interviewed the artist: "'It takes ten percent ability, fifty percent industry and forty percent enthusiasm and interest to be a good artist', says Edward Hughes, an associate of the Royal Canadian Academy of Art. Mr. Hughes, 55, is the only ARCA [from Vancouver Island] and has been a resident of Shawnigan Lake for 17 years . . . Mr. Hughes completes approximately 12 paintings a year and works an average of seven hours a day."[60]

Jane Young's 1983 show for the Surrey Art Gallery brought Hughes national attention. That substantial survey included ninety-two paintings and drawings, many of which were illustrated in Young's thoughtful 102-page catalogue. After opening in Surrey in 1983, the exhibition was seen at the Art Gallery of Greater Victoria, the Edmonton Art Gallery, the Glenbow Museum in Calgary, the National Gallery of Canada in Ottawa, and the Beaverbrook Art Gallery in Fredericton.

"E. J. Hughes in Perspective," an article written by Scott Watson about the exhibition, appeared in *Canadian Art* magazine in the fall of 1984. "Edward John Hughes is a reactionary artist for whom the modern movement need not have occurred . . . despite their literalness, Hughes's paintings often contain disturbing undercurrents reflecting an anxiety that links him to the mainstream of the modern movement . . . As a draftsman Hughes knows few equals in Canadian art history. His portrait drawings, such as the one of his wife, Fern, done in 1941, show an astonishing facility that can be compared to Ingres . . . "[61]

The Nanaimo Art Gallery played host to the hometown artist with a show entitled *From Sketches to Finished Works by E. J. Hughes* in 1993. Pat Salmon wrote the "catalogue narrative" for the accompanying booklet and, with the assistance of Jane Young, gathered sixty paintings and their drawings to reveal the working methods of Hughes. In my position as art writer for Victoria's *Times Colonist*, I reviewed the show with a two-page feature article on January 23, 1993. The story began: "I consider it a great loss to us that the paintings of Duncan artist E. J. Hughes are not known and appreciated by the public here, for he has painted the best image of our own corner of the world, an image which brilliantly informs non-artists what this region really looks like."

As the advocacy for his work at the Dominion Gallery waned, Hughes was encouraged by Salmon to have an exhibition at the Auld Kirk Gallery in Shawnigan Lake. That gallery, a rather quaint deconsecrated Anglican church in the village by the lake, was a project of Dr. Frank and Nancy Roseborough. With a wonderful enthusiasm, Frank put the building to rights, and Nancy made contact with the local artists. Because of Hughes's deep attachment to Shawnigan, Salmon suggested a Hughes exhibit to the Roseboroughs, who were delighted to work with her. Work from Hughes was consigned to the Auld Kirk by the Dominion Gallery, and this was really the first time Hughes's paintings had been offered for sale to his neighbours, and a number were sold.

It also marks the only time when Hughes attended the opening of one of his art shows. He enjoyed the attention and signed autographs on prints and posters throughout the afternoon. A second exhibition was held at the Auld Kirk Gallery in September 1996.

At the same time as the first Auld Kirk show, Jann Bailey, director of the Kamloops Art Gallery,

was putting together an important thematic exhibition about Hughes titled *The Vast and Beautiful Interior*. Salmon wrote an essay in the seventy-two-page catalogue and acted as liaison between the Kamloops gallery, lenders across the country, and the Dominion Gallery. Specially for the show, Hughes painted five new watercolours of scenes based on his earlier drawings of the Interior. After opening in Kamloops, the exhibition went on a regional tour to six galleries.

Before long, a grand retrospective of the work of E. J. Hughes was being discussed by the Vancouver Art Gallery, and in 2000, newly appointed curator Ian Thom took the lead in creating the definitive exhibition of the artist. Private sponsorship came forward to ensure a top-quality exhibition, with an accompanying "coffee table" book. The gallery's invitation put its case clearly: "E. J. Hughes is famous for his strong images of the landscape and seascape of British Columbia: distinctive in clarity of form and colour, yet tinged with an air of mystery. Hughes shares his sense of wonder and love of the beauty of shore, sea and sky, inviting us to experience and understand place and nature in new and deeper ways."[62]

The day before the opening of the Vancouver show, Michael Scott wrote a story in the *Vancouver Sun* entitled "The Absent Artist: BC's E. J. Hughes lets his paintings speak for themselves." He began: "They will turn out tonight by the hundreds for the opening of the Vancouver Art Gallery's big springtime exhibition. *Le tout Vancouver* will be there . . . a huge crowd of smiling intelligent faces come to see the work of British Columbia's quiet superstar, E. J. Hughes." He described his feelings: "Links can be made between his work and a variety of traditions, but this does not explain the singular power of his art to affect the psyche. Hughes's oeuvre is a great deal more sophisticated than it might initially appear . . . the work is too subtle and too complex to reduce to a simple description."[63]

Scott's review concluded with these words: "Hughes agreed to make work available for a show but told the young curator that he had no intention of discussing any aspects of his work. In preparation of his new book Hughes, who will be 90 next month, has always maintained his work is capable of speaking for itself. And so it is, in terms that are both intense and compelling."

The exhibition was subsequently seen at the McMichael Gallery in Kleinburg, outside Toronto.

As the years went by, many honours came to Hughes. Though Hughes didn't graduate from high school, he was pleased to receive three honorary doctorates: from the University of Victoria (1995), the Emily Carr Institute of Art and Design (1997), and Malaspina University-College (2000).

Hughes received the Order of Canada in 2001. "It's a great honour, especially in my line of work," he said at the time. "It shows my work is being recognized by everyone, not just art authorities."[64] The Order of Canada was followed by the Order of British Columbia, which was presented to Hughes in a private ceremony in the Duncan City Hall by Iona Campagnolo, then Lieutenant Governor, in 2005.

The prestige of the artist continued to soar higher. On November 25, 2004, a classic Hughes painting, *Fishboats, Rivers Inlet* (1946), was on the cover of the catalogue for Heffel Fine Art Auction House. Yvonne Zacharias wrote of the event in the *Vancouver Sun*: "There were gasps and tears among the 400 people gathered in the staid ballroom in Toronto where the auction took place [in the Park Plaza Hotel]. There was a feeling of history. Then there was applause. The highlight came when the artist himself came on the speaker phone, a rare moment given that most artists are dead when their works command a price in the six figures. The artist never dreamed his sombre but dynamic 1946 painting, *Fishboats, Rivers Inlet*, would sell for that amount. 'Isn't that amazing,' said Hughes by telephone from his home in Duncan. 'That was way more than I expected.'"[65]

In fact, fame and fortune had little effect on the artist. Hughes continued to lead his quiet life, painting every day and taking meals now and then at the Dog House Restaurant in Duncan. No longer able to drive, he still had his Jaguar Vanden Plas parked in the carport at his modest home. After the death of Fern in 1974, the artist was helped out in many of his daily activities by Salmon, and his neighbours looked out for him, a frail, elderly widower living alone.

Hughes had avoided doctors throughout his long life, but in his ninety-third year Hughes agreed to have his cataracts removed. The operation took place on December 27, 2006, and was considered a success by doctor and patient alike. But soon after, on January 5, 2007, the artist suffered cardiac arrest at home and died at the hospital in Nanaimo some hours later.

The response to his passing was a nationwide chorus of respect and appreciation for the artist. Kevin Griffin, writing in the *Vancouver Sun* on January 13, 2007, quoted Ian Thom at length: "'The loss of E. J. Hughes is a tremendous one for the province,' said Ian Thom . . . 'His remarkable images have transformed the way many of us view our native province. The integrity and length of his commitment to his subject (the landscape of British Columbia) has few parallels in the history of art and he achieved that rarest of goals—a personal vision which maintained the highest artistic standards and was also of almost universal appeal.

Canadians, and British Columbians in particular, are fortunate that this gentle, self-effacing man has left us a wonderfully rich visual legacy which celebrates the beauty of the natural world and our relationship to it.'"[66]

A celebration honouring the artist's life took place on January 12, 2007, at the Dog House. There, visitors reminisced about Hughes in a room permanently hung with reproductions of thirty of his paintings. This is where the artist had eaten lunch for nearly a decade. "Some people came in just to see if they could see Mr. Hughes," recalled manager Deidre Haines. "He was a true gentleman with a great deal of dignity and he certainly brightened our day."[67]

On Saturday, February 17, 2007 the Anglican Church of St. John the Baptist, Cobble Hill, held a service "in Celebration and Thanksgiving for the life of Dr. E. J. (Edward John) Hughes." At the end of the service, the congregation sang the hymn "All Things Bright and Beautiful." A short time later, many gathered at the Shawnigan Lake Cemetery on Chapman Road where Hughes's ashes (and those of Fern and his parents) were interred. The grave is marked with a granite stone bearing insignia of the province of British Columbia, the Canadian Armed Forces, and the words:

EDWARD JOHN HUGHES
1913–2007

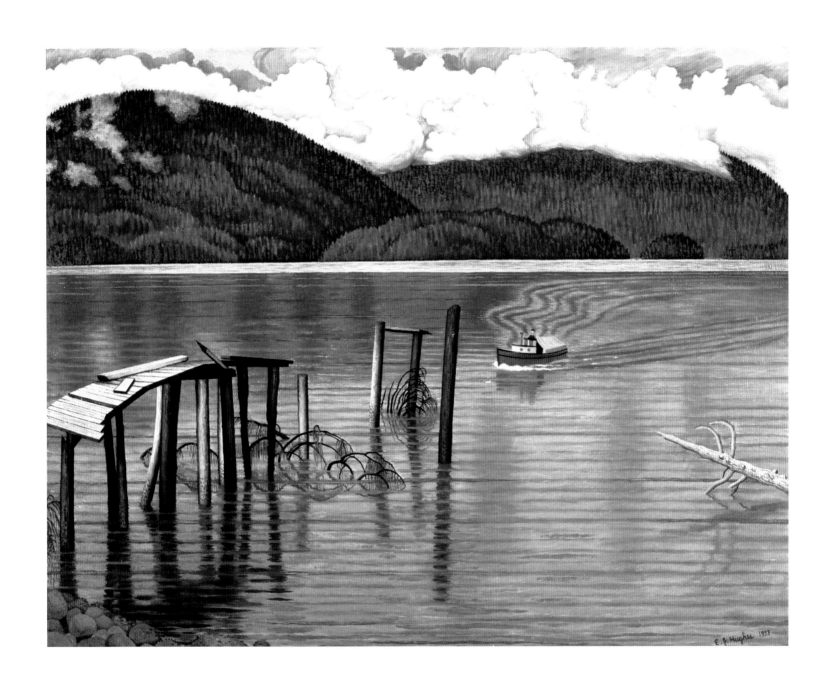

Rivers Inlet (1953). Oil, 23" × 19" (58.4 × 48.3 cm).

Acknowledgements

This book is dedicated to my wife, Sarah Amos. When Hughes first made contact with me in 1993, he included Sarah in the invitation. Her unwavering support allowed me to produce the Hughes books. Sarah introduced me to the British Columbia Interior, and she chauffeured me to almost every site Hughes painted. She contributed a number of photographs for the project and was my first editor and proofreader. In many ways, this is our book.

Most of the images and much of the information that went into this book were gathered by Pat Salmon, who began working on her biography of Hughes in 1977. She created a wonderful archive about the artist, and this book is the culmination of her efforts. Others who generously provided images include Hans Wilking, Suzan Kostiuk of Excellent Frameworks Gallery in Duncan, and Lara Wilson of the Special Collections Library of the University of Victoria. I also acknowledge the timely assistance of Heffel Auctions and a number of collectors who remain anonymous.

It was my good fortune in 2007 to meet Pat and Rodger Touchie, owners of the Heritage Group and proprietors of TouchWood Editions. It's a pleasure to work with the able staff at TouchWood. Publisher Taryn Boyd is in charge of the big things; Renée Layberry directs the production; Warren Layberry and Claire Philipson polished my spelling and punctuation; designer Colin Parks and I see eye to eye; and Tori Elliott gets the books before the public. This is my seventh book with TouchWood, and I look forward to working with the team again.

Ultimately, bringing Hughes's work before the public is an act of stewardship and a labour of love. I am particularly grateful to the family of the artist, who direct the Estate of E. J. Hughes. Their trust and encouragement has enabled me to do this work.

— ROBERT AMOS

Notes

1. Maria Tippett, *Stormy Weather: F. H. Varley, A Biography* (Toronto, ON: McLelland & Stewart, 1996), 159.

2. Unnamed author, "The Art School" (clipped newspaper article, source not known).

3. Pat Salmon, notes from her interview with Hughes on January 18, 1996.

4. Ibid.

5. Unity Bainbridge, *Visions* (Vancouver, BC: Emily Carr Institute of Art and Design, 1996).

6. Ian Thom, *E. J. Hughes* (Vancouver, BC: Vancouver Art Gallery, 2002), 36.

7. Maud Sherman quoted by Michael Clark, *Maud Sherman* (Vancouver, BC: Emily Carr Institute of Art and Design, 1999), Volume 5 issue 2.

8. Noel Robinson, "B.C. Artists Discover Savary Island" (Vancouver, BC: *Vancouver Province*, May 1933), quoted in *Sunny Sandy Savary*.

9. Ian Thom, *E. J. Hughes* (Vancouver, BC: Vancouver Art Gallery, 2002), 2.

10. Ian Thom, *E. J. Hughes* (Vancouver, BC: Vancouver Art Gallery, 2002), footnote 22, 215.

11. Ian Thom, *E. J. Hughes* (Vancouver, BC: Vancouver Art Gallery, 2002), 36.

12. E. J. Hughes quoted by Pat Salmon, *From Sketches to Finished Works by E. J. Hughes* (Nanaimo, BC: Nanaimo Art Gallery, 1993).

13. Ian Thom, *E. J. Hughes* (Vancouver, BC: Vancouver Art Gallery, 2002), 25.

14. Pat Salmon, notes from her interview with Hughes on January 18, 1996.

15. E. J. Hughes interviewed by Mark Forsyth, *B.C. Almanac* (Vancouver, BC: Canadian Broadcasting Corporation Radio, November 26, 2004).

16. Pat Salmon, *E. J. Hughes, Painter of the Raincoast* (Madeira Park, BC: Harbour Publishing, 1984), 42.

17. Jean Barman, *Stanley Park's Secret* (Madeira Park, BC: Harbour Publishing, 2006), 39.

18. Susan Crean, *The Laughing One: A Journey to Emily Carr* (Toronto, ON: Harper Flamingo Canada, 2001), 146.

19. Ian Thom, *E. J. Hughes* (Vancouver, BC: Vancouver Art Gallery, 2002), 77.

20. Pat Salmon, notes from her interview with Hughes, January 18, 1996.

21. E. J. Hughes, Hughes notes on his war experiences given to Pat Salmon, August 1993.

22. Dean Oliver, *Canvas of War* (Ottawa, ON: Canadian War Museum, 2000), 74.

23. E. J. Hughes, Hughes notes on his war experiences given to Pat Salmon, August 1993.

24. Edythe Hembroff-Schleicher, *Emily Carr: The Untold Story* (Saanichton, BC: Hancock House Publishers Ltd., 1978), 157.

25. Lawren Harris quoted by Joseph Plaskett, *A Speaking Likeness* (Vancouver, BC: Ronsdale Press, 1999), 49.

26. Max Stern, transcription of a speech given at the opening of the E. J. Hughes Exhibition, Beaverbrook Art Gallery, Fredericton, N.B., 1982.

27. *The Lamp* magazine (Bayonne, NJ: Standard Oil Company, 1954).

28. Pat Salmon, notes from her interview with Hughes, March 1990

29. Pat Salmon, notes from her files regarding *Echo Bay* (1953).

30. Pat Salmon, notes from her interview with Hughes, February 1984.

31. Pat Salmon, "A Life Like No Other," essay in *E. J. Hughes: The Vast and Beautiful Interior* (Kamloops, BC: Kamloops Art Gallery, 1994), 35.

32. Ibid.

33. Pat Salmon, notes from her files regarding *The Fraser River Near Cheam View* (1958).

34. Marie Cadorette, "Academy Artist Visits Here on Sketch Tour" (Prince George, BC: *Prince George Citizen*, July 1967).

35. Ibid.

36. Ian Thom, *E. J. Hughes* (Vancouver, BC: Vancouver Art Gallery, 2002), 87.

37. Ina D. D. Uhthoff, *Best of Moderns in CIL Collection* (Victoria, BC: *Victoria Daily Times*, January 9, 1964).

38. Author not named, "Centennial Cover Painting For New Telephone Books" (Victoria, BC: *Victoria Daily Times*, January 12, 1958).

39. Wilf Bennett, "Good Morning" (Vancouver, BC: The *Province*, February 25, 1958).

40. Pat Salmon, *From Sketches to Finished Works by E. J. Hughes* (Nanaimo, BC: Nanaimo Art Gallery, 1993), unpaginated.

41. Jann LM Bailey, *E. J. Hughes: The Vast and Beautiful Interior* (Kamloops, BC: Kamloops Art Gallery, 1994).

42. Ibid.

43. Ian Thom, *E. J. Hughes* (Vancouver, BC: Vancouver Art Gallery, 2002), 193.

44. Pat Salmon, A Life Like No Other, essay in *E. J. Hughes: The Vast and Beautiful Interior* (Kamloops, BC: Kamloops Art Gallery, 1994), 39.

45. Robin Laurence, "Hughes and Darcus: The Gift of Landscape" (Vancouver, BC: *Vancouver Sun*, December 16, 1965).

46. Pat Salmon, A Life Like No Other, essay in *E. J. Hughes: The Vast and Beautiful Interior* (Kamloops, BC: Kamloops Art Gallery, 1994), 42.

47. Pat Salmon, *"A Life Like No Other"*, essay in *E. J. Hughes: The Vast and Beautiful Interior* (Kamloops: Kamloops Art Gallery, 1994), 41.

48. Pat Salmon, written notes on the photograph of *Chalk Cliffs, Okanagan Lake* (1958).

49. Rebecca Sisler, *Passionate Spirits: A History of the Royal Canadian Academy of Arts* (Toronto, ON: Clark, Irwin & Co., 1980).

50. E. J. Hughes, speaking on *The Lively Arts* (Toronto, ON: Canadian Broadcasting Corporation Television, December 26, 1961).

51. Pat Salmon, A Life Like No Other, essay in *E. J. Hughes: The Vast and Beautiful Interior* (Kamloops, BC: Kamloops Art Gallery, 1994), 44.

52. Marie Cadorette, "Academy Artist Visits Here on Sketch Tour" (Prince George, BC: *Prince George Citizen*, July 1967).

53. Philip Ward to Pat Salmon, November 3, 1989.

54. Ibid.

55. Gerta Moray, *Unsettling Encounters: First Nations Imagery in the Art of Emily Carr* (Vancouver, BC: University of British Columbia Press, 2006), 295.

56. Philip Ward to Pat Salmon, November 3, 1989.

57. Pat Salmon, notes from her interview with Hughes, March 1990.

58. Pat Salmon, notes from her files.

59. Joan Lowndes, "The Hughes Revelation" (*Vancouver Province*, October 6, 1967).

60. Donna Clements, "Artist Seeks Realism in Portraying B.C." (Victoria, BC: *Victoria Daily Times*, November 24, 1968).

61. Scott Watson, "E. J. Hughes in Perspective" (Toronto, ON: *Canadian Art Magazine*, autumn 1984) 64–69.

62. Invitation for the exhibition *E. J. Hughes*, from Vancouver Art Gallery, 2003.

63. Michael Scott, "The Absent Artist: BC's E. J. Hughes lets his paintings speak for themselves" (Vancouver, BC: *Vancouver Sun*, January 29, 2003).

64. E. J. Hughes quoted by Peter Rusland (Duncan, BC: *The Cowichan Valley Pictorial*, August 26, 2001).

65. "E. J. Hughes 'amazed' after his painting sells for $920,000", Yvonne Zacharias (Vancouver, BC: *Vancouver Sun*, November 25, 2004).

66. "A self-effacing artistic genius", Kevin Griffin (Vancouver, BC: *Vancouver Sun*, January 13, 2007).

67. Deirdre Haines, quoted by Peter Rusland (Nanaimo, BC: *Nanaimo News Leader Pictorial*, January 13, 2007).

Bibliography

Amos, Robert, *E. J. Hughes Paints Vancouver Island*. Victoria, BC: TouchWood Editions, 2018.

Barbeau, Jacques, *A Journey with E. J. Hughes: One Collector's Odyssey*. Vancouver, BC: Barbeau Foundation, 2005.

Cole, Jane Walton, *From Sketches to Finished Works by E. J. Hughes*. Nanaimo, BC: Malaspina College Art Gallery, 1993.

Cole, Jane Walton, *E. J. Hughes: The Man and His Art*. Nanaimo: Nanaimo, BC Art Gallery, 2009.

Dawn, Leslie and Salmon, Patricia, *E. J. Hughes: The Vast and Beautiful Interior*. Kamloops, BC: The Kamloops Art Gallery, 1994.

Heffel Fine Art Auction House sales catalogues, canadianart@heffel.com: Vancouver, BC.

Shadbolt, Doris, *E. J. Hughes*. Vancouver, BC: Vancouver Art Gallery, 1967.

Thom, Ian, *E. J. Hughes*. Vancouver, BC: Douglas and McIntyre, 2003.

Young, Jane, *E. J. Hughes: A Retrospective*. Surrey, BC: Surrey Art Gallery, 1982.

List of Images

30. *Study of a Stove, Rivers Inlet* (1937). Pencil.

31. *In a Cabin at Rivers Inlet* [portrait of Paul Goranson] (1938). Pencil.

32. *Fishboats, Rivers Inlet* (1946). Oil, 42" × 50" (106.7 × 127 cm).

33. *Study for Fishboats, Rivers Inlet* (1946). Pencil.

34. *Abandoned Village Stump* (1937). Pencil.

35. *Abandoned Village* (1947). Oil, 30"× 38" (76.2 × 96.7 cm). University of British Columbia.

36. Top: St. Paul's Church, Mission Reserve, North Vancouver. Photo by Sarah Amos.

36. Bottom: St. Paul's Church, North Vancouver, 2018. Photo by Robert Amos.

37. *St. Paul's Church, North Vancouver* (ca. 1933). Pencil.

38. *Indian Church, North Vancouver, BC* (1939). Pencil and watercolour, 8¾" × 11" (22.3 × 28.1 cm).

39. *Indian Church, North Vancouver, BC* (1947). Oil, 40" × 48" (101.6 × 122.0 cm).

41. *Coastal Defense Gun and Crew, Stanley Park Battery* (1941). Oil, 20" × 40" (50.8 × 101.6 cm). Canadian War Museum.

42. *Entrance to Howe Sound* (1949). Oil, 32" × 36" (81.3 × 91.4 cm).

44. Princess Louise *Docked at Alert Bay* (1947). Pencil.

45. *Steamer in Grenville Channel, BC* (1952). Oil, 28" × 36" (71.1 × 91.4 cm).

46. *The deck of* Princess Adelaide *at Alert Bay* (1947). Ink.

47. *Houses at Alert Bay* (1951). Oil, 20" × 25" (50.8 × 63.5 cm)

48. Photo of a page from Hughes's pocket notebook— "Char. Of Mt. sides," (1947).

49. Top: Channel South of Prince Rupert (1947). Pencil.

49. Bottom: Compositional sketch for *Steamer in Grenville Channel, BC.* (1952). Pencil.

50. Home of E. J. Hughes on Shawnigan Lake Road (1951–1972). Photo: Pat Salmon.

52. *Imperial Oil Dock at Prince Rupert* (August 1953) (1961). Watercolour, 12" × 16" (30.4 × 40.5 cm).

53. *Oil Tanker at Allison Harbour* (1953). Pencil.

54. Top: *Storage Tanks at Bones Bay, Cracroft Island* (1954). Oil, 18" × 22" (45.7 × 55.9 cm).

54. Bottom: *Looking to Gilford Island* (1953). Ink. Shawnigan Lake Museum.

55. *Looking to Gilford Island* (1954). Oil, 18" × 24" (45.7 × 61 cm).

56. *Echo Bay* (1953). Oil, 24" × 18" (61 × 45.7 cm).

57. *Christie Pass, Hurst Island* (1996), underdrawing for watercolour.

58. *Christie Pass, Hurst Island* (1996). Watercolour, 18" × 24" (45.7 × 61 cm).

59. Above left: *Christie Pass, Hurst Island* on a postage stamp, issued by Canada Post on Canada Day, 1992.

59. Above: E. J. Hughes with his watercolour *Christie Pass at Hurst Island* (1996). Photo by Pat Salmon.

60. *Dawson's Landing, Rivers Inlet* (1966). Oil, 30" × 40" (76.2 × 101.6 cm).

61. *Tanks at Dawson's Landing* (1953). Pencil.

62. Above: *Near Namu* (detail) (1953). Pencil.

62. Right: *Namu Cannery, BC* (1991). Label.

63. *Namu Cannery, BC* (1991). Acrylic, 18" × 24" (45.7 × 61 cm).

65. *Cumshewa Inlet, Queen Charlotte Islands* (1990). Acrylic, 25" × 32" (63.5 × 81.3 cm).

66. *Beattie's Anchorage, Cumshewa Inlet* (1953). Pencil.

67. *Beattie's Anchorage, Cumshewa Inlet* (2000). Watercolour, 18" × 24" (45.7 × 61.0 cm).

70. *A Farm Scene North of Chilliwack* (1958). Ink. Courtesy of Shawnigan Lake Museum.

72. *Farm Near Chilliwack* (1959). Oil, 25" × 32" (63.5 × 81.0 cm).

74. *The Highway East of Chilliwack* (1958). Graphite.

75. *The Highway East of Chilliwack* (1961). Oil, 12" × 16" (30.5 × 40.5 cm).

76. Label of *South of Chiliwack* (1973).

77. *South of Chilliwack* (1973). Oil, 32" × 40" (81.3 × 101.6 cm).

78. Hope River at Chilliwack, site photograph 2017. Photo by Robert Amos.

79. *Hope River at Chilliwack* (1961). Oil, 25" × 32" (63.5 × 81.3 cm).

80. *Mt. Cheam and the Fraser River mural study* (1958). Pencil. Photo by Pat Salmon.

81. *Mt. Cheam and the Fraser River* (1959). Oil, 25" × 32" (63.5 × 81.3 cm).

83. Hughes in his studio painting the SS *Umatilla*, 1958.

84. An antique postcard of Yale, BC.

85. *Yale, BC in 1858* (1957). Oil, 30" × 25" (76.2 × 63.5 cm). Reproduced as the cover of a telephone directory.

86. *The Fraser River at Lytton* (1959). Oil, 24" × 20" (61 × 50.8 cm).

87. Junction of the Thompson and Nicola rivers, 2017. Photo by Robert Amos.

88. *Junction of the Thompson and Nicola Rivers* (1986). Acrylic, 25" × 32" (63.5 × 81.3 cm).

89. Top: E. J. Hughes with his painting of the junction of the Thompson and Nicola rivers, 1986. Photo by Pat Salmon.

89. Bottom left: Label for *Junction of the Thompson and Nicola Rivers* (1986).

90. Above: *Ashcroft* (1965). Oil, 32" × 48" (81.3 × 121.9 cm).

90. Left: Ashcroft, 2018. Photo by Robert Amos.

91. Above: *The Thompson Valley* (1964). Oil, 32" × 48" (81.2 × 121.9 cm).

91. Bottom left: The Thompson Valley, 2018. Photo by Robert Amos.

91. Bottom right: *The Thompson Valley* (1963), original drawing wrapped with thread.

92. Top: *The Thompson Valley* (1994). Watercolour, 18" × 24" (45.7 × 61 cm).

92. Bottom: *The Thompson Valley* (1994). Photo by Pat Salmon.

93. Above: *Kamloops Lake* (1968). Oil, 32" × 48" (81.3 × 121.9 cm).

93. Left: Kamloops Lake, 2017. Photo by Robert Amos.

94. Above: *Kamloops* sketch (1956). Pencil.

94. Below: *Kamloops* (1994). Watercolour in process, 18" × 24" (45.7 × 61 cm).

95. *Kamloops* (1994). Watercolour, 18" × 24" (45.7 × 61 cm).

96. Letter to Max Stern from E. J. Hughes, 1963.

97. Letter to Max Stern from E. J. Hughes, 1963.

98. Top: E. J. Hughes on the road near Kamloops, 1994. Photo by Pat Salmon.

98. Bottom: *East of Kamloops* (1965). Oil, 32" × 45" (81.3 × 114.3 cm).

99. Top: The bridge at Pritchard, 2018. Photo by Robert Amos.

99. Bottom: *The Bridge at Pritchard* (1956). Pencil.

100. E. J. Hughes near Chase, BC, 1994. Photo by Pat Salmon.

101. *South Thompson Valley Near Chase, BC* (1957). Oil, 25" × 32" (63.5 × 81.0 cm). Vancouver Art Gallery.

102. Label of *South Thompson Valley at Chase, BC* (1982).

103. *South Thompson Valley at Chase, BC* (1982). Oil, 32" × 36½" (81.3 × 92.7 cm). Vancouver Art Gallery.

105. Museum Ship, Penticton, with E. J. Hughes, 1994. Photo by Pat Salmon.

106. *Museum Ship, Penticton, BC* (1994). Watercolour, 18" × 24" (45.7 × 61 cm). Photo by Pat Salmon.

107. *Museum Ship, Penticton* (1959). Oil 25" × 30" (63.5 × 76.2 cm). McIntosh Gallery, University of Western Ontario.

109. *Museum Ship, Penticton* (1959). Graphite cartoon, 18" × 21" (45.7 × 53.3 cm).

110. *Okanagan Lake at Penticton* (1958). Pencil, 9" × 12¼" (23 × 31.3 cm).

111. *Okanagan Lake at Penticton* (1992). Watercolour, 18" × 24" (45.7 × 61 cm).

112. *Above the Yacht Club, Penticton, BC* (1991). Acrylic, 25" × 32" (63.5 × 81.3 cm).

113. Top: *Above the Yacht Club, Penticton, BC* (1958). Pencil.

113. Below: *Label for Above the Yacht Club*, Penticton, BC (1991).

114. *Above Okanagan Lake* (1958). Pencil. Photo by Pat Salmon.

115. *Above Okanagan Lake* (1960). Oil, 24" × 36" (61 × 91.4 cm). Royal BC Museum.

116. *Chalk Cliffs, Okanagan Lake* (1958). Pencil. Photo by Pat Salmon.

117. *The Beach at Kalamalka Lake* (2006). Watercolour, 18" × 24" (45.7 × 61 cm). Photo by Pat Salmon.

118. Wasa Lake, 2018. Photo by Robert Amos.

119. *Wasa Lake (1973)*. Oil, 38" × 51" (96.5 × 129.5 cm).

120. *Kaslo* (1977). Oil, 32" × 40" (81.3 × 101.5 cm).

121. Label for *Kaslo* (1977).

122. Kaslo from the north. Photo by Robert Amos.

123. *Kaslo on Kootenay Lake* (1969). Oil, 32" × 25" (81.3 × 63.5 cm).

124. *Above Kootenay Lake* (1968). Oil, 25" × 32" (63.5 × 81.3 cm).

125. Balfour on Kootenay Lake from the ferry, 2018. Photo by Robert Amos.

126. *Kootenay Lake* (1967). Pencil.

127. *Kootenay Lake* (1974). Oil, 25" × 32" (63.5 × 81.3 cm).

129. *Kootenay Lake from Riondel* (1968). Oil, 24" × 36" (61 × 91.5 cm).

130. *Revelstoke and Mount Begbie* (1962). Oil, 24" × 36" (61 × 91.5 cm).

132. Hughes in his studio, September 1961. Photographer not known. Courtesy of the E. J. Hughes Archive.

133. *Eagle Pass at Revelstoke* (1958). Pencil.

135. *Eagle Pass at Revelstoke, BC* (1961). Oil, 18½" × 24" (47 × 61 cm), Vancouver Club.

136. *Mt. Stephen* (1963). Oil, 32" × 25" (81.3 × 63.5 cm).

137. Letter to Max Stern from E. J. Hughes, 1963.

138. *Mt. Burgess and Emerald Lake* (1967). Oil, 30" × 40" (76.2 × 101.6 cm).

139. *Moraine Lake* (1963). Pencil.

140. *Mt. Edith* (1963). Watercolour, 18" × 24" (45.7 × 61 cm).

141. *View of Banff* (1963). Pencil, 32" × 48" (81.3 × 122 cm).

142. *Mt. Rundle and Vermilion Lake* (1964). Oil, 25" × 32" (63.5 × 81.3 cm).

143. Label for *Mt. Rundle and Vermilion Lake* (1984)

144. The Three Sisters, from the town of Canmore, Alberta. Photo by Robert Amos, 2018.

145. *The 'Three Sisters', Canmore, Alberta* (1972). Oil, 25" × 32" (63.5 × 81.3 cm).

146. Above: *West of Williams Lake* (1964), 32" × 45" (81.0 × 114.3 cm). Oil.

147. *The Fraser River Near Lillooet* (1969). Oil, 40" × 30" (101.5 × 76.2 cm).

148. Williams Lake, 2018. Photo by Robert Amos.

149. *Williams Lake (1969).* Oil, 32" × 40¼" (81.3 × 102.2 cm).

151. *Hazelton* (1967). Pencil.

152. *Hazelton, BC* (1985). Pencil and watercolour, 20" × 24" (50.8 × 61 cm).

154. *A Bridge North of Hazelton* (1967). Pencil

155. *A Bridge North of Hazelton, BC* (1985). Pencil and watercolour, 18" × 24" (45.7 × 61 cm).

156. Kitwanga, 1967. Photo by E. J. Hughes.

157. *Kitwanga* (1967). Pencil.

158. *Kitwanga II* (1991). Acrylic, 24" × 36" (61 × 91.4 cm).

158. *Label for Kitwanga II* (1991).

159. E. J. Hughes with his painting *Kitwanga II* (1991). Photo by Pat Salmon.

161. *Totem Poles at Kitwanga* (1994). Watercolour, 19½" × 23½" (49.5 × 59.8 cm).

162. E. J. Hughes on the day he was made a member of the Order of British Columbia, September 2005. Photo by Pat Salmon.

167. *Rivers Inlet* (1953). Oil, 23" × 19" (58.4 × 48.3 cm).

Endpapers and back cover: *Channel South of Prince Rupert* (1947) (detail)

Index

In this index, page numbers set in italics indicate an illustration.

Photo by Sarah Amos

ROBERT AMOS is an artist and writer living in Victoria, BC. A graduate of York University in Toronto, he discovered Hughes while working at the Art Gallery of Greater Victoria as Assistant to the Director (1975–1980). From 1986 to 2018, Amos was the art writer for the *Times Colonist* and has published eight books of his painting and writing about Victoria. His book *Inside Chinatown* (with Kileasa Wong, TouchWood Editions, 2009) received the Award of Excellence from the BC Heritage Foundation. The recent volume *E. J. Hughes Paints Vancouver Island* (2018) was shortlisted for the Bill Duthie Booksellers' Choice Award in 2019.

As a painter, Amos was elected to the Royal Canadian Academy of Arts in 1996, and his paintings are in the collections of the City of Victoria, the Art Gallery of Greater Victoria, and the University of Victoria, among many others. He was named an Honorary Citizen of Victoria in 1987. Amos is creating the Catalogue Raisonnée of the art works of E. J. Hughes. If you own artwork by this artist, please contact Robert Amos (robertamos@telus.net) to ensure that your artwork is properly represented in this essential document.

Edited by Warren Layberry
Designed by Colin Parks
Proofread by Claire Philipson
Map on pages x–xi by Leinberger Mapping

LIBRARY AND ARCHIVES CANADA CATALOGUING IN PUBLICATION
Title: E. J. Hughes paints British Columbia / Robert Amos.
Names: Amos, Robert, author. | Container of (work): Hughes, E. J. (Edward John), 1913–2007. Paintings. Selections.
Identifiers: Canadiana 20190127724 | ISBN 9781771513104 (hardcover)
Subjects: LCSH: Hughes, E. J. (Edward John), 1913-2007. | LCSH: Landscape painting,
Canadian—British Columbia—20th century. | LCSH: British Columbia—In art.
Classification: LCC ND249.H815 A46 2019 | DDC 759.11—dc23

TouchWood Editions gratefully acknowledges that the land on which we live and work is within
the traditional territories of the Lkwungen (Esquimalt and Songhees), Malahat, Pacheedaht,
Scia'new, T'Sou-ke and W̱SÁNEĆ (Pauquachin, Tsartlip, Tsawout, Tseycum) peoples.

The publisher acknowledges the financial support of the Government of Canada through the
Canada Book Fund and the Canada Council for the Arts, and of the Province of British Columbia
through the British Columbia Arts Council and the Book Publishing Tax Credit.

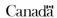

This book was produced using FSC.-certified, acid-free papers, processed chlorine free, and printed with soya-based inks.

PRINTED IN CHINA

23 22 21 20 19 1 2 3 4 5

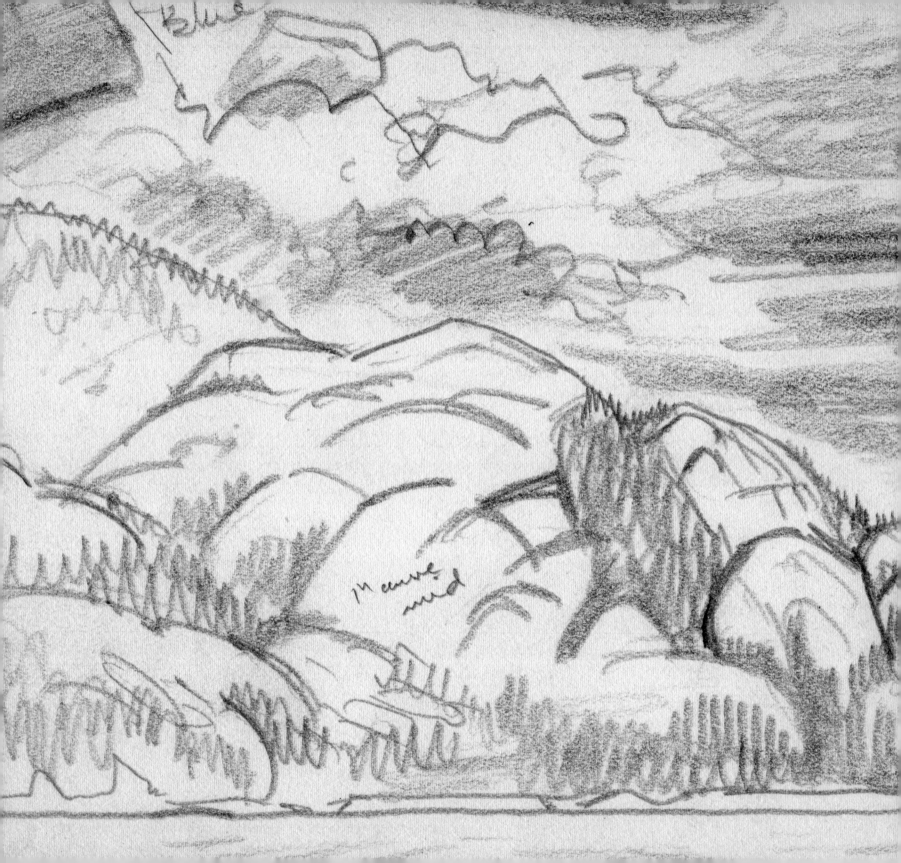